WITHDRAWN

Rev. Dr. Martin Luther King Jr. kind, where you envision an impossibly beautiful reality over the horizon of human history. We'll call these Prophetic Dreams.

Then there's the kind of dream where you're wearing nothing but a clerical collar and riding a dolphin through a grocery store. Occasionally, these visions present us with important messages from deep within our hearts, about what we fear and need, such as additional medication, but mostly they're terrifying and harmless. We'll call these Porpoise Dreams.

Next, we have Aspirational Dreams, where you long to build a small summer home on an inlet where you might spend your last years on Earth scanning the horizon for dolphins, which might explain the recurring porpoise dream. You won't die if these dreams don't come true, but they can at least give you a reason to get up in the morning. Nothing wrong with that.

This book is about none of these kinds of dreams, neither Prophetic nor Porpoise nor Aspirational. We are here to discuss the best dream most any of us can hope for, one that might actually come true and fundamentally alter our fortunes and lives, should we apply ourselves and manage not to lose everything that matters down the fathomless quarry of ambition.

I talk of American dreams.

For the purposes of this book, I am going to define the American dream as the answer of a calling to eschew the more common pursuits of personal peace and affluence in order to do something beautiful and exceedingly difficult with your life, such as writing a book that shames your family and all but guarantees you will never again be invited to certain homes to celebrate national holidays, which is what happened to me.

I am talking about vocation here: The ache to do and be

# PRELUDE TO AN AMERICAN DREAM

*I came to America because I heard the streets were paved with gold. When I got here, I learned three things: One, the streets were not paved with gold. Two, they were not paved at all. And three, it was going to be my job to pave them.*

—NINETEENTH-CENTURY IMMIGRANT LAMENT

WHAT IS A DREAM?
According to Cinderella, "A dream is a wish your heart makes."

It is instructive to note that our hero sings these words to a family of birds who wear kerchiefs and don't appear to have the power of language, revealing the first important thing you need to know about dreamers, which is, most of them need psychiatric evaluation. If you have a dream, you may need to be evaluated, too. The dream will make you crazy. That's how they work, in my experience.

Far as I can tell, the word *dream* means about a hundred different things. The most important kind of dream is the

CONGRATULATIONS,
WHO ARE
YOU AGAIN?

## NOTE TO THE READER

I have changed a few names in this book and made efforts to downplay the physical hideousness of my enemies, where possible.

*This book is dedicated to my favorite child,*
*you know who you are.*

HARPER ● PERENNIAL

CONGRATULATIONS, WHO ARE YOU AGAIN? Copyright © 2018 by Harrison Scott Key. All rights reserved. Printed in the United States of America. No part of this book may be used or reproduced in any manner whatsoever without written permission except in the case of brief quotations embodied in critical articles and reviews. For information, address Harper-Collins Publishers, 195 Broadway, New York, NY 10007.

HarperCollins books may be purchased for educational, business, or sales promotional use. For information, please email the Special Markets Department at SPsales@harpercollins.com.

FIRST EDITION

*Designed by Jamie Lynn Kerner*

Library of Congress Cataloging-in-Publication Data has been applied for.

ISBN 978-0-06-284330-2 (pbk.)

18  19  20  21  22   LSC   10  9  8  7  6  5  4  3  2

# CONGRATULATIONS, WHO ARE YOU AGAIN?

## — A MEMOIR —

# HARRISON SCOTT KEY

HARPER ● PERENNIAL

NEW YORK • LONDON • TORONTO • SYDNEY • NEW DELHI • AUCKLAND

ALSO BY HARRISON SCOTT KEY

*The World's Largest Man*

CONGRATULATIONS,
WHO ARE
YOU AGAIN?

something amazing when you grow up, maybe even to become famous in the process, to manifest a vision of yourself that feels improbable yet perfectly possible, and to pay off your student loans and mortgage doing it. These are the dreams that college admission representatives and retired athletes are always going on about, in front of awed and occasionally disbelieving crowds of young people. I have had many such dreams in my life, which is perfectly normal, this being America, the greatest nation in the history of the world, alongside Rome and perhaps Iceland. People still fly and float and walk to this place, to seize joys untrammeled with their minds and talents. One of the great things about America is, your dream can take many forms. You can do something wholesome and productive, like practice medicine in a place where they ride llamas, or build mattresses that never wear out, or design affordable water-filtration systems for remote villages, or you can do something evil, like make another Spider-Man movie.

Whatever you dream, just be careful.

Mark Twain said this famous thing, how the two most important days in your life are the day you were born and the day you find out why. What he didn't say is: *A dream is also a monster that wants to eat you.*

A dream doesn't start out as a monster. It starts out as a little baby that comes out of the uterus of your burning heart, and this little dream-baby grows up and gives birth to more dream-babies. Some dream-babies die in utero. Some get born and are then exposed to the gamma rays of vainglory and mutate into menacing beasts that will try and destroy you and your loved ones.

Nobody tells you this part of the American dream.

All they tell you is, *Dream big! You can be anything!*

But you cannot be anything.

You cannot be a bird, or a television, or an elected official who does not lie, constantly, to those he professes to love most. Some things, sadly, are not possible.

What is possible: You can give birth to a dream and nurse the baby until it is big and strong and monstrous, and you can share your dream-baby-monster with the world in such a way as to bring light to humankind, or at least a few thousand people, depending on the quality of your marketing materials, and you can be wholly transformed by the light-bringing experience. And then you may look around and see that the light you bring also burns. That's what this book is about: One man making his American dream real, while simultaneously almost immolating everything important in his life.

As a result of my dream coming true, my life was transformed beyond all comprehension. I got famous. Strangers took photographs of me in a Waffle House. I did photo shoots for magazines, including one in a bathtub, with my clothes on, for which all involved parties were grateful.

I was handed more money than anyone in my family had ever seen on a check with their name on it, which bought us a very luxurious home, with five ceiling fans. My childhood was one of general impoverishment, where our house only had, like, two ceiling fans. I try to explain this to my daughters, but they don't get it. They just stand there in the kitchen, eating decadent candies and pastries that my dream has provided, while the fan blows luxurious air on them.

"When I was a boy, we didn't have a fan in the kitchen," I say.

"What are you even talking about?" they say.

"You ungrateful humans!" I say, and storm out.

This is one of the things you do when you're famous: You storm out of rooms.

I was not always famous, sadly. Time was, I could be at a Waffle House or in a bathtub and nobody would ask to take a photograph with me. It was embarrassing. I could go for a walk in the park with my family, and nobody would gawk. At church, people would ask perfectly inappropriate questions, like, "How are you today, Harrison?"

Or, "How are the children?"

Or, "How's class going?"

It hurt, a little.

But now that I am famous, people gawk constantly. My wife, Lauren, and I might be having dinner at a restaurant near our home in Savannah, Georgia, and people come right up to the table.

"Are you Harrison Scott Key?" they ask, thrusting a book at me.

"I am," I say, while my wife pretend-vomits on her salad.

She's a funny lady. Hilarious.

And it's fine, it's fine, because I sign their books, and these fans buy my beautiful wife and me a round of drinks and we have a good laugh. Ever since I got famous, I haven't paid for a single cocktail. I couldn't tell you how much drinks even cost. Do you barter? Do you have to pay in pelts?

The last few years of my life seem like a drug-induced hallucination, weird and wondrous. I now travel the country, being asked to tell the story of How It All Happened. If your American dream comes true, people will ask you, too. It's flattering

and frightening because birthing a dream feels like being sucked up into the vortex of a tornado you summoned out of your very own heart shortly before being hurled back down to the earth, after which local TV crews run up to your bruised and battered body with microphones and say, *Amazing! How did you do that?*

I mean, what do you say?

That's why I wrote this book, so I would know what to say. I think it's important to get it all on paper now before I become even more famous and start wearing an ascot and walking around with an expensive cat, which could make writing books difficult. I want my children to know, and my students, and the world, how beautiful and terrifying it was, for my dream to come true, and how it made me believe all sorts of bizarre things, such as how I was famous, even when I'm not. Because let's be honest: You probably don't know me. I have never been mentioned on *E! News*. I don't even have my own Wikipedia page, unlike, say, Baby Jessica, the little girl who fell down a well in 1987 when she was eighteen months old.

If I thought it would get me a Wikipedia page, I might fall down a well, too.

Having a dream is not unlike falling down a well.

How else to describe the dizzying sensation of being the first member of my family to have his name said aloud on National Public Radio, which felt sort of amazing, and would have felt even more amazing if anyone in my family knew what National Public Radio was.

I mean, it's not like I have a driver or an entourage or a personal stylist. I generally feel no pressure to be thin, or even clean. I am not a beautiful man, and cannot say that I enjoy seeing my picture everywhere, which is one thing that happens

when you become a little famous. I don't mind some pictures, but sometimes my head feels too large on my body. I try not to think about it. I have done a pretty good job of forgetting it's even there, until my wife reminds me, as she does sometimes when we're lying in bed, looking at one another.

"Your face is so big," she'll say.

"That's sweet," I'll say.

Not that I believe I'm hideous, although from certain angles I do look like Sloth from *The Goonies*, according to several people who were my friends before they told me that.

"Can we take a selfie?" the fans ask.

What am I supposed to say? *Yeah, sure, as long as my head isn't in it?*

They take the photo and then put it on the Internet, which is fine, really it is. I don't mind other people having to see my head. That's what it's there for. And now I see my giant head everywhere, in magazines and newspapers and on websites and flyers, and it's weird. You do get tired of seeing yourself. Nobody tells you this.

But I am going to tell you. I am going to tell you everything.

# ACT I

Don't Settle for Anything Less

Than What You Have Agreed in

Advance to Settle For

# CHAPTER 1

*Eugene wanted the two things that all men want: he wanted to be loved, and he wanted to be famous.*
—THOMAS WOLFE, *Look Homeward, Angel*

MOST FAIRY TALES BEGIN WITH THE HERO ALREADY KNOW-ing what she wants. Dorothy wants to flee Kansas. Luke wants to flee the desert. Cinderella wants something beyond the service professions. There seems to be a great deal of fleeing, honestly. In *Titanic*, Rose wants to leave the big boat and go make pottery and ride horses, apparently. These are big movies about big desires, where, in the first few minutes, you learn what these characters long for. They long for it deeply, desperately, almost mournfully. They sing about it to birds and think about it while staring super-intensely into twin sunsets. The hero declares his dream out into the universe, and the universe says, *Come and get it.*

Which can be misleading, because we are not in a movie. You and I, we spend the first few decades of our lives declaring

various dream-proposals out into the universe, while the universe says, *I don't know, maybe!*

Dreams are diaphanous and maddening things. How do you know your own dream? It reveals itself like the moon through a shrouded curtain of clouds, here and then gone, appearing in a new part of the sky every time you look up, and in a whole other shape.

As a schoolboy, I demonstrated no special gifts or talents, aside from running my mouth in class, in the back of the room, in the direction of whichever young lady was trying hardest to ignore me. When talking would not pick the lock of adoration, I turned to the composition of amorous messages on notebook paper, which I then folded and handed to girls in my class, in hopes that they would allow me to lick their faces, however that worked. I had seen this licking on television and thought it looked interesting.

In sixth grade, I began writing letters to everyone—my grandmothers, friends, pen pals. My favorite correspondent was Diana, from Vietnam. Diana was my age. Back in my day, before children were encouraged to send pictures of their genitalia to one another via small handheld computers, we actually took the time to get real paper and draw pictures of our genitalia by hand, which we then mailed to one another via a system of wagon trains.

I did not send lewd illustrations to Diana, but I did send stories, in exchange for pictures of her, which I showed to friends to make myself seem more interesting. And it worked, among a certain demographic. I suppose lust and love are what's behind all art, in the end, no matter where you come from.

Where I come from is Mississippi.

Like many white children in the American South, I was born into abject lower-middle-class non-poverty, with both of my parents and all my original body parts.

Out there in the idyll of rural Rankin County, all piney woods and pasture, most of the dads had jobs involving engines, balls, hogs, or Jesus. The moms were nurses and cafeteria ladies and school bus drivers, usually. Everybody worked like a mule. Dreams were not spoken of much. What was spoken of was work. My father hated his work, I was pretty sure, a fact I deduced from how often he described wanting to whip the asses of the men he worked with, mostly the ass of his boss, Clyde, who cast a long shadow over hearth and home.

Pop was a salesman for an asphalt refining company, a job he would explain to anyone who wanted to listen.

"It's a shit-ass job," he'd tell you, "and I'm lucky to have it."

He complained all night, most nights, about his shit-ass boss and his shit-ass job and the general shit-ass-ness of it all. Pop returned from work, downcast and surly, with tales of the vocational cruelties he'd had to suffer at the hands of Clyde. He never shared these with us boys, Bird and me, just Mom, but it was a small house, and his Hill Country brogue was cultivated to carry.

Mom seemed to hate her work a little, too. She was a schoolteacher at McLaurin Attendance Center in a tiny community called Star, home of Faith Hill and a gas station that sold potato logs so good you'd fight a man for the last one. I saw it happen.

She liked teaching okay, I guess. She loved the children generally, but at the end of every summer, she'd start moaning,

slouching around the house, speaking to the furniture, lying across beds diagonally, staring into the abyss, talking to God, or perhaps the ceiling fan, asking it to fall on her before the new school year began. She made no effort to hide her disdain of certain children.

"He's born of the devil," she'd say, of this or that child. "They'll all be in Parchman Farm one day, you watch."

Were these their callings, to have jobs that made them curse and moan and speak of Satan? From the very first, when talk of professions and careers began launching from the mouths of my schoolteachers, I had but one thought: Whatever I did with my life, I decided, it would not make me moan. I wanted non-moaning, non-shit-ass work, if I could get it.

That was my first dream.

———

Money was tight. Guns and other accouterments of war and bloodshed filled our home, but all else was subject to the greatest fiscal scrutiny. School clothes were acquired from Bill's Dollar Store. Salmon croquettes and fried ham filled us up. Most vegetables we shelled and shucked ourselves, grown on my grandparents' farm in Coldwater. The Deepfreeze, that great bounteous coffin, held many pounds of meat we'd felled with our own hands, cotes of frozen doves like pygmy chickens in repose, deer sausage and backstrap wrapped in heavy white paper, and catfish fillets the color of white peaches, caught on trotlines of a special design, perfected by Pop in his boyhood.

It was a childhood of plenty, rich in provender and adventure, but always and forever short on legal tender, causing not

a little marital strife between Pop and Mom every month, before payday. When she wanted to get her hair done, she held a yard sale and afterwards always gave us a little. Walking-around money, she called it.

The only time I ever feared for the wholeness of their marriage and the permanence of home was when they fought over money, and it was usually Pop doing the fighting. Mom tried to be helpful, combing through receipts, defending her ration of Aqua Net. I tried to help out where I could. By the age of ten, I was an avid cutter of coupons.

My brother, Bird, and I began working outside the home as soon as we could be expected not to humiliate ourselves or besmirch the family name. My first paid employment was at age eleven, at Rivers Plant Farm for $3.10 an hour, minimum wage at the time. Bird and I filled flats with potting soil, moved and stacked and tossed flats away. Once Bird could drive, we began cutting yards in town. We put ads in the *Rankin County News* advertising our services. We did farm work, hauled hay. Bird bagged groceries at the Jitney Jungle, and I made gas money by hand-lettering wedding invitations in various medieval fonts, a skill I'd learned from a library book.

"How much you get for that?" Pop asked, looking over my shoulder at the dinner table.

"A dollar per envelope."

"Heck, son. That's a fine skill."

Every month, another fight over the checking account, and every month, I sat in my bedroom growing anxious and sad about work and money, praying on the tattered carpet and telling myself: Whatever non-moaning, non-shit-ass profession I

should choose for myself, it must provide enough money such that I will not go caterwauling at my family every time I have to touch the checkbook.

This was my second dream.

———

My third dream was to make Jesus happy, because I was a member of the Church of Christ, a nineteenth-century evangelical sect consisting of good country people who believe Satan came in the form of a piano. I was baptized at age twelve by a preacher named Brother Dale who was later voted out of the pulpit and run off to Alabama, where it was rumored he became a salesman of vacuum cleaners. Why he was let go, they didn't say. He seemed like a good man. He hit the sides of the pulpit for effect, which upset certain influential laity. Maybe that's what did it.

Before he disappeared to spread the gospel of advanced suction power, Brother Dale preached often on the parable of the talents. The basic thrust of this recurring sermon was, God gave you a gift, and you had better do something worthwhile with it or you could end up on welfare, which could lead to all sorts of wickedness, such as additional pianos.

I was thus led to believe by the joyous rhetoric of ministers that a job should be meaningful, should fill the worker with purpose and clarity about his place in the economy of God's kingdom. I just couldn't see how my father's work did that. Perhaps he had cultivated in himself the wrong talents, which is what led to his work-related melancholy? Identifying my talents seemed the key to finding non-shit-ass work.

What were my talents?

I could spell okay. I was pretty good at changing the lyrics

to songs, in the manner of Alfred Yankovic, whose weirdness I found agreeable. The very first thing I wrote on my own, and not for school, was a parody of "You've Lost That Loving Feeling" called "You've Lost That Bloated Feeling," a soulful number about acid reflux. I was very proud of this song, which I performed for everyone at Sardis Lake Christian Camp, a weeklong odyssey of horseflies and spontaneous swimming hole baptisms, while people prayed for me.

After church camp, I returned to a summer of yard work, driving tractors, dragging bush hogs, slinging blades, patching fence, feeding hogs, and giving bottles to calves, their dark endless eyes rolling back, tugging, biting, fighting, the way we all do.

Mom would come pick me up from whatever farm they'd leased me out to, and I'd sit there at the supper table, farmer tanned and peckish, telling the story of some amazing thing I'd seen—a coyote we caught chasing sheep, a calf I'd helped pull into the world.

"It's hard," I'd say.

"What's hard?" Mom said.

"Anything on a farm. All of it."

"A rich man ain't got to work with his hands," Pop said, across the table, tapping his enormous skull with an enormous middle finger. "A rich man works with his noodle."

I looked to Mom.

"You have a good noodle, son," she said, reassuringly, touching my hand.

"What you should do is be a lawyer, see," said Pop.

He spoke about lawyers with a peeved and reverent awe. They were always trying to take our house, he said.

"Even shit-ass lawyers make money," he said, "and most is shit-ass."

"Lanny, language," Mom said, then turning to me. "It's true."

"Every lawyer I know got two houses," Pop said. "A beach house or some foolishness."

"A beach house does sound nice," Mom said.

"Ole Miss, they got a good law school," Pop said. "That's what ye ought to do."

I was still in junior high, but this lawyer talk had already begun.

"I don't care what you do," Mom said, "so long as you're a medical doctor."

Something was always swelling on Mom, nodules and such. She needed somebody to show her moles to. She went on about her thyroid like it was waiting in the woods across the road with a knife and a gun.

"You'll have to take care of me, one day," she said.

I knew: Whatever I did for a living, I'd have to make enough money to pay my bills and fend off the shit-ass lawyers and keep the shit-ass glands from killing my sweet mother, while simultaneously making Jesus proud and using all my shit-ass talents in such a way as to stay off welfare. It was a lot to ponder for a child.

———

And the next morning, I'd go off to school, where dreams were all the rage. They inspired us with posters, mostly about war. *Aim High*, the war posters said. If we did, we could get paid by

the government to kill people. *Be All You Can Be*, other posters demanded. Yes, but what would we be? How would we know we were being all of it and not just some of it? It felt like a threat.

*You better eat all the food hidden behind this curtain!*

*Don't settle for anything less than what you have agreed in advance to settle for!*

My first legitimate career goal, at age thirteen, was to work for the Mississippi Department of Game and Fish as a game warden. I liked the idea of driving around the woods in a truck, arresting people for poaching, which seemed the easiest way to keep my father out of prison for poaching. I wouldn't have called this a dream.

I dabbled in magic tricks, ventriloquism, sleight-of-hand, avocations that involved some measure of performance and wizardry. My boyhood heroes were weathermen and comedians, two professions quite similar in form and substance, when you think about it, where the difference between telling the truth and talking shit is often known only to God. Both professions seem to involve summoning the demons of anxiety, then exorcising them. They are buffoons and heroes both. One hero was the weatherman Woodie Assaf, a Mississippi broadcasting legend, the son of Lebanese immigrants and who spoke like a sober Tennessee Williams. Woodie was beloved by all and helpful during storms, and I liked the idea of helping, and of being loved, and being the first to know the location of all the tornadoes.

But weatherman had, at heart, a serious cast, and my temperament was always and forever unserious, insufferable, like my other heroes, Mel Blanc, Don Rickles, George Carlin,

Eddie Murphy, Robin Williams, Johnny Carson, Bill Murray. Who knows why a child winds up funny? Does one blame the parents? Is it a gift, or a disease? All I know is, when I looked into the face of Alfred E. Neuman, I saw me. *Mad* Fold-Ins gave me life.

Quotidian existence was too serious, I felt, and I was drawn to those who punctured solemnity, which seemed a very human malady, a sickness that comedy could heal, somehow. I often brought my Animal Muppet doll to school and made it speak in tongues during homeroom. Sometimes, the doll performed healings.

"Something wrong with him," they said.

"Touched in the head," they said.

On Saturday nights, I listened to *A Prairie Home Companion* in my bedroom and tried to imitate Tom Keith's sound effects, while my mother stood at the locked door and prayed for me.

One day in tenth grade, I found a hot mic on the floor of the gym and a small wicker basket and passed it around as an offering for the Lord, while I healed classmates, who were happy to volunteer, it being flu season.

"Blasphemy!" the teacher, Mrs. Pulaski, said. This was Mississippi, where public school teachers could still demand you seek God's forgiveness.

A coach was summoned, Coach Mann, to arrest my heresies, and I was sentenced to three licks with his paddle. This corporal punishment was nothing compared to the stropping I got at home. His broad paddle had a mighty sting on denim buttocks, it's true, but the wallops dulled in the burning glow of comedy. These scenes, when I commanded an audience, playing spiritual healer, summoning and dancing across waves

of disbelief and hysteric laughter, carried me to the very limits of paradise.

"Why would you do such a thing, son?" Coach Mann asked, threatening to tell my mother, whose classroom was but a few steps away. He had been a preacher once. "Those who parrot the Lord risk judgment."

But these faux healings and other performed tomfoolery were not parroting to me. They had real healing power. Laughter was medicine, according to *Reader's Digest*. Whatever I was doing to get laughs, it felt as divine as anything I'd seen on stage at a youth rally. The buzzing frenetic power of those moments dangled me over a thrilling abyss. My blood sparkled. Anything felt possible. Illumination, anger, laughter, sadness, revelation. My father had tried to teach me the ways and means of power—violence and virility, meat and blood—but no, no. Laughter was power. This was Holy Ghost power.

---

Comedy was always more fun with a friend. I found my best one in 1990, in tenth grade. Mark was the first young man I'd ever met who admitted publicly that he sometimes felt a compulsion to read books, considered a rare disorder in our community. At our high school, admitting to peers that you read a lot was like admitting you'd had rickets as a baby.

"Wow," they'd say. "That sounds awful."

For both Mark and me, stories offered a starship away from the desert of our lives. I can remember visiting his bedroom for the first time and discovering, arrayed in splendor around his room, up the walls, behind his headboard, creeping across every surface of his odorous domain, hundreds of books,

paperbacks leaping from the walls of his doublewide like geodes from the sides of a hidden cave, a goblin's plunder of stories. I pulled them down, one at a time.

"Who's Plutarch?" I asked.

"That dude was nuts," he said. "Rome and shit."

"What's this one about?"

"Aliens," he said.

"And this one?"

"Moral philosophy."

"And that one?"

"Oh, death and whatnot."

We traded books in class the way other kids traded Skoal and cigarettes, passing dog-eared volumes low across the aisle when the teachers weren't looking. All the reading naturally occasioned an almost involuntary compulsion to write. I wrote stories, poems, letters, parodies of New Testament parables. By my senior year, I discovered that I could earn gas money by writing research papers for classmates.

"This term paper is so good," friends said, handing me the eighty-five dollars we had discussed. "You're gonna be famous."

Actually, what they said was, "Where's the bibliography?"

And I said, "Bibliographies cost fifteen dollars."

Did it feel wrong, cheating? As a follower of Jesus, I knew that the Messiah, being the son of a famous author, would probably not like my plagiarizing, but I also knew that God had hired at least three or four dozen Holy Ghost writers to compose His book. Incidentally, I wrote my own paper on the writing of the King James Bible, which King James also paid others to write for him.

That same year, my class named me Most Likely to Succeed, maybe because I had helped some of them graduate by writing their papers.

"What do you want to do with your life?" everybody asked.

I had no answer. I wanted to get out. To flee, like Dorothy, like Luke. On the night of graduation, dark and hot, Mark and I sat on a porch pretending to enjoy the beer my brother had bought us, trying to imagine futures for ourselves.

"We could start a band," I said. "We would have to learn some songs."

"That seems like a lot of work," he said.

We had both just finished *Hammer of the Gods: The Led Zeppelin Saga*, which we considered the greatest work of nonfiction ever published. It was glorious, tragic. We wanted that life, without that part where you die young, like Bonham. But the rest, the gold records and adoring fans and the large private airplane orgies, that sounded pretty good, or if not the orgies, at least the opportunity to politely decline an orgy.

Even then, we knew but could not say it in words, that we felt called to a life of difference, of something besides a mere job. We wanted lives of books, stories, music, comedy, travel, wonder, power, sound, rooms full of people stomping the floor until we appeared. But what would we do when we got into the room?

"What are we going to do?" Mark asked.

"We have to do something," I said.

"I know, it sucks," Mark said.

Night came down like a slow curtain. We stared into the black Mississippi dark and let the chains of the swing creak under the weight of the question. I knew what I wanted, but

how do you say it out loud? How silly do you sound, once you finally declare what you want from the universe? What I wanted was to be amazing. To make people stand and howl. To slay, like the Viking warlords of old. This was my fourth dream, formless and void.

What form would it take?

I was about to find out.

# CHAPTER 2

*My plan was to never get married. I was going to be an art monster instead.*
—JENNY OFFILL, *Dept. of Speculation*

IN THE FALL OF 1993, I ENROLLED AT BELHAVEN COLLEGE IN Jackson, Mississippi, a small liberal arts school where one might assume I majored in English, given my lifelong love of reading. Instead, they placed me in remedial composition: Turns out I was actually kind of an idiot. Just because I wrote term papers for money didn't mean I could write. Apparently, writing standards were somewhat low in Mississippi's public schools. Who knew?

This remediation took place in a bleak basement classroom and was taught by a humorless teacher who looked like Samuel Beckett, which was unfortunate, as she was a woman. She had many gifts, though, including a gift for making all literature boring. Every time she spoke about literature, the literature died. And so, in an effort to keep her from murdering more stories,

the safest thing for me to do was major in psychology, which included almost no reading and thus would help make the world safer for literature.

Early in my matriculation, a roommate, Brian, editor of the college newspaper, was kind enough to ask me to write for him.

"Why?" I said. Clearly, I was a poor writer.

He said what all editors say when they need somebody to write for them, which is, "I have space to fill."

I could fill space. I'd been filling space for years. I agreed to pen a weekly column, largely about music, which granted me a press pass that I flashed at bouncers when touring bands came to town.

"I'm a journalist," I said.

Nobody believed me. But they let me in for free, and I danced and drank and tried my best to note odd things and describe them for my imaginary readers, the way I described the birthing of calves to my family as a boy.

Naturally, readers responded to my writing, mostly by hating it, and I learned that some people's expectations are very high, such as demanding every story include facts. Words were fun, but journalism was not my scene. I'd try to cover some important campus event and end up writing haikus about everybody's hair.

———

Sophomore year, everything changed when I found a fat green book on Brian's shelf. I felt an ever-increasing urgency, with each passing day, that some secret wisdom might live inside this book, waiting to be discovered. I tried my best to ignore it. We had enough reading assigned in college. They'd already made

me read Dostoevsky and Calvin until I felt like a rescue animal. But there it was, this ridiculous book with its ridiculous title— *The Hitchhiker's Guide to the Galaxy.*

One day, I picked it up. It wasn't one book, I should say, but a series of four novels and a novella, all bound in a single omnibus, fat as a *Funk & Wagnalls.*

"You should read it," Brian said. "It's really funny."

I did not believe him, of course. Books were not supposed to be funny, everybody knew that. Deep, important, profound, yes, but not funny. Funny was for public radio.

The next day, a Friday in October, I took the book to the school cafeteria for breakfast, which I did not normally eat, preferring the extra minutes for sleep, but the book wanted to be read. Books do that. Some of them, if they're the right one, show up on your doorstep like a baby you didn't know you needed until you hold it and you're like, *I love you so much.*

I sat there at breakfast with the overachievers and early risers and my grits and began to read. How can I explain what happened? The prologue melted my brain.

It was barely two pages, not even seven hundred and fifty words, and the world cracked open like a magical coconut of love and inside the coconut I found my dream. The real one: My calling.

When I finally looked up from the book, the cafeteria had emptied of students. Class had begun, but what was class, anymore, with such feelings inside me? I took the book outside and found a shaded stretch of porch on the administrative building, and continued to read. The pages shook me loose of my body, the gasses of my soul igniting in a great blazing ball of wonderment.

It was a silly book, ridiculous, almost upsettingly so, and felt like wizardry, like Holy Ghost power, this book, riven with comic sacrilege and papered with satire, about the vastness of the human condition and politics and existentialism and robots so advanced they were capable of achieving clinical depression. It was almost as if a funny book could not just mean something, but rather that it *must* mean something to be funny.

I read until noon, and I ate lunch and continued to read, calling in sick to work at the clothing store where I sold Vasque hiking boots to the wealthy children of the Jackson Metropolitan Area. I read under trees and read on steps. I read in rocking chairs and at the library. I read all weekend, and when I finished the book on Sunday night, I was reborn.

Something about this book brought it all together, rerouted every narrow watercourse of my life into the same deep basin of feeling, and I knew. In a dazzling burst of light, my childhood dreams were irradiated, transfigured. I wanted to make people feel the way this book made me feel. This revelation fell on my skull like a sack of Bibles.

Now, I should say: If you read *The Hitchhiker's Guide*, I cannot guarantee that a hydrogen bomb of glorious divine light will detonate inside you, but if you are a dreamer, there shall be a bomb inside you. You will be blinded by the Damascus light, and it will produce inside of you a new knowledge, that you must paint or preach or dance or sell your worldly goods and join a Peruvian mission to the poor or make the world laugh. The urge to answer these callings is no mere desire. It is a conflagration, a savage upending of the nature of the life you believe possible. It reconfigures your very insides.

Was it possible?

Was I a writer?

Had I been one all along?

Is that why Brian told me to read the book? Had he known what it would wake up inside me? Was it an accident that he was an editor? We had chosen to room together, a few months into freshman year. Had the literary nascence in him pinged the soul antenna in me? What odd fate brought this young man, who brought this book, which stirred these questions inside me? My body was a lake in winter sunshine, formerly hidden fish rising to the surface.

I had never given any thought to writing as a profession. I knew coaches and farmers and preachers. That's what I knew. And yet, I came from this beautiful disaster called Mississippi, where we have so many good role models for writers, such as William Faulkner, regarded by most Mississippians as a shiftless turd. Sure, he invented American consciousness, but when he spoke, he sounded like a lecherous Looney Toons character with tuberculosis. Mention Faulkner to my great aunt from up in Oxford and she'd say, "Oh, you mean the mailman?"

In school, in American literature, we read Flannery O'Connor.

"She sounds demented to me," I said to the professor.

"She was Catholic," he said, and we young Protestants nodded sagely.

We also read the work of a Delta man who grew up down the road from my grandmother, Walker Percy, another papist, although slightly less demented, a result, we were told, of his being so bad at Catholicism. We read Willie Morris, too, writer

of one of my favorite books, *The Courting of Marcus Dupree*, who lived somewhere in the vicinity of our college.

"Is he Catholic, too?" we asked.

"No, but he drinks like one," the professor explained.

I was a poor student, always staring out the window, longing to write something that made people feel the way *Hitchhiker's* and *Mad* magazine made me feel, and with no courage at all to call myself a writer. I wasn't a writer. I wasn't anything.

Out the window, I stared at the façade of a home belonging to another writer, a quiet and queer-looking lady who could be seen sitting at her desk in the window, working, even though she was very old. This was Eudora Welty. I'd read a few of her stories and thought they sounded more like poems, the sort of writing that got English majors high.

My new friend Rob and I rode our bikes into her yard and knocked on the door. On this door, she had two pieces of literature. One, a Clinton-Gore '92 bumper sticker, which we reasoned some ambitious operative had affixed out of righteous vandalism. The other was a piece of paper, on which she had written, *No autographs today, please.*

"They say she's famous," I said.

"She's probably a liberal, like my mom," Rob said, deducing.

Could she hear us, from her writing table? If I'd had any sense, I might have knocked and tried to befriend the genius upstairs. Perhaps everything would have happened differently. But what did I know? Writing was too much fun to think about doing for a living. Livings were supposed to be cruel things, made by sweat and fear. Writing was the opposite of all that. Writing was probably not my dream, I figured.

What my new dream was, my fifth one, was growing more specific by the day: I was being called by God to melt the world's brains via flaming balls of comic wonderment. It would be a full gospel healing, like in high school, but how? I checked at the career services office and there were no internships in brain-melting and satirical healing.

I had done some plays, so I figured, maybe, I should be an actor? That would at least get me an audience.

I auditioned at a few universities, Alabama, Florida State, others. For the audition, I recited my favorite lines from *Raising Arizona* in the voice of my father. The faculty members must have believed I was insane. I was admitted to the MFA acting program at Ole Miss, probably on a dare. Studying this urbane art in the quiet hills of Lafayette County, Mississippi, made about as much sense as enrolling at Julliard to study poultry science, but whatever. You get desperate. One forgets that for most of his journey toward Damascus, and even after he arrived, Paul was blind and groping, with purpose.

Incidentally, that's also a great way to describe my acting skills: Groping with purpose. I was not great on stage, not unless I was allowed to play me, which is unfortunate, as I am not a literary character. I was only able to access real emotion through comedy, and only obliquely, wildly. The real goods, the sadness and hurt that fill any human heart, was too hot and bright for me to look at directly, at least, in my own life. I pretended the hurt wasn't there, which is great, if you're trying to suppress your trauma, like a regular human person, but not

great if you're an actor, who must access the trauma and make it art.

Actors, I decided, had too many emotions. They were troubled people. And thus I decided to pursue, with a brief and flailing passion, a career in stand-up comedy, because comics have only one emotion, and it is rage. I could work with rage.

I remained in acting school but focused all of my efforts and energies on comedy improv and open mic sets around Oxford and in other towns around Mississippi. I deeply enjoyed writing jokes for myself, which allowed me to opine on a range of subjects as vast as the firmament while simultaneously being heckled by angry drunk women, which turned out to be great, since I enjoyed feeling terrible about myself.

All the writing of second-rate jokes convinced me that maybe I had a new calling, to write funny plays, and thus was born my sixth dream, to be the next David Mamet, the hillbilly Aristophanes. Plautus the Cracker.

"I'm going to be a playwright," I announced to my parents, one Thanksgiving. I was twenty-three.

Pop stared at his turkey. He'd yanked off a whole leg of the bird, just for himself.

Acting had been bad enough, but there was always the hope I might become the Chuck Norris of my generation. He'd let himself believe it.

He studied that turkey leg and attempted to digest this new information. His boy would never be another Charles Bronson. He looked at the leg like he had not meant to pull the whole thing off. He'd made a terrible mistake. His boy, pride of the family, son of a son of a son, with a good noodle, the one who could have already been two years deep into the study of law,

this boy, his boy, was going to become some simpering little animal, sightless and cave-dwelling, hunched over a desk, hiding in the back row of a theater. A playwright?

"Like Shakespeare," I said.

"Shakespeare?" he said, looking up.

"Shakespeare's dead," Mom said, clarifying.

"Hell, I know that," Pop said.

"I'm paying for it," I said. "Loans, scholarships. I'll work it out."

"Good," he said.

"I think it's great!" Mom said.

"Long as I ain't got to pay," said my father.

"I think it's great!" Mom said again, in case we hadn't heard her.

"An actor, and now a playwright!" Bird said, coming up for air from the mountain of casserole. "And he ain't even queer!"

"Thank you," I said.

"He's not gay," Mom said. "You're not gay."

"Hell no, he's not gay. Look at him."

Everyone looked at me, my grandparents, cousins, the whole lot, looking for the marks of non-gayness which they reasoned must be visible on my person. I looked haggard. I'd let my hair grow wild and fibrous, along with my beard—a wayward apostle.

———

That winter, I enrolled in a different graduate program, this one in Texas, and I set myself to writing plays, and approximately none of those plays were good, including one I wrote about a North African Christian martyr who was put to death

for getting baptized, which I conceived of as a comedy. The plot was based on the historic martyrdom of Perpetua, who admitted to the Carthaginian authorities that she was a Christian and was put to death by wild cow, which I found funny. Death by cow is funny.

"How's graduate school?" Brian, my old roommate, asked, via this new technology called Hotmail. Brian was working in southern politics now, a star on the rise.

"I need ideas," I said. "If I can't make religious persecution funny, maybe I've picked the wrong thing to be."

"Have you read *A Confederacy of Dunces*?" he asked.

"Never heard of it," I wrote back.

He mailed me a copy, which I opened, and read, and learned about Ignatius J. Reilly, a failed writer-slash-hot-dog-vendor who lived with his mother and constructed his worldview around the Neoplatonist Catholic philosophies of Boethius, while drinking Dr. Nut and writing prayers to Fortuna, the pagan Roman goddess of luck. This book hissed and crackled with spiritual power, sacred and profane. My brain melted again, in the manner of old.

It was the sort of book that confirmed everything you secretly believed about the world's extraordinary strangeness, a story as ridiculous as death-by-cow, and it won a Pulitzer! Oh, Fortuna! How! How might I write something like this, and see the wheel thrust me skyward!

This book bloated me anew with possibility, which is how, at age twenty-five, two degrees in hand and not a single funny play to my name, I enrolled in a PhD program at Southern Illinois University, hoping the degree would add a veneer of respectability to my many failures as a human, or at least create

insurmountable debt that might give me deep wells of sorrow from which I might plumb a comic *weltanschauung* that could make all my dreams come true.

And friends, let me tell you, that is almost exactly what happened.

———

It was suggested to me that if I wanted to be a serious writer, I needed to write serious things, or at least something confusing enough to be misunderstood, which was the highest achievement to which a work of art could aspire, according to those professors I admired most. And so, setting aside the two-headed alien presidents and Lucky Dog vendors of high comedy, I began to write many confusing plays about adultery, deception, and suicide.

"Brilliant," everybody said. "I don't even know what it means."

"So raw!" they said. "So rife with opacity!"

"Audiences will hate this!" they said. "It's perfect."

But it wasn't. It was the worst. It was serious and solemn and deep and the worst, the fakest kind of bad, the shallowest deep you can imagine. I was sad, on the verge of new kinds of sadness, the real kind. It was frightening. I worked what felt like too much, teaching until noon, then sitting at a diner, inhaling coffee and cigarettes until four o'clock, then off to another café, more drinking and smoking until midnight. A solid twelve hours of reading and writing every day for nearly a decade, and the work was just terrible, so flaccid and derivative that I began to feel maybe the universe was trying to tell me that Pop was right: I should've studied law.

"So much discipline!" my classmates said, seeing me at the diner.

"Are you still here?" they said, after leaving, and returning.

On weekends, they'd invite me out, and I'd say no, I had writing to do.

"A better man than me!" they'd say, and go out, and make lifelong friendships, have such fun, which they described in lurid detail the following Monday, while I sat there, a tobaccoed husk of a man, who'd spent a weekend toiling in the isolation of my self-imposed hackery.

This was no life. Wasn't I talented? Hadn't my high school classmates named me Most Likely to Succeed? Suddenly the "Most Likely" part of the equation took on ominous tones. Statistically, a man likely to do something was just as likely not to.

In the final year of my doctoral program, after a decade in higher education, on the cusp of my third academic degree, I considered the sad comedy of it all. I'd had some great writing teachers, who had a gift for lying about how good my plays were. They were not good. I was not good. What I needed was a teacher who wouldn't lie, and I would meet her in my final year of graduate school. Five minutes into our first real conversation, I knew that I would marry this teacher and we would make a thousand babies.

But I was wrong. It would only be three.

# CHAPTER 3

*Wendy had thick blond hair, small and nimble hands, and
a skeptical expression that invited you to talk her out of it.*
— TOM DRURY, *Pacific*

HER NAME WAS LAUREN.
   I was home for Christmas when it happened. She was
rooming with an old friend, Sarah, and the old friend and I sat
on a Mississippi porch, smoking and discussing art like a cou-
ple of assholes. We had begun with futurism. It was brutal and
fun, exactly what you want to be talking about when you're
a failed scholar who knows nothing but how good he's not.
It was late that December night, the air cool and damp, the
concrete glowing orange in the streetlight. Lauren walked up
in the dark after a long shift at Keifer's, the Greek restaurant
where most everybody but her snorted coke and the hummus
was so good you didn't care.

   "Hello," she said.

   "Hello," I said.

"We were just discussing all the isms," Sarah said.

"Sounds fascinating," she said. "Good night."

She was the prettiest human I had ever seen in the light of a high-pressure sodium-vapor lamp, and I felt it would be sad to see her go. She bummed a smoke and stayed, and every few minutes punctured a hole in the balloon of our carefully curated aesthetic solemnity with an acid squirt of irony, which was upsetting. That had always been my job.

"What are you two even talking about?" she said.

"Antonin Artaud," I said. "*The Theatre and Its Double*. Have you heard of it?"

Lauren was a ballet dancer by day. Weren't ballet dancers supposed to be grim and worldly, broken and beautiful and Gallic?

"Um, no," she said.

"What are you reading right now?" I said.

"I just finished *People* magazine," she said. "Have you heard of it?"

I hadn't known beautiful people could be funny. I thought it wasn't allowed. Comedy, I had been led to believe, was the province of us hideous folk.

Over the next few days, while I crashed on their couch, I learned much about this sardonic Helen of Troy, how she believed she was dying at least once a day, from various rare cancers that aren't actually real (One way I knew she liked me, or at least didn't hate me, was when she turned to me and touched her cheek and said, "I think I have face cancer."), I learned many useful facts about this strange beautiful creature, like how she can't eat fast food in a car, even as a passenger

("What if the car goes over a bridge, and into the water, while I'm eating?" she said. "No, I can't risk choking and drowning at the same time. That's too much."), and I learned how sometimes in church she would get dead arms ("Dead arms. Dead hands. Numb lips, fingernail sensitivity, pelvic discomfort."). When I realized she was both telling the truth and quoting *What About Bob?*, that sealed the deal. We would be together forever. I made a mental note to let her know this as soon as possible.

I drove back to Illinois and pined.

"It's weird," I told Mark, on the phone. "She hates reading."

"Yeah, that is weird."

I'd grown so full of rancid ideas and abstract philosophies that my soul longed for somebody allergic to all those things. Perhaps an antidote to all this learning was required. Everything had felt so wrong for so long, and this woman, as bizarre a match as it seemed, was the first thing in a long time that felt right.

A year later, we married.

Her family appreciated my imminent PhD, and my family found it incredible that a woman so beautiful would deign breed with such a gruesome freak as me. There was a natural comedy in the match. Our love was maybe the first good funny story I ever helped write.

A month after the wedding, they awarded me the doctorate. Getting a PhD is not as hard as people imagine. As long as you turn in all your assignments on time and don't sexually harass any prominent donors, they will almost always give you one.

Pop was proud, as was Mom. Their boy was a doctor. But

I felt as far as ever from the reality of making people laugh and getting paid to do it. I didn't have the juju. Something didn't work right in my head. I had turned the wrong way to Damascus and ended up on Tatooine.

"What is your doctorate in?" people asked, at our wedding.

"Poverty," I said.

———

That summer, I decided to present my new wife with a special gift: I would go insane. I'd been interviewing for teaching jobs in Florida, Tennessee, Oregon, Pennsylvania, and she was looking forward to the beginning of a quiet, happy, almost-fairy-tale life with her husband the professor.

"Maybe I don't want to teach," I said.

"False," she said.

"Maybe I want to be a dentist," I said.

"No," she said. "What? No."

"You can do anything you set your mind to," my teachers had always said, and what they really meant was, "You can be mediocre at anything you set your mind to," and I was mediocre at so much, the possibilities were endless.

"I feel crazy in my head," I told my new wife.

"It's fine, we're all crazy," she said, explaining which members of her family were on medication for various psychiatric and mental disorders, which calmed me down, and once calm, I did the sensible thing, taking a job teaching dramatic literature at Mississippi State University in Starkville, where I got paid $30,000 a year to teach eight courses and have students threaten me with litigation, should I grade their essays accurately.

People think college educators make good money because people are dumb. I could have made more money cleaning vats at a hummus factory. Lauren waited tables and made more cash. Am I complaining? No. There's no universal human right that declares all doctors of philosophy deserve a base middle-class salary. It was a rude awakening is all. That is the story of most careers, an escalating series of rude awakenings, culminating in a retirement party.

The most devoted celebrants of Mississippi State would tell you it is a proud and earthy institution, a great moral counterbalance to the aristocratic corruption of its depraved rival, Ole Miss, which is true, in a way, or was true many years ago, in generations past. Bob Dylan never had to write protest songs about State.

As a boy, I'd always understood Starkville as a kind of Manichean contrary to Oxford, the ideal destination for ambitious young farmers, who longed to study poultry management and the animal reproductive arts, where one might learn the fine art of semen collection and rectal palpation, should that be of interest.

When I visited for my interview, I noted with some relief that the university was not as the younger me had remembered it, all cattle runs and chicken houses, but in fact enjoyed a commodious library and as much bourgeois zeal as every other American university, with perhaps more camouflage footwear than is normally observed, and which only made it feel like home. And that's what it was now. Home.

But something in me didn't sit right. As soon as we moved to Starkville, I felt like a hog being shoved into a trailer, with a sickening sense of where the trailer might be headed.

I attempted to teach play analysis to two hundred and fifty humans in a capacious auditorium where most of the students played Uno or napped. I made an effort to hew to high standards, as eager young faculty will do, going so far as to fail several students on my first exam. As a result, one young man threatened me with his python, via email. Another explained in person that because I had failed him, his father was going to make him go to Afghanistan to die for his country, although I am pretty sure the young man failed at that, too.

To make matters worse, I'd recently quit smoking, which led to a significant increase in the eating of cake-based foods, which led to an increase in the wearing of fat-based pants. I took to weeping a lot, in university parking lots and public restrooms, my new fat jiggling in a totally non-jolly way. I felt old and sad. I wanted to die, to be dead, the deadest man alive, to burn it all down and start over, but no: I had a job, and a wife, with her own burning desires, of babies, a house, a home.

———

I tried to shake it off, the weird nameless sadness that gripped me like a great gorilla hand. Someone had told us that it'd be good for our marriage to have no television, that it would compel us to cohabitate organically, and so we did that. We played gin, charades, Pictionary. We made brownies and ate them all and pretended like we weren't both getting fatter. We were happy, even if I was sad. I learned a lot about my wife during the "Year with No Television," as it came to be known. Her favorite thing in all the world was eating cakes and pies and brownies, with which she drank the very coldest milk.

"Let's save room for dessert," I'd say, at dinner, facing one of those casseroles, a mother's recipe, designed to feed a battalion, chock with caloric victuals, butter and starch and meat, enough to power a team of bricklayers through a day, and which must now be eaten by two young people who do not fully realize how fat it is about to make them.

"We can just have dessert for dinner," Lauren said, teaching me perhaps the most important life lesson I would ever learn, which is that if you don't want to eat the main course, you don't have to: You can eat a whole peach cobbler instead.

"And that's it? That's our dinner?"

"Why waste our calories?" she said, microwaving the Pyrex.

It was the most sensible advice I'd heard in three years.

"I like this diet," I said.

"The cobbler has fruit, so that's our vegetables," she said, pulling the masterwork of buttered pastry out of the microwave and scooping ice cream onto the gurgling surface.

We played games, so many games. I cleaned up on all the language games, Scattergories, Scrabble, inviting me to showcase the ocean of two-dollar words I'd been compelled to learn during a decade in our nation's universities. In Trivial Pursuit, I'd get some obscure question right, about the birthplace of Martin Van Buren, say, and she'd roll her eyes. The uselessness of the information was evidence enough that I was lacking in moral fiber.

"It makes me angry that you know that," she'd say.

When it was time for her to dominate, we turned to games of speed and memory, at which she excelled. She dominated a game called Rubik's Race, a two-dimensional spinoff from the

popular cube puzzle of the 1980s, in which two competitors raced to complete a single flat Rubik's puzzle, matching it to a randomized pattern determined just before the game commenced, painfully frenetic and anxious, players sliding pieces as quickly as possible, the winner (her) slamming down a frame on her winning puzzle, the loser (me, always me) looking on in amazement.

"Let's start over!" I'd say, in the final seconds of the game, right before she was to win.

"I'm amazing!" she'd say, laughing madly.

"Your beauty distracted me."

It was the sort of impressive feat one typically associated with idiot savants on *The Montel Williams Show*, blind children who sculpt or who play a concerto after hearing it once.

"I am the champion," she'd say. "I am always the champion."

"I married a freak."

"So did I."

These were happy, if impossibly hard times, our checkbook empty and fallow, the teetering towers of student loans casting a shadow over everything. I possessed the highest degree capable of being earned in all the world but made so little money. I hadn't expected to be this poor after so much effort. I'd been a fool. After all that school, how had I ended up in the very same bondage as my father, professionally miserable and financially impoverished? I could've been laying waste to all the thyroids in exchange for great heaping buckets of gold. We could've been playing Pictionary at a beach house if I had just bitten the bourgeois bullet and become a shit-ass lawyer. Was poverty the price of doing meaningful work, and how was this work meaningful again?

I tried to ignore the question, and Lauren helped with that. We listened to the radio, and I rewrote the songs for her as I had for others in my childhood, and she laughed the way I'd always wanted the prettiest girls to laugh.

John Mayer's "Your Body Is a Wonderland" became "Your Body Is a Chuck E. Cheese."

We'd be naked, doing what you do when you're naked, and I would sing to her.

"You want love? We'll make it," I'd sing, followed by verses about making sex athwart the Skee-Ball lanes. "Swim in a big sea of tickets."

"Gross," she'd say, laughing.

Sometimes, I sang that her body was a Disneyland.

"After all that cobbler it's more like a Disney World," she'd say.

"Your body is a Dollywood," I sang. "And your urethra is the toilet of the Dollywood."

"Oh goodness, I'm wetting myself," she'd say, holding her now urine-soaked crotch, while I marveled that such a thing can happen to an adult. The first time her bladder exploded in my presence, I simply could not believe it. I had not known this was a thing. Where I grew up, out in the country, if you soiled yourself after a certain age, they sent you to a sanitarium.

We laughed often back then. Sometimes I think it took us so long to conceive a child because it's hard to do that when you're wetting yourself, which I made her do a lot, even in the darkest days of my depression.

"She softens you," old friends said, and I tried not to be insulted that we'd been friends for ten years and they'd never alerted me to my need for softening. Maybe they had. Maybe

I hadn't been listening. I was listening now, and all I heard was my own softened rage and general unhappiness, in the midst of all this simple, unsullied marital joy.

That first year of marriage, as much as we laughed, I still got in fights with the kitchen sink, tried to rip doors off their hinges, considered disfiguring myself with the iron. In one especially dark moment, I watched an entire episode of *PBS NewsHour* with Jim Lehrer.

---

I don't want to be overly dramatic and tell you I was suicidal, but I'll say this: I started to do that thing that all depressed people do where you start to think, *Hey, if I die, at least it will be a change of scenery.* Those were bleak days. I took to reading the Bible, alternating Psalms with Edward Albee plays.

One day, there I was, dressing for work, the way normal people do, when I noticed an unfortunate wrinkle on one leg of my pants.

"Look at this," I said to Lauren, who was dressing for work, too.

"What?"

"Here," I said, pointing out the wrinkle, at which point I began weeping uncontrollably.

"Goodness, what's wrong?" she said.

I collapsed onto the floor and laid there and wept, which, let me just say, is not a thing I do. I do lots of odd things, but I am not a floor weeper. I have ridden flaming bicycles down the street, rappelled off the roofs of condemned hotels, and courageously attempted to outrun the law enforcement agencies of

at least two southern states. I'd always believed I was a strong man, but I was wrong. I was weak as a kitten, there on that floor, while my new wife stared.

"What's wrong?"

"I don't know."

I stayed home from work that day and sat on our little apartment balcony, contemplating, the way one does, trying to think up answers to the question of my sadness, none of which existed in my head. I drove through the black beautiful fields and woods of Oktibbeha County, Mississippi, and found no answers in the wind through the windows, and I stopped and walked through Tombigbee National Forest, and found no answers in the sweat of my brow or in the cocklebur on my socks, and by eventide, answers having eluded me, I took my Bible to a bar in downtown Starkville and sat there drinking and trying and failing to pray.

I looked in the Psalms for a message, a warning, anything. *Lord, you are the blah, blah, blah, and the sun and the moon and the blah*, the Psalmist wrote.

I kept riffling. I was going to find something meaningful in that goddamned Bible or drive my car into a river. I found myself staring at Psalm 102.

> *For my days are consumed like smoke, and my bones are burned as an hearth.*
> *My heart is smitten, and withered like grass; so that I forget to eat my bread.*
> *By reason of the voice of my groaning my bones cleave to my skin.*

> *I am like a pelican of the wilderness: I am like an owl of*
> *the desert.*

It was the word *pelican* that got me. You don't see pelicans in ancient literature very much. Owls, fine. But the freakish and ungainly pelican, he is not a prime-time bird. This bird, I felt, was me. Here I was, wandering the wilderness of my hopes and dreams, bones turned to ash, heart like dead Bermuda, so sad and lost I didn't even want to eat bread, which is pretty sad.

It's funny, what makes you feel better. Because just like that, in a rush of air and words about a friendless, breadless, boneless aquatic bird, the bleak wilderness in which I'd been dying cracked open and I finally felt like maybe I remembered what I should do with my life.

---

I drove home from the bar in a blaze of joyous wonderment and found Lauren in the kitchen, returned from her double shift, clutching a plate of unheated leftovers comprised of a cold sweet potato and a biscuit.

"I have to tell you something," I said.

It strikes me now, as I write, that I hardly knew this woman who stood before me, both of us young and poor and ignorant of what was to come. We'd been married for eight months. What I was about to tell her could end it all. It was the kind of announcement that breaks vulnerable little infant marriages right apart.

I told her. I said, "I've been very sad."

She said, "I know."

"I am going to quit this job. I hate it so much."

She said, "I know you do."

And then I said it.

I said, "I want to write a funny book. That is what I'm going to do."

I'd been too foolish and ignorant to see it before, I explained to Lauren, but I knew, yes, this was why I was born, of course, the thing I had been called to all along, as a boy who wrote song parodies about love and flatulence, a young man who did puppet healings and helped his classmates plagiarize, as a college student who read funny books and got so fired up with joy that my very organs felt illuminated, a young man who grew quiet and pensive and stared longingly at Eudora Welty's window and wondered how I, too, could make a living just sitting in my bedroom all day. Eudora was up there in her bathrobe, I just knew it. I wanted that life, I told Lauren, there in the tiny kitchen. I wanted to write funny things for people to read and laugh and have their heads explode, and if I did, we could maybe have it all—a house, a family, a future, children, enduring happiness, all of us wearing our bathrobes, and all our organs illuminated, joyful and bright, until the end of days, amen.

We would start over, hit reset, begin the game again if we had to. All I needed was her blessing. She stood there. I stood there.

"Is this real?" she said.

"It's the realest thing that ever was," I said.

I was unsure what to do next. Should we fall into one another's arms and weep out all the sadness and make love like otters?

"Oh, okay," she said, heating up her yam. "If that's what you want to do."

This is what love looks like. Sometimes, it looks like a person saying, *Oh, okay.* Not getting weird, not interrogating, not having a conversation. Just saying, *Okay, cool.*

Inside, maybe she was dying, too. Maybe she was privately, inwardly freaking out, that I was about to hurl everything into a crevasse, including our chances at economic stability, but her bearing countenanced only confidence and faith and belief that I knew what I was doing.

That night, we made love like humans. We did this all night, or at least for several minutes, and then I lay there next to Lauren, considering how beautiful life can be. I was going to write a book. Would I become famous? Fame would be all right, I guessed. Tremendous wealth, also, is no crime. One could do much good with large stores of gold. Perhaps I would be one of the good famous people, kind to animals and the elderly. I would start a foundation and fund scholarships for the children of the non-famous. It was all very exciting.

"Night, night," Lauren said.

"Night, night," I said.

I was twenty-eight years old when my seventh dream was born—the magical number, the holy number, jersey number of Jesus, quarterback of dreams. This was it. This was the one, manifest from fetal urge into something I could finally say out loud without feeling like a liar. A fool, maybe, but not a liar. I could look up into the sky and see this desire full and bright. There it was. Everything had been leading to this.

"I will do it," I said into the dark.

"What?" she said, nearly asleep now, eyes closed.

"Write a funny book," I said.

It was a beautiful little dream. I swaddled it in the blanket of my heart, kissed its soft froglike skin, smelled its beautiful dream-baby smell. This little dream was going to grow big and try to kill us all, but I had no idea.

# ACT II

---

## The Ass in the Chair

# CHAPTER 4

*The writer is that person who, embarking upon her task,*
*does not know what to do.*
—Donald Barthelme

THE DAY AFTER I HIT RESET ON MY GENERAL LIFE PLAN, I
went to the bagel shop where I graded papers before class,
only today, the papers could go eff themselves. I was now a
Great American Writer and had an obligation to my vast imagi-
nary readership to write a Great American Book.

I opened the laptop. I would write a sentence. Something,
like, insane. Something very imaginative. I would make it a
story about a man, yes. A man. A white man, sad and fat. Like
me! But wait, who was this sad, fat man? He needed a name.
I couldn't go writing stories with nameless characters. I wasn't
Kafka. But wait! Was I Kafka?

What I needed were some names for all the people in my
Great American Book. I obtained a phone book from the lady

behind the counter and flipped through it for all the best names, and then I made up some of my own.

Atwood Radishberry
Linda Henbarley
Dale Wagontrain

*Wagontrain* was not a real last name, probably. But now it was, because I had just made it one. I'd already contributed to the evolution of American letters and the robust multifariousness of the English language. I was an artist. I felt so alive.

It was now ten thirty in the morning. I had officially passed my first three hours as a Great American Novelist, in which I had created three character names, determined that I was probably not Kafka, and written nothing. Later, after a full day of teaching, I went to the library to see about my calling. What I needed was some help. How does one write a book, exactly?

⸻

The complexity of the dream had suddenly revealed itself to me, the numberless and variegated decisions that must be made to manifest even a single paragraph onto the hateful whiteness of the screen. I'd written paragraphs before, of course, but not these kinds of paragraphs. What was Dale Wagontrain's job, for example? What in god's name do his teeth look like? Has he had reasonable dental care? What in the hell is this story about? How much should people talk? Is Dale the narrator? What the eff kind of name is Dale, anyway? What is he, a tractor salesman? What did I know about the retail tractor business? Was I

supposed to go interview a tractor salesman at the Oktibbeha County Co-Op for clues about an imaginary man's imaginary interior life?

Who cared about any of this?

I did not.

This was a bad idea. I was not a Great American Writer. I was probably not even a great American. A great American contributes to society and does not go harassing sales associates at the Feed-n-Seed to find out what they long for in the dark of night, so that he can write a story about them that nobody will ever read because the protagonist's name is Dale Wagontrain.

I checked out every great novel I'd ever lied about having finished. Melville. Austen. Dostoevsky. Kafka. A few contemporary authors—Larry Brown, Raymond Carver. A memoir, for fun—Nabokov.

What I needed was a solid opening line.

## GREAT FIRST LINES FOR A NEW BOOK

- Call me Dale.
- As Dale Wagontrain awoke one morning from uneasy dreams he found himself transformed in his bed into a monstrous pelican.
- It is a truth universally acknowledged that a single man in possession of a good fortune must be in want of a tractor.

Now that I was on campus, I could use the Internet. Here's what I Googled, in this order:

"How to write a book."

"I want to write a book."

"I want to dance with somebody."

"I want to feel the heat with somebody."

"I have a dream."

I watched Dr. King's speech. I got pretty inspired. By the end, I was weeping. Man, that Dr. King could really bring it home. He had a dream to manifest the sacrificial love of Jesus in the burning heart of America whereas I wished to write a paragraph about Dale Wagontrain.

Next, I Googled: "How to be a writer."

So many hits. There were many blogs. Blogs were huge, back then. Boom time for blogs! Many of these blogs included helpful tips on how to write a book, like, *Write what you know*, and also, *Write what you don't know*.

Google "How to be a firefighter" and you will get fourteen million hits, each very specific and helpful. *First, be a volunteer firefighter*, one website says. *Become an EMT*, suggests another. It might be difficult, but it's clear: Do this, do that, and you, too, can fight fires.

Now Google "How to be a writer," and you will get 360 million hits, and none of them will be useful. I found one site that listed exactly 210 steps to becoming a writer including helpful information such as, *While writing, drink water to avoid fatigue*.

This was the best advice I found: Hydrate.

My brain hurt. Perhaps I needed water. Imagine Kafka doing this! Or Dos Passos. Or Welty. What a ridiculous man I was. Which is exactly how writers feel most of the time, I have since learned, and anybody else with a dream. This is unfortu-

nately the process for becoming great at almost anything. You will be reduced, via punctuated moments of horror and illumination, to ever-deepening abysses of ignorance, until such time as you know absolutely nothing, at which time you will begin to write something true.

But not yet.

Not for me. I had miles to go. Years.

I stared out the library window contemplatively and remembered the thing I'd forgot, which is: I hated my teaching job and would likely need to resign and seek new employment. The benefits of staying in this position at Mississippi State were obvious (summers off to write), but the costs of not resigning were also obvious (teaching classrooms full of hundreds of people who'd rather not be there, no matter how entertaining you are, and also, death by python). I couldn't imagine going for tenure in the discipline of theater while devoting all my creative energies to this whole other discipline about which, let's be honest, I knew very little.

I typed up a resignation letter and the next day delivered it to the chair of the department, who said, "Oh, okay."

She didn't even seem surprised. This is one of the great cruelties the young dreamer must face, being surrounded by people who do not give an eff. Sometimes this is what not giving an eff looks like, like someone saying, *Oh, okay.*

Part of me wanted her to ask me not to go. The dream was delicate in those days. I required signs and wonders at every step.

What I also required was a job that paid more and demanded less. I needed meat to feed the dream and also my wife, who loves meat, and who wanted meat to feed our future babies, once they were manifest in the world and had teeth, and I was becoming increasingly aware that babies, in addition to meat

and teeth, would also have their own dreams. My little heart was running at capacity. How would we find room and meat for other dreamers? Isn't this fear why I wanted out of teaching, because the students never stop burdening you with their own pulsating baby-dreams? The very seams of me felt bursting with desire for greatness. There was no room at the inn for others, and it was a little terrifying to imagine how I was going to write a book and find a new career while also feeding my wife and children and their own dreams.

Which leads us to the inevitable and ignoble part of all this, which is that all dreamers have at least two jobs. Job number one is your dream. Maybe you want to become an influential and culturally relevant designer of home furnishings that are simultaneously comfortable and beautiful, or perhaps you desire to make powerful films that prophesy into the miasma of contemporary moral decay. These are difficult dreams and take time, in most cases, especially when tremendous skill is required to master the art and craft that comprises your calling. One cannot traverse the vast deserts of time required for the mastery of most enduring human vocations. The desert must be crossed by you and you alone.

Job number two is the meat to feed the crossing of the desert of your dream. This is where you get your health insurance and money for food, to feed all the people you have promised to feed, and money for wine, which you will need to quiet the crying baby of your dream at night, just for an hour or two, so you can rest, and the wine your wife will also need, to quiet the actual crying babies, which have not been born yet but soon will, should you keep having sex with her like that, every night, because of all the wine.

Hydrate.

The endgame here for most of us is that job number one and job number two will actually fuse into the same throbbing organism, such that the thing you love to do will become the thing that pays for the meat and the insurance and the wine.

How long would it take me to write a book? I figured two years, three, tops. One year to write a rough draft. One year to make it amazing. One year to convert it into legal US tender via magic. I would be thirty-one years old with my first book. Not too shabby! Which means, whatever job number two was, I'd only need to do it for maybe three years. That felt like a long time, but totally doable. With this thought, I had reached stage one of the dream: Delusion.

## THE TWO STAGES OF THE DREAM

1. Delusion
2. Death

I have since learned that most dreams have only these two stages, or at least it feels like this for much of the time. You need delusion, for the opposite of delusion is realism, and realism is facing the reality that it's very likely going to take at least a decade to make your dream come true, and it's going to be a largely friendless decade, hollowed-out and harrowing, empty of so many things that make us more human—kickball leagues, weekend getaways, beach bonfires—all those happy little things that flicker in the night sky of human experience and constellate into meaning and community.

Many good things would happen in the years ahead, during and beyond the long lonely decade about to unfurl before Lauren and me, but my dream would often dull the good things I experienced, make them harder to enjoy, harder even to see. If somebody had held me down and said, *If you want to be a good writer, you're going to have to be willing to be bad at lots of other important things that, when done badly, as you will surely do them, will hurt that which matters most*, I would not have believed them.

———

What was I going to do for money while I wrote a Great American Something? My wife and I owed nearly $100,000 to various faceless entities and possessed nothing of real cash value.

Every morning, I had a new idea.

Maybe law school because John Grisham wrote *A Time to Kill* while practicing law?

Or med school because Walker Percy wrote *The Moviegoer* during his residency?

Or high school because Stephen King wrote *Christine* while teaching English?

The thing with day jobs is you need one that will not cannibalize all your spiritual currency. Law, medical, and teaching professions empty the tank. You throw every imaginative proton at your day job, and you look up and have no protons left over for the dream. It's a wicked problem.

What might not require all my protons? Pharmaceutical sales rep, management consultant, magazine journalist? All winter, I sent out CVs and called hiring managers, and many of them called back because it was probably pretty clear that I was a

white man, given my Anglo name and unfettered enthusiasm for areas of knowledge about which I knew very little.

"So, you have a PhD?" one hiring manager said.

"Yes!" I said.

"And you want to be a copy editor at *Cooking Light* magazine?"

Yes, yes, I did, explaining that I had always yearned desperately to write about low-calorie meringues. But it wasn't enough. I soon discovered that nobody in the private sector really cared about the PhD unless it allowed me to generate discounted cash flow models with Microsoft Excel. But at least the degree got people's attention; they were curious to see what sort of man might be throwing away his entire education, which, let me remind you, required tens and tens and more tens of thousands of dollars to service. It was like paying off a house I'd already watched fall into a ravine during a mudslide.

The good news came one spring afternoon in the final month of my teaching contract. Tulane University in New Orleans had taken the bait and wanted to interview. The job was a corporate fundraising position for their medical school, which made total sense, as I'd never written a grant and knew nothing about medicine. They said the job was all about people. Meeting people, communicating with people. I was a month away from being jobless, and so I went to the library and started to bone up on people.

I found many great books, like *The 7 Habits of Highly Effective People*, which gave me great career advice while simultaneously

making me want to microwave my own head. The advice included such helpful nuggets as *synergize*, which is known as "collaboration for jackasses." The book also taught me to "put first things first," in which I was instructed to complete urgent tasks before non-urgent tasks, which made me sad that the world needed a book to explain this, and so I non-urgently hurled this book into the garbage. Other books introduced me to bone-chilling new words and phrases, such as *influencer, low-hanging fruit*, and *breakfast meeting*.

It was a pungent spring, verdant and bright and wet. Everything was alive, the air heavy and happy. Azaleas grew big as trees. I bought a new suit and did my best to collaborate with it.

"You look nice," Lauren said.

"What do you mean?"

"I mean you look nice."

"It feels like a costume," I said.

The suit, I hoped, was a temporary thing, a hazmat barrier that would allow me to go incognito into the wastelands of sensible unhappy adults without exposing me to the radioactive materials of their dolor. I'd learned all sorts of terrible things, that fundraising is really friend-raising, and friend-raising is about building relationships. I was not very good at building relationships, although I had destroyed some, which seemed like relevant work experience.

I could not fathom wearing the wool hazmat suit while trying to work my way around an omelet. Wearing a necktie to breakfast was going to feel like a funeral, like lying. Is that what being an adult is? Lying continually to yourself and others, in a helpful way, so as to build wealth, to build a dream? I was not a very good liar. I could hide nothing. If anybody

wants to know if I'm having fun at a dinner party, all they have to do is look at my face. Am I smiling, or does my face suggest inflammation of the joints? My face is a mood ring.

———

I drove to the Tidewater Building on Canal Street in New Orleans, took an elevator to the eleventh floor, and commenced to answering many questions about multitasking, which was all the rage in 2004, when everybody believed a short attention span was a sign of genius.

"Are you a multitasker?" my potential future boss, a nice lady named Christine, asked.

The true answer was, "No."

What I said was, "Yes."

"Can you give an example?" she asked.

I regaled her with an anecdote about the student who threatened me with his python, the recounting of an especially difficult passage of Saint Augustine, and an extended metaphor involving reptiles and putting first things first rather than last. "Or in the middle," I said. "The middle is also a bad place for first things, which go first, in my opinion."

I tried crossing my arms thoughtfully during the interview, but could not, because I was wearing a suit, which meant my arms and legs could only stay in the down position. How did bankers and attorneys use their arms? Didn't they have to obtain things from shelves occasionally, like their souls, which must be kept in a small box of walnut?

I did what felt like a lot of lying in the interview and got the job.

We needed money: That was no lie.

My salary increased from $30,000 per year to $50,000, which, after taxes and student loan and car payments, came to forty dollars.

Still, Lauren was proud; this seemed like an improvement in our fortunes.

That summer, we moved to New Orleans. I was now the Assistant Director of Corporate and Foundation Relations for the Tulane University Health Sciences Center. It was the longest title I'd ever had, and the first job in which they granted me business cards. I thumbed the card, touched the forest green lettering. It felt good, to be endorsed by the world in this small way, the heavy box of cards a kind of institutional sanction that I belonged to somebody's village. Tulane was a good school, especially for a hill country cracker like me, august in its old stones and high gothic windows. I'd made it to this special place, somehow, but it still felt wrong, like pretend. Who are you, really, when you must provide your name and credentials on a card to be believed? It was like handing a copy of my birth certificate to everyone I met: *Here, this is me. I am real. As you can see, my name is embossed.*

———

Three years earlier, I recall being summoned to the office of Dr. Raab, my dissertation advisor, a churlish, long-limbed Chicago playwright, the tallest writer I have ever known, big as a power forward but stooped over with some nameless guilt. I loved this man, and looked up to him, his Emmys and Drama Desk Awards arrayed about the office, which brought him no apparent joy.

I entered his office, that holy of holies, and he closed the door. I sat.

"I'm worried," he said.

"About what?" I asked. Me, I reasoned. He was about to dismiss me from the program, I feared, for my failure to write more baby caskets and adolescent cutting into my plays.

"I'm worried that everyone will find out," he said, looking out the window into the darkening Midwestern gloom.

"Find out what?" I said.

I sifted through possibilities. Had I plagiarized? Been caught stealing pencils? Why couldn't I buy my own pencils? Who uses pencils?

"That I'm a phony," he said.

He opined for a good half-hour on the central lie of his career—that he was worthy and good at anything, which he was not, according to him.

Although to me, to all of us young students, he was god-like.

"You have so many awards," I said, having been thrust suddenly into the role of therapist to Yahweh. "You are tenured."

"I am exceedingly gifted at being phony," he said, smiling.

He went on about the tragedy of his many failed relationships, his scorched-earth former marriage, the calamitous disunity of his family, the adult children who he feared wanted him dead, the God who was not there, the windswept prairie of his soul, and the general foolishness of every life choice that had contributed to his vain greatness. I had never heard a grown man speak so openly of pain, outside a church. It was horrifying. I longed for home, where men did not discuss such things, where

instead they buried the hurt deep and let the pathologies seep down into the groundwater and ruin everything, unlike this anxious, urbane, godlike writer before me, who buried nothing and still managed to ruin it all anyway, according to him.

"Why did you call me in here?" I asked.

"I can't remember," he said.

I stood and saw, on his desk, a play I'd recently finished, a comedy about a young bearded lady who longed to join a sorority and the abusive clown lover who could not abide this betrayal. Lord. Embarrassing. What a joke my talent was.

"What did you think?" I asked, pointing to the script.

"It was funny."

"Do you mean that?"

"No."

———

Three years later, business cards in hand, I recalled my dear professor's painful fear of being exposed, "Ye Olde Imposter Syndrome," a pox that afflicts the ambitious, the dreamers, who must bluff their way into imaginary parties in their own heads.

Did my new job make me feel like a phony? Honestly, what it felt like was a demotion, a backwards trajectory, from assistant professor to fundraising functionary. University teaching is a profession, a calling, a thing you train and prepare for through years of intense study and consideration of the highest, deepest passions of the human heart, while the role of corporate fundraiser is a job for most anybody who can put on a suit and a smile. The former took me a decade to attain, and I abandoned it, threw it in the bayou. The latter took only a résumé and a cover letter and a little charm to acquire. Everything seemed

backwards. I suppose this is how it is with dreams: You make decisions that look foolish to almost everybody, including yourself.

When I put on my suit and looked in the mirror, it hurt my heart a little, I won't lie, and so I reminded myself of the new salary, which had a soothing effect.

This was the right move, I told myself. This was the move that would make the space to make the book possible. I had to keep reminding myself of the book. It was going to be so good, once I started writing it, but I couldn't start, not yet.

First things first.

# CHAPTER 5

*When my brain begins to reel from my literary labors,
I make an occasional cheese dip.*
—JOHN KENNEDY TOOLE, *A Confederacy of
Dunces*

THE NEW JOB CONSISTED OF MEETINGS AND COCKTAIL
parties with physicians and big pharma, where everybody
spoke to one another about monetizing science via National
Institutes of Health funding while I stood there saying, "Wow,
that's amazing," and praying for a meteor to fall on us.

I'd read books on how to behave in these types of situa-
tions, which all said the same thing: *Be yourself.* But I felt like
a thousand selves. Which self should I be today? The one with
dignity? The one who screams at houseplants and urinates in
the sink? I am legion.

My various duties at these fundraising events was to make
contacts, build networks, collect business cards, and feast on the
flesh of mammon, but I had difficulty internalizing the mission

of the job. Most white-collar jobs require you *to want* to want to do them, to do them well, but I lacked all ability to want to do anything but make my dream real, which was hard, because nobody was paying me to dream.

To do one of these soft-skill jobs well, the professional kind that more and more of us are compelled by economic progress to find, where most of your time is spent in meetings, problem-solving and planning and ideating and pursuing mostly intangible ends, these jobs are easy to perform in a perfectly acceptable subpar fashion, because almost nobody knows what anybody actually does, which works to the advantage of the shiftless and mediocre.

If you want to thrive in these diaphanous professional roles, what you've got to do is devote your imaginative life to them, allowing the brain to work through questions even when you're not at work. You drive home, letting the knots of the day settle. You eat dinner, watch some television, have a beer, start untangling the knots. As you sleep, the untangled knots reconfigure into potential solutions, and you wake and run and shower, and the solutions appear to be weaving themselves into surprising and complex new forms that appear to solve the organization's current challenges, and you drive to work and put it in an email heading that you've figured it out. This is what so many professional jobs consist of, even the easy ones, demanding the mind be a perpetual thinking machine, twenty-four hours a day, all week long, with occasional breaks for lovemaking and birthday parties, and this is a problem.

Well, for dreamers, it's a problem.

For non-dreamers, it can be invigorating. The working out of the knots of professional responsibilities into complex woven

patterns of solution is a great delight to the mind and heart. People who love their jobs experience this joy constantly, daily, weekly. But for those of us with a whole other dream, these damned dreams have their own knots to be worked out, which only the mind, at rest and play and sleep, can untangle.

When would I untangle my dream knots? I'd always written at night, but now I spent so many nights standing next to wealthy people at parties, guessing what to say to not seem like a total weirdo, which I feared was not possible.

"It sounds like a fucking nightmare," Mark said, on the phone.

"The world is full of people who hate their jobs," I said, helpfully.

I tried to do the work well, or well enough. At every mandatory cocktail party, I tried my hardest to comport myself with professionalism.

I distinctly recall one such event, an anniversary party for the Tulane Medical School, to which many New Orleans physicians had been invited. It was a pre-party, really, a party before the real party the following night, which they do in New Orleans, because, you know, they like to party. The real party was in truth a prelude to the gala the following weekend, the precursor to the most intense party of all, the after-party, which was a rehearsal for what happened after—the after-after-party, also known as "Drunk Breakfast."

So here I was at this pre-party in the Quarter, in an upstairs room at the House of Blues. Weeknight, happy hour, surgeons, podiatrists, cardiologist, radiologists, they all came pouring up the stairs after work, looking to get hammered before the complimentary dinner. Tulane was providing the drinks, of

course, which is how you get anybody to come to anything, I've learned, especially the wealthy ones, who feel shame when required to pay for drinks with their own money.

I arrived early, along with a small army of fundraising colleagues, other nice people who, like me, had stumbled into this profession. Nobody grows up wanting to ask people for money for a living, and if they do, they should be quarantined. It's not the kind of thing you want spreading.

The guests arrived. It was time to work.

*What has any of this to do with the dream?* you may be asking.

And the answer is: nothing, and everything.

———

I did the usual thing I did at cocktail parties during this period of my life, which is to get pleasantly drunk as quickly as possible, so as to make myself appear eager to listen to tales of summers in Tuscany and such. I was learning a lot about the rich. The drinking helped me look like I was listening when what I was really trying to do was quiet the wounded kitten of my sadness who lived in the place behind my eyes.

I drank bourbon and ginger ale, which made me funnier and more amorous with the elderly wives of the New Orleans medical gentry. I flirted and danced with all the wealthy grandmothers, got them drunk. This was my specialty.

"I haven't danced like this in ages," said a lady my mother's age, as we shuffled irregularly across the floor.

"Ages?" I said. "You can't be more than twenty."

"Hush, young man."

I dipped this nice lady once, and then twice, and was surprised to find myself dipping her head into a tray of mussels,

which she didn't seem to notice, which is what happens when your blood has high concentrations of rosé.

"Wow, aren't we having fun!" she said, pulling lemon wedges from her hair.

"Makes you smell like spring, Lois."

"I'm Janice."

When the song concluded, I worked my way toward the food. We had an hour to go. You throw one old lady into a delicious array of mollusks, you're a fun guy. Do it twice in one night and you're a menace. It was time to attempt communication with the doctors; it was their money we wanted. Most of the alumni physicians were in their forties and fifties, men and women both, hale and attractive, tanned and vigorous. They were runners. They sailed and fished. Their teeth gleamed.

I stood with my plate and tried to make eye contact with the most approachable-looking alumni from across the room, which is not always advisable when you're eating jumbo shrimp. At these parties, guests always gather in groups of two and three, creating a cluster that functions very much like a protoplasmic entity, ingesting nearby life-forms to make itself more powerful. The ingestion into a party cluster can be frightening. People sometimes stare, wondering why you are now in their cluster. At this point, I always tried to say something funny, like, "Fun cluster!" or "I regret the choices that brought me to this moment."

I found such a cluster, populated by three men, serious-seeming. They spoke of their families, their boats, the threat of rain. I hovered in their cluster without drawing attention to myself. What do I say? Do I introduce myself?

*Hi, I'm Harrison Scott Key, and my job is to take your money and use it for important educational purposes, such as the open bar.*

I hovered, rocked on my heels, said nothing.

They could see me hovering there and pretended not to notice.

I would wait until the perfect time. I would make a hilarious and personable remark. We would become friends. They would ask me on their boats. We would hold sailfish in photographs. This is how you got somebody to put the university in their Last Will and Testament, which was the endgame to all this nonsense.

Deferred giving, they called it.

"Ask about their children," a buddy had advised me, once. "People love that."

I had no children and felt the subject beyond my dialogic capabilities. I could identify one, in a painting. My wife wanted some. Her body was a Disneyland, and babies were hidden inside her Tower of Terror.

"Audrey still at Ben Franklin?" said Doctor Number One, the short one.

"She starts at Newman this week," said Number Two, the tall thin one.

"Really?"

"We want to support the public schools, but you know."

"I know."

Doctor Number Three, the quiet one, nodded sagely. He, too, knew. What, I didn't know.

"You have children?" I said, jumping in.

"Yes," said Number Two.

"What kind?"

I had meant to ask, you know, boy or girl? It seemed like one of the first things you ask about children. They either had penises or not, I knew that. I had read it somewhere.

"Pardon?" Number Two said.

Number Three, sensing that the cluster had just gotten funky, excused himself for a drink.

Now, at this point, what do I do? Do I clarify, or do I take the awkward moment and deepen it into a sacred and glorious fullness? The little angel in my head reminded me that this was work, this was my job.

*Don't be a weirdo,* the angel said.

The little demon said, *A weirdo is what you are.*

I did, and did not, want to be fired.

"I'm sorry," I said. "What did I say?"

"You asked if I had children, and then you asked what kind," Number Two said.

"I did?"

"You did."

"Well, what kind are they? Are they human, or something else?"

"My children are human."

"Good," I said. "That's always a good sign."

## SAFE NEW ORLEANS COCKTAIL CONVERSATION TOPICS

- Money
- Fishing

- Hunting
- The Saints
- Mardi Gras
- Tulane Football
- What Restaurant You Went To
- What High School You Went To
- The Poor State of Public Schools in Our Fair City

After the parties, I went home, sneaking a tiny crème brûlée or cheesecake wedge into my suit jacket, placed there so very delicately like a little bird, to carry home to Lauren. She worked as a nanny to two small children, dreaming of her own.

She had become the only bright spot in my day. That's one thing you learn in the washed-out wastelands of work: Everything at home, if you have a good thing there, takes on new color. Lauren taught me how to live. What you do is, you watch *Lost* and eat casserole. We had a TV now, and cable. They were heady days.

"What should we have for dinner?" I'd say.

"Brownies!"

It's amazing how, sometimes, calories and *Lost* are all it takes to feel not crazy. We'd eat brownies and then I'd have three to ten additional brownies, trying not to think about telling a prospective donor it was probably good that his children were humans.

It was a quiet life in our half of the duplex, Lauren's sister and brother-in-law in the other half, which was nice. How easy it would be to carry on in this way, next door to family, full of baked goods and love, in the same job, which would

soon grow more tolerable, if I would only let it, plus the good health insurance and occasional free booze. When I thought about it that way, our life didn't sound so bad, did it? As a boy, this was my dream, was it not, to pay the bills and keep off welfare and hold the boat steady and plow on through low waves into the sunset of paradise? Wouldn't that have made Jesus and my family happy enough? But that destiny seemed juvenile now, pushed out of the way by a bulb shooting up from deep in the earth, the strange timeless urge to conquer an earthly kingdom.

I could not explain it and still find the words inchoate and difficult to summon, this desire to carve my name into history. I don't know who or what put it there. God? My father? Some inborn knowledge of the gaping chasm of eternal darkness that swallows us all, if all this heaven business turns out to be a lie? At times, this urge felt and feels still, now, like that ancient terrifying lust of the human heart, which slays its brother and sets fire to villages and builds monuments to itself in vanquished lands among enslaved peoples. At other times, the desire for greatness felt and feels like the great crowning glory of humankind, what we were designed for, to seize creation and make something new and beautiful with the raw stuff of it.

Which would I choose, the quiet pleasing life in the plain American style, or the wild beautiful Viking warlord conquering one? Did I have a choice? I imagined this compromise happening all around me, in faces on the streetcar, in the elevator, men and women growing soporific and content in the coursing rhythms of life—work and food and sex and work and children and vacations and work—not remembering the name of the dream they once had, until it's too late.

I saw how it could happen to me, this perfectly acceptable American happiness. Lauren ennobled our home with tiny humanizing acts of love: I'd come home to find a candle in the living room, flame dancing in the breeze through the front door. She'd have nailed something decorative to the wall, made everything smell like autumn and butterflies, baked cookies and put them on a plate we'd been given at our wedding. Maybe this life was enough. Maybe I didn't need a dream.

I had no sense back then to say thank you. I looked at the candle and the cookies and did not know that they were making me more human, even as my work made me less. I tried to wake up early and write every morning, and sometimes I did, and sometimes I did not. I seemed to be growing dumber. In a fit of desperation, I agreed to teach a playwriting workshop in the English department and was reminded that teaching was not something I hated.

After a year of this, every new work event making less sense to my soul, but knowing I could make six figures in a single promotion if I would only buckle down and not go all George Costanza, an old friend called and asked if I wanted to teach English at a boarding school back home in Mississippi. I'd never taught high school but I liked the idea of not having to drink and carb-load to feel human.

Lauren and I discussed it. Babies could be arriving any day. The thought of raising them in our natal land had no small appeal. She was sad at the prospect of moving away from her sister, but it wouldn't be far.

"Plus," I said. "Summers off. For the book."

"For the baby, too," Lauren said. "For whenever the baby comes."

I said, "Let's go."

Again, she said, "Okay."

That August, I left the cocktail party circuit for good, or so I believed, and became an English teacher in Mississippi, a few dozen miles upriver, on high ground. Two weeks later, Hurricane Katrina destroyed the house my wife had made into a home, water to the rafters. It had been strangely good timing for us, but not for her sister and her husband and their month-old infant. They lost everything but each other and a few Polaroids the dirty black water hadn't dissolved.

I wonder, sometimes, what might have happened, had Lauren and I stayed in New Orleans for the storm to wash away. Would the hurricane have hastened the dream, tossing us on a distant riverbank, cleansed and unburdened of expectation and ready to start fresh? Or would the storm have soaked and bloated and broken us, the way it had broken others?

———

The boarding school, we soon learned, would break us in its own way, part *Dead Poets Society*, part *Full Metal Jacket*. Teaching English, which I loved, for $32,000 a year, which I did not, demanded so many creative protons early in the morning and late again at night and every weekend that I had none left over to write very much, and two semesters into the job, I found myself as bookless as ever.

A few months after the one-year anniversary of Katrina, I got another phone call, this one from a hurricane refugee friend. The storm had heaved friends all over the South, and this particular man had washed up in Savannah. He now worked

at an art school called SCAD and said they were looking for a writer.

I was done with new jobs, I told him. Every interview required new forms of lying, and I was done with lying. I had a fine job and a book to write and a new baby.

"Congratulations, man!" my friend said. "What's her name?"

"Stargoat," I said.

This is not her name, but in this book I'm going to act like it's her name.

I told him I wasn't interested in any new job, as fun as that might sound, but he asked me to apply anyway, as a favor, and I did, because what is a cover letter but an act of the most creative writing? I mailed the letter and SCAD called back.

They offered to fly me over, and I went. Why not? A free trip to a lovely city.

"Ever written a speech?" the president of this college, a nice lady named Paula, asked.

"Actually, no," I said, "but I've heard some."

I walked around town and was rather surprised to find Savannah exactly as beautiful as the university's promotional literature declared it to be. It was a little upsetting, all the trees and verdant squares and Victorian architecture, the Moorish cupolas and Romanesque windows, and everywhere you looked, dreamers! Some kid taking a photograph, or a student drawing under a tree, or a woman on a bicycle, having the audacity to sing. It felt like the kind of place where somebody could write a book.

And yet, I had a fine little teaching position in a fine little village in Mississippi, in which I was perfectly positioned to

write a fine little book, should I ever ascertain precisely how such a book might in fact be written, once I finished grading papers.

And yet, might the mandatory six thirty in the morning study hall duty and weekend lesson preparation and teaching the canons of rhetoric to boys who didn't always know how to read or deodorize themselves somehow be an impediment to the fostering of my own imagination?

Or was it time to stop moving, in pursuit of an elusive calling that kept moving farther out over the horizon?

SCAD made me an offer.

"It could help me be a better writer," I said to Lauren.

"I don't know," Lauren said. "You can write a book anywhere."

"You have to see this place," I said. "The churches actually have steeples."

"So."

"They have bookstores there," I said. "And parks, for children. Parks everywhere."

"Everybody's got parks."

"They have more."

Lauren had said *okay* during all my previous nervous breakdowns and grand schemes, and at some point, I knew, she was going to run out of *okays*.

"It's so far from family," she said.

"It pays well, for a writing job."

"How well?"

"Well enough for you to stay home with the baby."

She considered this, for a day, and a night, and again into the next day. I could demand she assent. I won the bread, and

bread was necessary to the function of this endless war of living. But I was no general, and she no soldier. The war we fought was only in our hearts. If we moved again, it would be together, earnestly, voluntarily, two dreams yoked like happy oxen.

She looked at me, and then at Baby Stargoat in her arms.

"I guess she'll be a Georgia peach," Lauren said.

# CHAPTER 6

*True, I talk of dreams,*
*Which are the children of an idle brain,*
*Begot of nothing but vain fantasy,*
*Which is as thin of substance as the air*
*And more inconstant than the wind.*
—WILLIAM SHAKESPEARE, *Romeo and Juliet*

WE PACKED UP ON NEW YEAR'S DAY 2007.
I was thirty-one years old and now earned enough money to afford a mortgage on a Savannah home the size of a large cookie tin. Here, Lauren could spend all day with Stargoat, thus making her dream come true, to stay at home with her own child whilst trapped inside a cookie tin. This home also had room for a kitchen table, where I could now write in the morning before work, such that while Lauren put food into the baby's mouth at one end of the table, I could be at the other end, not helping.

Having a dream is amazing!

I'd gotten very good at writing the most basic, expository stuff—reports, memos, summaries, proposals. I'd written enough cover letters to fill a library and had spent the last two years teaching *The Elements of Style* to young men, which taught me more about grammar than I'd learned in three decades as a student. I could control language to make the various kinds of sense I needed to make, but there was a thing I could not do, and that was write a story that shimmered with even the most basic magic.

I'd written the beginnings of a thousand stories, and no ends, hardly even any middles.

I continued to seek writing advice where I could get it—online, in books, during author talks at bookstores—but it all felt so mawkish and vague, drivel about listening to your heart and being present, which made writing sound like therapy, which felt sad to me, because a Great American Writer is a very strong man who boxes tigers for a living, I believed.

The only bit of advice I could understand was this: If you want to be a writer, put your ass in a chair.

*Apply seat of pants to seat of chair*, one book said.

*Step one*, a blog said. *Put ass in chair*.

Everybody was very clear on this particular point.

It is a deceptively simple rule, which I liked.

Now, the amazing thing about asses is that you can literally put them anywhere you want, although asses often do not wish to be put in difficult places. If an ass could talk, and many of them can, especially the ones named Chad or Courtney, and you asked the ass what it wanted to do for a living, its top three career goals would be:

1.  Being sat on
2.  Being lain on
3.  Being in a music video, if those still exist

I'd been putting my ass in a chair for a long time, and nothing much had happened. Or had it? Maybe I was further along than I knew.

"Can you finish feeding her?" Lauren would say, of Baby Stargoat, as I kept my ass snugly in place at my end of the kitchen table.

"I'm writing," I'd say.

"You're just sitting there."

"It only looks like I'm sitting here."

"Are you not sitting there?"

"In many ways, that is exactly what I am not doing."

This is what a dream looks like. It looks like you, trying to do an impossible thing in your head, while you sit there, doing what appears to be nothing, wondering how to explain that the apparent doing-of-nothing is in fact, you hope, something.

Seven o'clock in the morning, the baby crying, my wife crying, too, in the bathroom, because her desire to be a mother was just as difficult, and far more urgent and necessary, especially when your husband's dream is to sit in the house and stare out the window. I sat there, looking at my daughter looking at me, wondering how I would ever learn to write a book and feeling shitty for thinking of such frivolous things as books in the face of a human who clearly needed me, two humans, one stomping through the house, trying to busy herself to see how long it will take me to sit there while the other human, the diapered one, cried.

I was as confused by the real people in my house as the imaginary ones on my laptop. I stared alternately at both: The computer, the baby. The story, the baby. The dialogue, the baby.

"Why is she crying?" I said.

"She's a baby," Lauren said from our bedroom. "Babies cry."

"Is she hungry?"

"Maybe."

"Tired?"

"Everybody's tired."

Stargoat cried and cried. If I let it go longer, Lauren would do something. But she wanted me to do something, even though we agreed that this would be my writing time, and writing doesn't happen if you're not writing, which is exactly the definition of parenting in the dictionary.

> *parenting*
> ˈpɛːr(ə)nt:ing
> verb
> the act of not doing other things

I loved my wife, and also I did not love my wife—for not understanding how impossible the task of writing a book seemed, made all the more impossible by its apparent triviality. The hardest part of dreaming is that if you don't do it, nothing terrible happens. Life goes on. This is why crying babies and student loans always take precedence; if you don't see to those matters, things explode, break down, civilization stops being civilized. But if you never cut that album you always wanted to record, what happens? What worlds come crashing down, but the one in your heart? None.

I stood up, took Stargoat, changed her diaper. Lauren said nothing to me for the rest of the morning. I was a ghost. I sat down and tried to write for another forty-five minutes, but could not. How could I? I felt like a selfish assface, and then wondered if selfish assface-ness was a prerequisite to the task of American dreaming, and if my wife would leave me, one day, for somebody without the burden of such a foolish thing as a dream, an easier man who mowed the lawn and held the baby and did as he was told, because he was not locked inside the chamber of his own skull, conjuring realities that seemed more pitiful and useless with every passing day. It didn't seem right or good that my dream appeared to be making me more unlovable by the hour.

Put the ass in the chair, that's what they said, and now I knew: The ass is not a part of me. It *is* me. I am it.

That's what I did. That's what I was.

After two hours of staring at my wife and baby, I pried my ass from the chair and carried it dutifully to my new day job.

———

What I did at SCAD was write.

I wrote talking points, tour scripts, video scripts, blogs, bios, letters, lectures, presentations, and speeches, speeches, speeches, so many speeches for vice presidents and deans and commencement speakers, including my new boss, Paula, who had been writing her own words for decades, but now, as president of a large university, was too occupied with running the institution to spend all day, for example, trying to think of an interesting metaphor to help elucidate strategies for increasing instructional engagement and seat utilization rates.

Paula knew what she wanted to say, but she simply didn't have the time to stare out the window for three hours thinking about how to say it. This was my job.

She'd call me into her office and say, "I need some remarks for so-and-so event."

"You got it," I'd say.

And so I'd Google the event, and talk to anyone who knew anything about the event, and go to the place where the event would be happening, touching walls and furniture until I felt that I knew more about the event than anyone would ever want to know, and then I'd go for a walk around the park outside our building and float up into the virtual reality holosphere in my brain and try to imagine the guests of such an event. Who were they? What did they want and need to hear, in that moment, that place?

I conjured a speaker in my mind, speaking, and listeners, listening, and weather and air temperature, ambient sounds, smells, echoes of whatever had just happened, or anticipation of what was about to happen, whatever it was, a fundraising auction, a fashion show, a film screening, writing it all down, these disparate motes of mostly invisible atmospheric phenomena that one might use to summon a feeling, evoke an image, to elevate the moment above the drone of the average human day into kairotic time, charged with meaning.

I threw myself into this kind of imaginative trance, and wrote, and wrote, and wrote, made outlines, lists, birthing images, passages, punch lines, arranging, rearranging, reading aloud, hating, loving, and a few days later, I would proof and print and present the document to Paula, and the next morn-

ing would find it on my desk, with four simple words in her handwriting.

"Let's try this again."

But, but, but! Didn't she know about my imaginative trance? About the disparate motes of atmospheric phenomena? How dare my employer not love with rapturous passion the perfectly acceptable and exceedingly mediocre remarks I had written for her!

Try it again?

I'd show her!

And so I'd try again, and show her.

"Too many words," she might say next. "Looking forward to see what you do with it!"

The problem was, she was so kind about it. She offered feedback with grace and enthusiasm, like a beloved elementary school teacher politely asking you to stop gnawing desk legs. In heels, she seemed at most two feet tall, the world's tiniest college president, in possession of some secret faith that somehow, I could do better.

I found her faith in me disturbing. My first drafts were amazing, everybody knew that.

But that's not true, not at all.

And so I'd try again, and show her.

"More elevated words," she might say.

"This is all just words."

"This is not what we discussed."

"Be more careful."

"Do over."

"No."

Again.

And again.

And again.

I'd crumple into my desk chair, defeated, so very disappointed that I'd been lied to my entire life about the quality of my work. Most of my previous teachers had said things like:

"Nice work!"

Or, "Wonderful!"

Or, "You're so talented!"

Because they're very tired, these teachers, and if you show up to class and do the homework and contribute to class discussion in a totally non-insane way, many will give you whatever grade you want, because they've got students who can't even spell their names. I could see it now clear as new bathwater: All those years, I did the work, I showed up, and I was a good enough writer, and that is all I was.

Good enough is almost always never actually *good enough*, if you're writing for an editor or an executive or any audience with rapturously high expectations of quality, and Paula's desire for excellence was dizzying, ridiculous, unreachable, it seemed.

Did she really expect me to start over with this project?

"You can do better!" she said, and when it came out of her mouth, she'd say it so pleasantly and genuinely, as if she actually believed the words. It was very hurtful.

And yet this belief in me had a slightly narcotic effect, this dare of hers to make something better when the thing was already as good as I believed I could make it.

Every new thing I wrote, no matter how trifling it seemed in the grand scheme of the cosmos, captions or catalogs, footnotes or annual reports, toasts, roasts, eulogies, obituaries, from

the brief to the exhaustive, the trifling to the solemn, whatever it was, this woman was not going to lie to me about the quality of my work.

Pray for somebody like this to come into your life, a mentor to dropkick your bad habits out of your life forever, because if you do, just when you think *do over* are the only words you'll ever hear again, you'll hear them again. And again. And again.

———

When I received this perfectly reasonable rejection of my work, what I did was go back to my desk and stare out the window at the sky and beyond into the vacuum of space while desiring to set all the world's thesauruses on fire. Sometimes I'd stare for an hour, but after a year or two in the job, I got this down to several minutes.

I grieved over my work, as every artist must. But you learn to do it quickly. I'd sit and simmer a little, pondering why she did not like my brilliant clown metaphor, which I spent three hours writing, thinking very intensely about clowns for what seemed like too long, and then I'd move on.

When this happens to you, you cannot cry, or run into the office restroom and splash your face with water and look at your dripping and panicked visage in the mirror, no. You are a grown-ass adult with grown-ass responsibilities, so you affix a car battery to your brain to keep it working long through the night to do it over and over and over and over.

And over and over and over.

And over and over and over.

This ability to keep working, when all your best ideas have evacuated your mind, when the clock runs down, when wiser and more talented people tell you, "Nope, try again," once and then twice and then three times, and you are tired and it is time to go home and eat dinner and watch *American Idol*, this is what separates the amateur and the professional. You are playing a game of chicken with your own doubts about your talent, and you cannot flinch, for if you keep doing it over, pressing down against the carbon-based matter of your brain, for days, weeks, months, years, one day you will open your skull and pull out a clown metaphor that will make whole rooms weep in recognition of their common humanity.

"This is beautiful," Paula said, more and more, as the days grew into weeks and months and seasons. "Thank you."

Hearing these words—*this is beautiful, thank you, great work*—as simple and humane as the encouragement of a third-grade teacher who believes in every child, was like breathing pure oxygen after so many years, because I knew something now: I could write a thing, and then make it better, and better again, and then even better than that, because someone believed in me, and not only believed, but also compelled me via the extremely positive reinforcement of a monthly salary, to do the thing she believed I could do. Because when you tell people the truth about how good their work is, they will feel painful feelings of inadequacy, until such time as they either quit or their work improves, more and more, at which point the praise becomes more desired than gold, yea, than much fine gold. For it is not mere praise. It is evidence that you are moving in the right direction down the Damascus road.

My heart had carried me to Savannah, I think, because I knew this is what I needed. I needed somebody who would stop lying to me about the quality of my work. Truth is the only way anything ever gets any better.

———

And I kept at it, and then went home at the end of each day, carrying my ass dutifully back to the tiny house, where, suddenly additional asses had accumulated, upon the birth of our second daughter, Beetle, when Stargoat was two, which meant chairs for asses were becoming scarce. Every day before work, I'd plant my own ass at the far end of the kitchen table, while Stargoat and Beetle sat there on the floor watching me.

*Why aren't you playing with us?* their eyes wanted to know.

*Why are you a bad father?* their eyes asked.

Was I?

By one measure, I was a great father: I didn't drink, didn't philander, didn't curse or raise my voice all that much, had no ridiculous hobbies, nothing that sent me off into woods and lakes and golf courses every weekend, spent hardly any money on myself, and signed everything over to Lauren every month to pay every bill. Money was tight, sure, but never squandered on guns and fishing rods. We were disciplined. Never a late payment, unlike Pop. Always on time. Everybody had food and clothing. The lights stayed on.

By another measure, I was a perfectly derelict father, never quite there in spirit, always hovering in my own head, trying to work out the problems of a story that would not let me write it, believing that this would be the one, the breakthrough, the door through which I might discover the secret, the key,

the hidden code that would let me break the spell and finish the thing and get the agent and sign the deal that would invite my wife and daughters into a magical world where all the houses had more than one toilet.

Nights, at the dinner table, Saturdays in the yard, Sundays at the park, on a Wednesday morning before work, I would be there, totally engaged, and then a cloud would pass over the sun, and the most present part of me would vanish.

"What are you looking at, Daddy?" Stargoat would ask.

"Nothing," I'd say, picking a different nothing to not look at. "Writing."

I tried not to make eye contact, but that's hard to do when Beetle climbs under the sink and starts eating boric acid. You can't say, *Oh, it's fine, boric acid is only dangerous if inhaled in large quantities, and I'm really struggling to create dimensional characters here.* You have to stop writing. Your dream has to disappear, just for a second, as you wash boric acid off the wailing baby.

Which brings us to the real secret to making any dream come true.

———

What you have to do is, you have to leave your family. This method was perfected by William Shakespeare, who abandoned his wife and children in Stratford-upon-Avon, moved to London, and subsequently wrote the greatest literature in all of human history. Was it worth destroying his family, to give us these plays, which reshaped the very nature of the human mind? Yes? No?

That's the difference between Shakespeare and us. He left

his family, and us, we refuse to. Also, he had talent. You might have talent. At this point in my journey, I had none, it seemed. I could write a decent wedding toast, but not a story.

After two years in Savannah, I began leaving my family every morning at five fifteen. Sometimes Lauren drove me. I'd jostle her awake and dress and put the groggy little flopping girls in the truck and she'd drive me to a coffee shop a few blocks from the office, where I sat for two hours before work trying to write something that did not make me want to chew off my own tongue. I'd kiss her and the children and say good-bye, privately deliberating on how selfish this was, to make these fine people tote me into the darkness to tend a tree that might never produce fruit. What ancient magic powered the dream through these dark mornings? I cannot say what compelled me to wake and rise, when I did not wish to wake and rise, when all evidence pointed to fruitlessness and waste, but I felt a surging inside me, generated by a tiny throbbing quark of hope. Whatever greatness I was to manifest, it would come from this quark. I could feel some kind of hidden greatness there. I could.

On the darkest mornings, I worried: Maybe it wasn't a good quark. Maybe it was a quiet, evil quark, the poisonous seed of ego. But no, this couldn't be true. I believed that the quark was not bad, it was good, and it lived inside me. I cannot explain its origin, other than to say that this quark was faith. I had begun to believe that God put it there.

Perhaps all those sermons on the parable of the talents had plunged their pleading optimism into this bright trembling singularity. The quark hummed, ready to burst its light through me, and my dream to write, I felt, was how this light

would find its way into the world. I won't lie, the sensation of this hope within me was at times onerous, for it would not relent, and it was also deeply pleasurable, to know a thing was growing inside me and might soon burst forth.

My body, in those days, was transmuted into a quivering vessel of insistence. As soon as my feet touched the floor in the morning, I could not be at the writing table quickly enough. I set out my clothes the night before, usually on a dining room chair, so I would not wake Lauren and the girls with any pre-dawn fumbling. Let them sleep, while I made banked fires blaze. Shirt and trousers and shoes and socks, empty, flat, as if I had been raptured out of them, and each morning, a rapture reversal, the clothes filling with my body and blood, the quark making me hot and excitable, eager, a dog before a morning hunt.

An elastic bungee cord pulled me toward the coffee shop, and I jumped in the truck, ran stop signs and red lights, in all weather, blueblack cold and hot soupy rain, hoping to be at the door when they unlocked it, already in the underwater of my imagination, coffee sweet and simple, cord into wall, headphones on head, screen illuminated, throbbing, cursor blinking. Welcome back, friend.

On days that did not begin with writing, I became irritable, hangry, scowled at sunsets. There comes a time for all dreamers like this, when your body so desperately longs to be doing the thing it was born to do that not to do it becomes physically painful. This moment is key to dreaming, when you get to the place where it's harder not to work on your dream than to work on it. This is good. Your heart and soul and mind on the same page now. This dog will hunt.

The urgency that drove me to wake so early, when I had so many other tasks and responsibilities and people to please and nurture, was informed by the book of Ecclesiastes and the narrator's continual peroration that the light of my excitable quark would not last forever. Everybody dies. The light goes out. You've got one life to let it loose.

I had sailed through seas of doubt over the years and did not feel like one of those dutiful focused energetic disciples of Jesus. I was no wingman of the Lord. I felt more like Jacob, the tomfooling Old Testament clown who demands a blessing from the angel like a jackass at the customer service desk, refusing to leave until he gets cash. God had admired that ancient fool's tenacity, I believed, and I hoped he would admire mine. The angel of the Lord held my dream in his hand, if he would only give it over. We sparred every morning.

I realize all this talk of angels and quarks may sound insane to you. It sounds sort of insane to me, too. I am only trying to understand how it all went down, how I could leave my wife and children every morning when they needed me most. Leaving was going to make me not only a better writer, but a better father, a better husband, I hoped: Leaving, so that when I came home, I could be *home*.

I had 150 minutes every morning to write, from five thirty to eight o'clock, and a day has 1,440 minutes. Sleeping took about 480 of those minutes, and SCAD purchased roughly 600 of those minutes, which left 210 minutes for my family and

general hygiene. Which meant three and a half hours at night in which I was giver of candy and piggyback rides, tickler of tiny humans, doer of dishes. It sounds like a lot, until you realize your daughters go to bed at sunset, practically, because their mother knows what she's doing, because sleeping children are happy children.

Time. Always time. Time runs off and leaves you.

I decided to keep my dreaming and angel-wrestling between the lines, between those 150 minutes every morning, so that I might not look up and find my family changed, or gone. What they don't tell you about the placing of the ass in the chair is that you have to train the ass to sit, before you can make something with it. Most people's asses cannot just sit, without something to watch or eat. But you've got to train your body to be where it needs to be and do what it needs to do. So I stared. I stared at the computer. I stared at the people at the café. I stared and did not write much worth keeping. My ass said, *This has become tiresome.*

In those days, I had to distract my ass, to fool it into sitting for longer and longer periods of time. I distracted it with various activities. I read the Internet, all of it, hoping to learn something of my fellow man that might prove useful in composing literature, and what I learned is that social media is like those 3-D dolphin posters at the mall in the 1990s: You stare, hoping to see something amazing but even when you see the hidden thing, it's not that amazing.

I spent undue hours writing everything but literature— emails to friends, cover letters for jobs I did not want, long lists of potential rapper names, should that ever be an option.

White Lyin'
Just-Ice
DJ Tanner

Looking back, these many hours of not writing may have been writing after all. I was trying to make myself laugh, to sidle around the watchful logic-dragons of my brain and get at the comic gems hiding under their gaze, to recreate the comic conditions of my childhood, when I made whole classrooms laugh, reaching into the velvet sack of my imagination and hoping to pull out a rabbit, or God knows what. Meaning. That is what I sought.

These were the long dark days of my story, and they were not easy days, and they were not days at all. They were years.

———

Savannah, like most American cities, was sick with its own kind of dream, of money and what can be got with it. I often found myself on the church lawn surrounded by mostly decent men amidst much talk of boats and fishing.

"Do you like to fish, Harrison?" they asked.

"I like fish tacos," I said.

## SAFE SAVANNAH CONVERSATION TOPICS

- Kids
- Money
- Fishing
- Hunting

- The Falcons
- St. Patrick's Day
- Georgia Bulldogs Football
- What Restaurant You Went To
- What High School You Went To
- The Poor State of Public Schools in Our Fair City

The small talk with other men was brutal and the more fiercely I lunged toward the dream, it seemed, the more I grew inept at male friendship. How often did I stand in stoic manly herds among lengthy talk of redfish season or deer season or taking the kids out to Wassaw Island, which requires a boat to reach, where you can basically have your own private beach for the children to run wildly across, because, you know, the public beaches are just overrun with non-boat people and their non-boat lifestyles.

"What do you do for fun?" I was asked, often.

What I wanted to say was, *I used to hunt and fish, as a boy, but now what I do is sit at a table and watch my life run between my fingers like ground bone.*

But instead what I said was, "Baths. Mostly I take baths."

Did these men, whose wives were friends with my wife, find meaning in their work? That is the thing I'd been after, all these years. Meaning, the sort my father did not seem to find in his work. Meaning, to color every day, to power the heart. Perhaps their Boston Whalers gave them meaning. I tried not to judge these fine men and their preoccupation with the accouterments of wealth. For many of them, they were focused on a fantasy to pilot across the tide with a Ray-Ban tan on their faces. And, just given the many historical epochs when the best any of us could hope for was to die by having our throats slit by

Huns, I'd think, *Sure, that's fine. You get your boat, brother. Enjoy the wind in what hair you have left.*

When I was in my twenties, I thought, *Beach houses and boats are a waste of resources, attempts to shovel material goods into the God-shaped hole inside us all.* But now that I was thirtysomething and getting thirtysomethinger every day, I was starting to think it might be fun to put some boats into my God hole, too.

All these men, fathers and husbands, they worked hard, or seemed to. They appeared to be handling their shit, according to all the available evidence, their marriages mostly not falling apart, their children mostly heeding their commands.

I needed to handle my shit, too. I'd opted for a life in art, by God. I'd made this bed. If you're going to have the courage to live the dream, then live that shit. Art is work. Put your pants on and get your fool ass to work, son.

---

I kept at it, handling my father and husband shit like a man, at nights, on weekends, handling my work shit during the day, and every morning, handling my dream shit. After a year or so, my ass learned to sit. To be quiet and listen to the hum of the universe. I learned to be quiet and go into the deep places of me.

It felt like free diving, the way divers train to go deeper, a little at a time, one breath at a time, deeper, deeper, coming back up, then down again the next day, up, down, through the blue and down into the black, past the place where the sun can reach. So deep, so far down you're practically an amphibious creature, moving through the dark, discovering things, plots, characters, ways of writing you had suspected were down there but had never seen with your own eyes, and then, *Blam!* it's

time to resurface and clock in and be a father, an employee, a human again.

I sent stories and essays to *Orion, Ploughshares, Barrelhouse, Tin House, Brick House, Outhouse, The Pinch, The Smart Set, The Dope Boys, River Teeth, Salmon Lips, Bass Face, Image, The Believer, The Pagan, The Warlock, Destiny's Child*. I sent more stories to one magazine than all others, called the *Oxford American*. I'd mailed them three or four reams of paper over the course of five years, each story rejected via courteous postcards mailed by some twelve-year-old intern from Sewanee. The rejection postcard had a lyrical quality to it, with line breaks and everything.

> *Many thanks for your submission.*
> *We regret that it does not quite fit our publication's needs,*
> *but we appreciate the chance to consider your work and*
> *wish you the best of luck in finding a suitable home*
> *for it.*

I wrote my own version of this postcard, which I kept taped to the front of my laptop:

> *Many thanks for sending us your newborn baby.*
> *We regret that it is the ugliest goddamned baby we've*
> *ever seen,*
> *but we appreciate the chance to look briefly at it before*
> *it had a chance to steal our souls and*
> *we hope you don't mind, but we set it on fire and put*
> *it on a raft made of bamboo and*
> *released it in the Gulf of Mexico during a hurricane*
> *where it belongs.*

After receiving several dozens of these rejections, I decided: No more submitting to magazines, for now. Instead, I took my chair and my ass and the rest of my body and decided to go deeper down into the water than I had ever been, to find the pearl I sought.

# CHAPTER 7

*For a moment, nothing happened. Then, after a second or so,*
*nothing continued to happen.*
—DOUGLAS ADAMS, *The Hitchhiker's Guide to*
*the Galaxy*

AT THIS POINT IN MY TALE, I FEEL A CERTAIN RESPONSIBILITY to get painfully specific and elucidate some of the technical matters of my dream. All the talk of dreams in our nation's high schools and colleges and vocational seminars can be maddeningly vague. At the heart of any American dream, you have to learn the craft of a thing, and often many crafts at once. I want you to know how I eventually learned to do some things, and how dumb it made me feel that it took so long to learn to do them. I want to tell you how I learned to write a story.

It made me angry, how dumb I was. Why could I not figure it out, how to be as hilarious and wise and amazing on paper as I was in my own internal hallucination?

I have to be honest with you: There were many dark times, on the long desolate road of American dreaming. The darkness of those days was allayed by the familiar murmurations of home, of returning to our small, happy house, with a candle flickering on the coffee table, the same candle Lauren had been lighting for me every day of our marriage, the children grappling my ankle, the fragrant odors of Chinese takeout, the promise of a televised football game that might distract me from the horrors of my own imaginative fruitlessness. Two beers and a good meal and the love of a family can distract a man from any number of hateful horrors. God, it was awful, and beautiful.

The refreshment of family replenished my tanks with a variety of magic I do not understand; somehow, I kept on. I thank God I did. I don't know how anybody does, sometimes.

I began to watch TV with a notebook in hand, to diagram movies like sentences, to try and summarize novels in a single word, cooking down the au jus of a story into a cube of comprehensible bullion. I learned, for example, how every mountain climbing movie follows a similar plot:

Cool mountain. Product placement.
Avalanche. People die!
Sherpas know things.

Many twentieth-century novels also followed a similar tripartite pattern:

Cool, war. Let's go?
War happens. People die!
War is hell; now I'm crazy.

I began to see stories in terms of theme and metaphor, as the deployment of an idea into the atmosphere of action: the declaration of a theme (act one), the hydra-headed expansion of that theme into unwanted and unexpected terrors (act two), and the transformation of that theme into a new and culminating declaration (act three). Thus, Dorothy declares her desire to leave Kansas and go somewhere totally non-Kansan (act one). This desire expands into all sorts of beastly scenes, where Dorothy learns that wanting to leave Kansas may require her to be attacked by demonic trees and flying monkeys (act two). Dorothy is then transformed, along with her desire, and learns that she is capable of great feats, such as murder (act three). And it's a happy ending, because Kansas isn't so bad, and has no extradition treaty with Oz.

I learned how to perceive the source code of a story. The skeleton key to the whole thing, at least for me, was so simple as to be upsetting: Create a question—in the heart of the hero, and in the mind of the audience—and go about answering this twin-interrogation with each new sentence, via concrete images and the totally possible but highly improbable behavior of humane characters in occasionally inhumane circumstances.

Before, I'd thought a story was this:

Event A
Event B
Event C
Event D
Etc.
The End

But a story is not that at all. A story is an old-fashioned treasure hunt, and what makes it so very hard for the writer is that when you start to write, you don't necessarily know the nature of the treasure or even what the map looks like. All you need is a human with an empty place inside them they're hoping to fill. That's what a story is. We turn the page because we all have the hole in us, too, and we're all trying to fill it, and we're hoping the story will give us some ideas about how to do that.

That was it. That was the pearl.

---

This new knowledge made for heady days. I wrote stories every morning, so many, you have no idea, terrible stories, including a very long one about the man who invented New Coke and a novella about God, narrated by a unicorn, and they were all so bad, offering no compelling reason to turn the page. Something was missing, still. I had so many questions and nobody to ask them to but my poor wife.

"I need to ask you something," I'd say.

I'd say it while I dressed for work and she used a foot to keep one child back from the stove, where she was making breakfast while holding another child who was trying to access one of her breasts to check the expiration date on the milk, three baskets of unfolded panties and onesies awaiting her imminent attention on the living room floor. Our dreams battered one another in this fashion, without ceasing. She, too, had many disappointments in the second act of her journey, as she slowly realized that her vision of being a stay-at-home

mother, in reality, consisted mostly of folding laundry. Panties were her flying monkeys.

"Just a quick question," I said, checking my watch. It was time to go to the office.

"Can it wait?"

Until when, I wondered. We hardly spoke anymore. At night, we crawled through dinner and collapsed into our own private exhaustions. There was never a good time.

"I'm thinking about trying fiction again," I said. "Memoir is just not doing it."

"I really don't care what you write," she'd say. "I mean, that's not really my thing."

I'd get upset at it not being her thing. It was my thing, which should make it her thing. Hadn't we agreed to share all things, as per the wedding vows?

It's not that Lauren didn't want the dream to come true—no, no—the very opposite. But it was my dream, and the possibility of it actually resulting in additional toilets and a general amplification of square footage for surplus baskets of laundry was simply too distant to imagine happening, and my constant request for assistance in dreaming the dream was too much for a woman heavy with child, as she seemed to be, continually, in those days.

"I love you, but I don't know what you want me to say," she said, often.

She was happy for me, but dammit, it was my dream, not hers. The general vibe I picked up from her in the first decade of our marriage was that I needed to work that shit out with somebody else. She had milk ducts to be engorged.

"Are you having an affair?" Lauren asked, one night in bed.

In a way, yes. I was having an affair with a story about a talking unicorn, which I felt might be my first enduring masterwork, if I could only figure out the middle.

"No," I said. "Have you seen me naked? I'm not sure I could manage it."

"It's just, you're not here."

"I'm here."

"You're not."

"I do love you," I said. "I'm sorry."

She touched my arm and we slept, and I rose, and I wrote, and I worked, and I came home from work, and my two little daughters ran to the door to greet me, these little orbs of holy fairy light, casting away any darkness lingering on the ass after another day of failing to make progress toward the something out before me I still could not see. They did not know they were fairy orbs. They had no idea.

The quark of my ambition dimmed a little, on the worst days, when I questioned every decision that had led me far into this bleak wilderness alone, while my wife seemed lost in her own wilderness of motherhood. Just over the horizon, my future was waiting, but I had no idea. I saw no horizon. I wanted out of this self-imposed Sinai, to be with the girls, to be normal, whatever that was, to tighten the faucet of our love, to take Lauren and the children to the park and just sit, and play, and not dream.

"Tuck me in," Stargoat said.

"Me, too," Beetle said.

"Daddy?" Stargoat said. "Are you a writer? Mommy said you're a writer."

"I don't know," I said.

———

The year I turned thirty-five, emergency maneuvers were called for. The dream felt more urgent than ever, an appendix about to burst. At work, I thrived. Opportunities were presented, promotions, new windfalls of money that might expand and enrich our daily lives. I could feel the dream telling me goodbye.

I found myself, more and more, speaking with Paula, boss and mentor, about the future.

"What do you want to do?" Paula said.

Nobody had asked me that since high school, really. It knocked the wind out of me.

I could say anything: Buy a nicer house? Move to a nicer neighborhood? Have a second home? Invest? Travel? Contribute to the flourishing of the university in some new administrative capacity? That's another impossible feature of dreaming—the temptations to abandon your dream are not always cruel and trifling. Sometimes you are tempted by important and meaningful options, which make the dream seem vapid and foolish.

"You could lead people," Paula said.

"I could," I said.

"Is that what you want?"

"I want to write a book," I said.

It sounded so petty and small, to write a book, a silly thing, a feat that might only take a few weeks if I would only apply myself, according to the National Novel Writing Month zealots.

"A book, okay," Paula said. "You can write a book. Why not?"

I think she must've seen how much I wanted it, the burning ache of it emanating off my skin when I said the word *book*. I needed time to write it, I told her, or felt I might lose the vision of the man I wanted to be. I had a family that must be taken care of, and the weight of this burden grew more tremendous and precipitous with every sunrise and sunset. The children had begun eating processed chicken at a rate that could not be sustained without continual infusions of cash.

Life was getting away from me, I told her.

Paula listened. She had a dream, too, to create a university, which now employed and educated many thousands of people. I guess she knew a fellow dreamer when she saw one.

"I want it so badly," I said. "And it seems so impossible."

When I heard myself saying all these things out loud, the words became oxygen to the fire inside me, and the tiny dream-ember burst into happy flame.

That summer, 2010, mornings and nights and weekends, I wrote a memoir longhand, page after page, morning after morning, all summer long, until the bones of my hand resisted and groaned. I left my computer and headphones at home to silence the din of social media that made writing so pleasant and impossible, and by summer's end, I had finished the man-uscript, which lived inside a squat tower of spiral notebooks.

I put it aside for a month, to let it cool.

And then I read it, and wept. It was an amazing disaster, boring, meandering, flat, themes raised and abandoned, jokes left to die by the roadside. The story lacked sophistication and those focused expressions of human desire that make a story dance on the page. I had dithered away the most frenzied writing

season of my life on a derivative work of nonfiction that was such a poor representation of memory and history that it seemed to cheapen everything that mattered most from my past. I was angry. The thought of starting over made my heart hurt.

But still, somehow, that fall, I kept waking my ass up and hauling it to a chair. It became a kind of prayer. I shook myself awake and cracked my knuckles and wrote, old documents, new documents, anything, words, dangling myself over the canvas of the white page making the drip painting of my dream, not knowing anything about what it might turn into.

These hours of writing became the realest hours of the day, where I attempted to declare on paper everything I'd kept hidden from others, all the true things I stored in the walnut box of my heart. The habit of writing had begun to shape my very consciousness to the point that I even forgot what I was supposed to be writing or how. I just wrote and wrote and wrote and wrote and something happened.

———

Because think about it: If you spend 150 minutes doing the same thing every day, and you do this seven days a week all year long with no exceptions, not even family vacations or grave illness, you even got up extra early on Christmas morning to do this thing before the house woke up, and you behave in this mad way for five or seven or ten years, can you imagine?

During that long wilderness inside the cave, I read many good books and wrote many bad stories and began to divine the multifarious brilliant ways that writers accomplished the manufacture of the thing that makes you turn the page. Some created suspense with thrilling action, others with

ridiculous bone-jarring prose that made you keep reading just to see what new metonymy this writer would use to shake your mind out of its old skin. These lessons accreted over time, slowly.

Because if you stay with it, here's what happens:

You wake up one morning and tiptoe past the children and pick your heart up off the kitchen table where you charged it overnight and you drive to a well-lit place to stare out the window with your hands in your pants because your hands are cold and your pants are warm. You've been doing this foolishness every morning for nearly seven years now, and hating yourself, and hating your work, until such time as you hate it slightly less, until such time as your expectation level also increases, so that even as you hate it less, you actually hate it more.

The work is getting better.

And you love it.

And you hate it.

And you love it.

They say writing is like giving birth, and it is, it's just like giving birth, during the Middle Ages, when all the babies died. You get up every day and try to push out a baby, and when it finally comes out, it's dead, and if it's not dead, it should be, so you take it to the bathtub and drown it, and then you get upset and consider what fun it would be to take that promotion they're offering at the college, which will take up what remaining stores you have of time and energy but which will give you the money you desire for the home for your wife, who has not yet called you a bum even though, really, who are we kidding, you are a bum, and then you get up the next day and decide to be a writer again and have another dead baby, and you look in the mirror, and you're like: This is not fun.

You could be making money.

You could be paying off your school loans.

You could be doing so much for your family.

But no!

Do not listen to this demon!

Stay with it, friend.

Stay with it. Because every now and then, one of those babies comes out and it's the most beautiful baby you've ever seen. It has plot like a good, healthy baby. It's got exactly the right number of commas, and its paragraphs are perfectly bilateral. And you forget about all the dead babies for the last ten years and you hold that baby tight and spellcheck it like a good parent should.

In reality, it is a very ugly baby, but you don't care.

Its eyes are too far apart.

One of its ears is shaped all weird.

It has three arms.

But you don't care. So you send this baby to a magazine, and they mail you back a little postcard that says your baby is, in fact, sort of ugly.

*But no*, you say. *It is my baby!*

You made it. It is perfect.

And then you look long and hard at the baby, and you realize: Yes, it is an ugly baby. So you do like Abraham, and take it out back behind the woodshed to kill it, but God doesn't stop you like he stopped Abraham and so you kill your baby, and weep. And you wake up again and make another baby, and more and more babies, a whole army of ugly, three-armed babies, and send them out into the world so all the editorial interns can kill them for you.

And then one day it happens, you get an email from an editor saying they see something special in one of your ugly babies and they offer to help you make it less ugly by giving it a haircut that might keep its brow from seeming so prominent, or by removing one of the arms in a non-invasive way. And before you know it, a few of your ugly baby stories are alive on the Internet for anybody to see, and you soar, with pelican wings, and you run, and are not weary, and you walk, and do not faint.

# ACT III

—

## The Part Where We Roll Around

## Naked on All the Money

# CHAPTER 8

*Is pointing and laughing something we do naturally, or do we have to learn it? Likewise, can someone without a sense of humor be taught to have one, or must it be beaten into him?*
—JACK HANDEY, "The Mysteries of Humor"

SUDDENLY, IN A GREAT MAD RUSH, EVERYTHING THAT happened, every scene, every bit of overheard dialogue, every sound and sensation against my skin, the flavor of new and familiar foods, everything came alive. The world re-enchanted itself. Trees spoke. Feet cried out. Odors tiptoed around corners, waiting to attack. All around me, for so long, life had been falling away, uncaptured, unremembered, unconsidered, and writing, I now saw, was a way for me to grab onto it, to clutch and know it. It didn't matter what it was, a memory from last week or a lifetime ago. Why *did* that happen? Why *did* I feel that way when I saw that airplane? When I smelled that animal? When I heard my daughter cry for the

first time? Meaning was embedded in creation if I would only just seize it.

"I wrote something funny," I'd say to Lauren every month or two.

"Great."

"Can I read it to you?"

She wanted to hit me in the face with a bat, you could tell. But the children were asleep and she was tired and didn't have the energy to run away.

"Sure," she said.

I'd read, and before I finished, I already knew: It wasn't funny. I could tell, because there was no urine on the floor, not even a little. I'd look everywhere for it. There, over there in the corner, was that her urine? No. How about right there, under the coffee table? Nope. That was somebody else's urine, one of the children's, perhaps.

What made me funny, and how could I alchemize that quality into language? I could make Lauren wet herself, going on about Dollywood, but not with a story. In many ways, Lauren's bladder was too distracted in those days, as was the rest of her body, now that she was pregnant again. Like Stargoat and Beetle, this imminent baby, according to the nurse, was also wielding a uterus. Our home had become an ovary farm.

See? That was funny. Why couldn't I write something like that?

———

The funniest thing I ever did on purpose was in graduate school, at a coffee house in Carbondale, Illinois, where every

Friday night everybody stood up and read really intense poems about Islamophobia and cutting. One poetry night, I stood up and approached the mic in a very serious and somber way. I coughed a little, pathetically. There was a cosmic silence, in the small, dark coffee shop. These solemn holy moments are when I most desire to be funny.

There was the shuffling of a chair. The flush of a distant toilet. I pulled the poem out of my pocket, unfolded it. It seemed like a funeral. Everybody could tell this was going to be a pretty intense poem about depression or the Patriot Act.

"This is a love poem," I said.

And then I read the lyrics to "Jessie's Girl" by Rick Springfield. I read it like the saddest love poem ever written, how Jesse had himself a girl and how I wanted to make her mine and how she was loving him with that body, I just knew it. At first, nobody laughed, but by the end, I had them dying, cheering. It was easily one of the holiest moments of my life.

That was the feeling I sought to create, in others and my own heart, with my writing.

I checked out a few books. I read E. B. White's "Some Remarks on Humor," which I did not find helpful, and I read William Zinsser's "Humor" chapter from *On Writing Well*, which I also did not find helpful, and I read Freud's *Jokes and Their Relation to the Unconscious*, which I found very helpful for making me want to set myself on fire.

I went back and looked at all the funny novels and memoirs I'd ever read, and any book described as *laugh-out-loud funny!* on the back cover, and what I learned is that people who say that on the backs of books are liars, for I did not laugh out loud or even very quietly.

"Can you recommend any funny books?" I asked at every bookstore I visited in those days, and the helpful employees walked me to the humor section, and I reported those people to the police because I did not want to write a joke book. Sometimes, I'd buy what they recommended and then throw those books into the ocean and then retrieve them, for littering was also not funny, and not funny was clearly my specialty.

One thing I have since learned about myself is how the formal qualities that most often disgust me in literature are usually the very qualities I am trying to improve in my own work. When attempting to write a roman à clef, I loathed all Kerouac and Hemingway. If I tried to write a thriller, I found other thrillers repulsive. If I was hoping to sound less formal and more authoritative, then I detested the work of breezy, authoritative essayists. I think I was worried about stealing good ideas from others, borrowing solutions to narrative problems. I wanted to solve the problems of art on my own, which is a foolish thing to want. Scientists build off prior discoveries. Artists should, too.

This predilection for hating what I most needed to learn was especially true of comedy, and the harder I looked for comedy I didn't hate, the harder it was to find. I went to the library and read every great funny thing that was ever supposedly great and funny, and I prayed that God would let me not hate all of it.

Aristophanes
Ephron
Nordan
O'Connor

Perelman
Plautus
Portis
Saunders
Shakespeare
Thompson
Thurber
Twain
Wolfe

I worked hard at not working hard, teaching myself to let the left side of my brain rest while my right got a bucket of popcorn and learned to laugh again. I copied down in a notebook every funny passage I could find to study how it was made. That's what most of the epigraphs in this book are—lines and paragraphs I found funny and wanted to understand why.

I began to note certain techniques, how misdirection and surprise were essential, for example. One must write the very thing one is not expected to write at that moment in the sentence. There's a prestidigitation to it. Incongruity reigns. One describes a strange thing plainly, a plain thing strangely. Rhythm, also. As Seinfeld once said, it's more like writing a song than a sentence.

Most especially, I began to note a kind of weird expressionistic warping of facts in funny writing, the way Van Gogh painted cypresses. You can tell these are trees he is painting, but he torques them, makes them look like black fire. He doesn't make them not-trees, he just makes them look to your eyes the way they looked to his bewildered heart, like dark windswept flame.

I began to see this candid distortion all around me. I'd find myself noting the many remarkable ways people walk and run, how some young woman jogging in the park would let her arms hang all weird, like they weren't even there, like she didn't even know she had arms, even though, I was pretty sure she knew she had arms. That's the factual distortion that gets to the truth, which is: The woman runs weird.

I started writing more in this way, the way Francis Bacon paints faces, the way George Bellows paints bodies. It wasn't lying: I was merely attempting to show the reader how ridiculous the thing looked to my heart, such that ideas and objects were distorted, brighter, bigger, Fauvist, postimpressionist, some details omitted, ignored, others heightened, lit on fire, so you could see them from space.

I wanted to share the new work with my wife, but decided not to, as she was pregnant and now generally only answered questions about nachos. Instead I decided to ask my best friend, Mark, who I spoke to on the phone every month or six.

While I had spent many years wandering in the wayward wilderness of my dream, Mark never wandered or waivered from his calling, which was to marry into wealth. He longed for the contemplative life, playing his guitar around campfires for captive audiences, which he managed by hiding everyone's car keys. On his way to finding a loving and wealthy patroness, he became many things, a newspaper salesman, surgical assistant, actor, dishwasher, steelworker, canoe guide, raft guide, bus driver, finally settling on a career as a standardized patient, where he pretended to have diseases, a skill he picked up in high school.

It was flexible work, with a lot of downtime, in which he could read. He had no literary prejudices of any kind. He loved it all. The only thing he expected from a book was to be amazed, constantly, until the end.

He married a lovely woman named April, a flight attendant from Atlanta, which allowed him to travel for free to many exotic locations, such as Denver or Cincinnati. His life was unconventional, to be sure, and though he had far less money than most college-educated men I knew, he did live a glorious life, availing himself of the freedom to pursue nobler ends, such as walking his dog at any time of the day he chose. He was happy, and I was happy for him, and we still talked about books quite a lot. I called him often in those days.

"I'm emailing you a story," I'd say. "Tell me what you think."

Mark would dutifully read whatever it was, and he'd call back, and I knew he thought it was bad, because he wouldn't bring it up. Which was fine, and we'd turn our attentions to other unpleasant topics, like how much money all our college friends were making now. We talked of art and books, and it was a balm of Gilead to talk with this old friend.

After these phone calls, I felt happier, a load lifted. I hadn't known I was sad before the call, but this sensation of lightness afterwards made me wonder.

———

One thing you learn when you read interviews with funny writers, which I did a lot in those days, is that many interviewers believe funny people are sad inside. I called this the Sad Clown Theory of Comedy, which states that every funny

person is secretly masking his own sadness with a veneer of the shallowest vitriol, unlike stronger and more honest humans who lack senses of humor, such as interviewers, whom it should be noted are generally not funny, unless they are reading this and considering interviewing me, in which case, they are hilarious.

It made one think.

Is that what had made me funny all these years?

Was I sad inside? I did not feel sad inside.

Sure, I'd suffered seasons of melancholy for much of my life and it had only gotten worse with age, such that I continued to harbor dangerous and lingering thoughts of my own death, given the difficulty with certain paragraphs and the general dread felt almost daily for most of my adult life that I was squandering my best and most vigorous years on an enterprise that, at best, would make me eccentric and poor and, at worst, would destroy my most meaningful relationships and cast me among the great selfish bastards of human history. But that's not what they meant, was it? They meant some other type of sadness, surely?

No!

I was not sad!

I was a very strong man!

I only cried, like, every few days, while listening to Story-Corps on NPR.

And yet, I found myself remembering how, in my junior year of high school, one February afternoon, Mark and I saw Bill Murray in *Groundhog Day*, and it didn't just make us laugh: It shot us into the atmosphere of our own souls. We drove around in the late pink of a dying day, the trees still naked,

and couldn't contain our joy. The film seemed a kind of bright transparency, laid over our lives, bland and featureless, to show us what color the world really had in it.

"I can't go home now," Mark said.

We rolled the windows down, played Radiohead and Zeppelin too loud, drove across two counties, spillways, levees. Mark did donuts in an unfinished cul-de-sac while I hung out the window like somebody's dog, letting the winter air fill me. The comedy opened up veins of feeling, touching a nameless noun living way down there. It would be many years before I permitted myself to realize that this film depicts the hero's suicide many times over.

It's funny what you remember.

For most of my life since then, I'd have told you this was not a sad film, and it's not, but then when you look at the story, really look at it, all you see is sadness, a story soaked in sorrow, the saddest, most pathetic folks just trying to make it to another day, the melancholy gathered and concentrated into the bright white light of laughter.

In graduate school at the University of Mississippi, I took a class called Voice and Movement for Actors. We were told to wear comfortable clothes. We did a lot of stretching and grunting. The teacher wanted us all behaving like hurt animals. Everybody rolled around like grieving water buffaloes, writhing on the floor getting very emotional.

"Yes, good, find your trauma," the professor said, a tall, thin, brutal woman.

Our trauma lives in our bodies, she explained.

I got on the floor, breathed, moaned, looked for my trauma, whatever the hell that meant, trying not to sound too sexual about it. One woman sounded like Jabba the Hutt having an orgasm dream. I kept my eyes closed. Sometimes the students wept or laughed in a scary way.

"Access and release your trauma through the breath," the professor said.

I looked around in my body for trauma and located only a partially digested enchilada, which was not yet ready to be released. Whenever students had breakthroughs, everyone sat cross-legged and shared. It was not unlike church youth group.

"I was sexually abused," one said.

"My mom is still in jail," another said, weeping.

"I ran over a cat when I was sixteen."

They hugged, wept.

This class. This class was my trauma.

"I had impetigo once, in high school," I said. "On picture day."

Everybody hugged me. It felt weird.

Ever since, I'd believed it was all hokum, this belief that great art demanded great suffering. No way. Sure, great suffering could birth great art, but so could other stuff, like a long weekend in a sweat lodge, or a partially digested enchilada.

And yet, after seven years of suffering the trauma of my own dream, all these thoughts of trauma and where comedy comes from were doing something inside me. I felt a little baby enchilada kicking inside me.

I began making many lists of everything that ever made me sad, including my giant ears and most other parts on my body, including my giant head, which can appear quite beautiful in

certain light, such as complete darkness. And now I was shining a light on everything, all the things. I made a list of what I hated about myself, and my people, and my life.

I winced a lot making this list. It felt so indulgent. Who cared about all this raw pain and suffering? All my life, I'd been putting the pain where it belonged, down in the tornado shelter, in the blackness, where nobody had to look at it. And now I was down in the shelter and was shocked at how full it was of human agony, great seething ghouls of the everyday torment that everyone knows, embarrassment, inadequacy, physical deformity, gassy bowels, hating neckties, my failure to take my wife on even one nice vacation, the emotional Great Wall of China between my father and me, the monster of pride in my heart that refused to admit anything was bad, ever.

It all just came out. I may have wept.

I had found my trauma.

I decided: Funny people really *are* sad inside, because everybody is sad inside, and so I formed a new theory of comedy, which I called The Sad People Everywhere All the Time Theory of Comedy, which states that most of the world ignores the sadness with anger or pills or fun parties or Netflix or lots and lots of yoga or Internet trolling, while others are burdened and privileged to grapple with sadness obliquely via music or photography or other forms of art, while a very small tribe of courageous human souls grapple with this universal sadness head on, known as "Fans of the Cure" and "Lutherans."

So much of daily life comprises mostly of harmless posturing. We must pretend to be more amazing than we are, in job interviews, on first dates, because you can't go through life shaking the rancid meat of your soul at every human you encounter, it'd be miserable, so we spend much of our day lying. We even lie about how much we lie. Art undoes all that. Art is an exercise in not lying, for once.

Maybe comedians instinctively know what theologians and existentialist philosophers also know, which is how we are all hideous freaks, inside or out or both, and how in the dark darkness of our dark hearts we are all to some degree very shitty people? We think shitty thoughts, want shitty things, and commit acts of brazen shittiness, in secret and sometimes even in public, during karaoke. The most honest pastors and rabbis and teachers seem pretty keen on reckoning with the shittiness, and so does the comedian.

Thinking these shitty thoughts, I began to write.

Mostly what I wrote about was the shit in me, and the shit I thought and felt and saw, and the shit I wanted to do or say and could not, for shitty people who say their shitty thoughts out loud end up getting shot by other shitty people. It dawned on me like a slow moonrise, how the difference between the comedian and the tragedian are whisper thin. One has a gift for punch lines, the other for death scenes, but they tell the same tale: No matter how great we hope to be, left to our own devices, we cannot build a tower to heaven. The tower always falls, no matter who builds it, the king or the fool.

Shit runs through every human heart, which is why the Bible is one of the greatest comedy books of all time, acknowledging as it does that we are all holy shit, little atomies of

holiness running through the shitty architecture of every human creature. Laughter is one of the things that can light up the atomies. Laughter talks true. Sets you free.

It can set your people free, too, because every tribe has its sacred temple, which the funny writer must plunder. What you have to do is go into each tribe's holy of holies and see what they're protecting as inviolable. You need to violate it because that which we declare inviolable becomes a god. You've got to slip in past the veil and snatch away the gilded calf and smelt it down into what you hope is comedy gold.

These revelations accreted in layers of silt over days, months, years of reading and trying to find the door to my own idol-hoarding heart. Writing one funny line in a long non-funny story would give me a flashing glimpse into the profane holy of holies inside me, and the more I wrote, the more I could sustain this glimpse into a gaze. And then one day, it finally clicked.

It came like a thief in the night, early of a November morning, a Saturday, after my wife had been pregnant for thirty years. The third vagina was due in December. Lauren slept fitfully in those final days, a wounded monk seal. I lolled onto my back, also not sleeping, and got up.

"What are you doing?" she said.

"I have an idea," I said.

I sat down at the kitchen table. It was three o'clock.

One of the monsters in my tornado shelter was this: The generalized anxiety I'd felt since childhood about being from a place that almost everybody in the world, it seemed,

mocked—the South, in general. Mississippi, specifically. There was much to hate about Mississippi, and still is, and much to love. I'd been embarrassed, unconsciously, of this biographical fact, especially the deeper I got into the credentialed thickets of higher education. I wanted to write about this, and on that morning, it burst from me like water from the rock at Horeb.

It was the first thing I wrote that would end up in a book.

I won't quote those paragraphs here, because that seems, I don't know, weird. You had to be there. And you can be there, if you turn to pages sixteen and seventeen of that other book. What I'll say is this: These lines felt exactly like what I had been trying to create for the entirety of my adult life. This was going to be a chapter in my book, I decided. No, more than that: This *was* the book—the tone, themes, everything was in the DNA of this passage. I still didn't know what the book was about, exactly, but I knew the answer was somewhere in these one hundred words.

"Eff me!" I said, as I wrote. It was good, and it's weird, knowing it's good, after spending the whole of your life knowing it's bad.

I wrote and wrote and didn't look up, and when it was five thirty, I dressed quietly and drove to the coffee shop and wrote some more. This was the happy and elusive Zone, when you lose time, in which materializes the flow, during which you do not care, the ecstatic state in which the love of God emanates from your atoms through your bones and out into the atmosphere, such that you now hover several feet above the floor and speak to shrubbery and run red lights without even pretending to notice, as you float like a Mayflower through the

seas of traffic, smiling, eyes shining, as cars collide and explode in your happy wake. This is the Zone.

Everybody who loves what they do for a living, athletes and teachers and firefighters, cherish and pursue this elusive state, in which their command of the art of their work is matched and magnified by their joy in it, to know they are doing and making a beautiful and useful thing. The world falls away, and with it every human frailty. In this Zone, the pedestrian slings and arrows that puncture the day, the ache and pinch of Sunday shoes and bank statements dissolve into nothing and the skies open and one flies into the sun. The quark shines! The face of the Creator is in these moments, when one sees, finally, yes: This is what you were made for. This is why you were brought here, to this planet, from the great unknowable darkness beyond. This is the light you know how to bring.

I wrote and wrote and wrote all morning, laughing madly. I could have been naked and would not have cared or known. A gang of badgers could have been sent to mangle my legs and ankles, and I wouldn't have noticed. A platoon of Confederate re-enactors could have pierced my body with minié balls and bayonets and removed both arms with bone saws and I wouldn't have blinked, would have continued typing with my teeth and lips, bleeding out, barking into the air, howling with love.

"Yes, Jesus, thank you, Jesus Lord," I said, as I re-read what I wrote.

I had done it. I had melted my own brain.

At lunch, I drove home thirty feet off the ground and ran into the house like I'd discovered nuclear fission, which I had. There stood Lauren folding laundry and our two daughters watching *Daniel Tiger*.

"I have to read you something," I said.

"Now?"

"Sit down," I said.

I started reading. She laughed a little, folding all the tiny panties that littered our home.

I kept reading. More laughing.

"I'm going to wet my pants," she said.

But this glory train could not stop. She was laughing, dying, peeing all over herself because this is what happens when you push people out of your body, your bladder no longer works right, whole regions of the body resign.

The girls started laughing, too, because they were confused. They crawled on their mother, laughing, everyone peeing all over themselves and dying and laughing.

I had found my voice. I had found my power.

That night, I sat on the porch with a beer and stared into and through the Savannah dark to a future I could now see.

Lauren came outside. It was cool.

"You okay?" she said.

"I could be no better than I am right now," I said.

"It was very funny," she said, getting tickled all over again. She kissed the top part of my head, and then touched me there, where the kiss was, and went back inside. I guess she knew, too: Everything was about to change. In a way, everything already had.

Three weeks later, she gave birth to our third daughter, Effbomb.

# CHAPTER 9

*I don't like country music, but I don't mean to denigrate
those who do. And for the people who like country music,
denigrate means "put down."*
—BOB NEWHART

THE NEXT THREE YEARS WENT BY QUICKLY, COMPRISED OF A
more joyous writing and working. I lived with four
women, now ages two, four, six, and thirty-four, and soon
another wondrous woman would enter my life, a woman we
called Debbie. Debbie was going to be my literary agent. I will
now tell you how to capture one of these magical nymphs.

A few days after I wrote the first story that made my wife
laugh, really laugh, everything changed: I'd found my voice,
my mojo, my juju, and I knew it. The juju was delicate and
larval, but there it was. I found a way to sound on paper the
way I sounded in my head. I edited the story and liked it more
and more with every pass. By draft ten, it was even funnier. By
draft twenty, the essay glowed like the One Ring.

I showed it to Mark.

"This is it," he said. "This one does not suck."

Now was the time to take this gem, mined in the landscape of my inner life, and try and sell it to real people for legal tender. Every dreamer must make this leap, from make-believe playground to Earth, with all its traffic laws and humidity.

For me, what this meant was getting an editor to publish the story.

The way to do this is to have a best friend work at a magazine. This is the main reason most writers have best friends, I have learned, so that they can be certain somebody on the inside will ensure somebody more important will at least read the story they wrote, shortly before rejecting it, which they almost always do.

But I had no friends at magazines.

A few days after I finished the first good story I'd ever written, I learned that the editor of the *Oxford American*, the brilliant and churlish Marc Smirnoff, would soon be in town for the Savannah Book Festival. What I would do, I decided, is create a public spectacle. If I had no friends at magazines, I could at least make some enemies.

I would ambush him.

"You're going to do what?" Lauren said, later, when I told her my plan.

"Accost him."

"Attack him?" she said.

"Engage him," I said.

"You're going to get arrested," she said.

I told Mark.

"Holy shit," he said. "This is awesome. You're going to get arrested."

The editor Marc Smirnoff is straight out of Dostoevsky, tall and brash and garrulous, looking like the smartest and most tortured member of a basketball team from the former Communist Bloc. When his talk began, he didn't seem high, but also, he seemed a little high. Not on drugs, but on something. Irreverence? Drugs? It was thrilling, in a way, to know that my dream had thrust me into a world of such public strangeness.

This man was from a different age. Male magazine editors these days, they're polished and beautiful in their navy suits and monk straps and are easily mistaken for hotel concierges and sommeliers, but not Smirnoff, with his running shoes and two-dollar haircut and skeptical eyes. He wore a blazer like a man who'd forgotten to bring one to the restaurant, too bothered with remaking the American literary landscape to worry about ironing his shirts. He seemed simultaneously exhausted and charged with energy, like a man who'd just ridden a bus across three states.

Like Hunter Thompson, he often wore sunglasses indoors, peeling them off dramatically when it was time to make a point. I'd heard stories, how he'd sit in the back at a conference and stand up and challenge a speaker with his sunglasses used for punctuation marks, waving them threateningly. Sadly, literary types never threaten people with eyewear anymore.

I sat there with my story in an envelope, laying across my lap, listening. Smirnoff railed and joked, raving about the flaccidity of American writing and his general disappointment in every magazine that was not his. He was offensive in the best way, jovially so, answering to a higher ethic beyond tepid

politeness, cut from an impressive bolt of H. L. Mencken cloth, the edges raw. I loved him instantly. The world needed editors like this, with their edges and difficult truths. An editor like that would not lie to you about how good your work wasn't.

"I guess we have to take questions now," Smirnoff said, at the end.

A few hands went up. I could feel the burning bush inside me turn icy and cold. The world stopped breathing. I raised my hand.

"You," he said, pointing.

The key to shamelessness is knowing exactly when to expose it to the world. If you do it at the right time, you catch people unaware and they might actually be impressed by your sheer naked vulnerability. Do it at the wrong time, and they'll point and laugh for the same reason.

"You should read this," I said, holding up the envelope like it held important grassy knoll evidence.

"What is that?"

"A story I wrote."

The audience, full of literary strivers, gasped. Some covered their mouths, fearing a great public embarrassment was underway. The room got officially weird.

"Is your story any good?" he said, daring me while everybody stared.

"It made my wife have to change her panties," I said.

The moderator called security. Suddenly, I very much seemed like the kind of nice white man who maybe has a gun.

I'd like to tell you what happened next, but my brain got knocked off the station. All I heard was static. When it was over, I staggered to the stage, dizzy with the ebb of adrenaline.

"My life is in your hands," I said, handing the story to him. He smiled, said he'd put it on the pile with the thousand other stories-by-nobodies waiting to be read. I thanked him in a very I-have-a-family-not-a-gun way, and disappeared through a side door.

A week later: Nothing.

A month, two months: Nothing.

I would never again hear from this man.

And then it came, an email.

The story, he said, was terrible. Way too long. Too many exclamation points. But some paragraphs weren't terrible.

"We'll take it," he said.

They offered me $400 for the non-terrible paragraphs, which I negotiated up to $450, to show that I, too, could be a difficult jackass. After writing for nearly a decade, I'd earned enough money with my writing to fly my wife to Bermuda, although she'd have to fly alone, and she'd be without lodgings or food when she arrived. No matter. This wasn't about a little money. This was about a lot of money. The dream was near. I could smell it.

⸻

The writing ideas came in great surging waves now, and I made the rather risky decision to move back into the class-room, teaching English and writing at SCAD, which meant a not-insignificant cut in pay, about which Lauren was very excited.

"Time," I said. "Time is what we need."

"Money is what we need."

"Summers are what we need."

"Groceries are what we need."

On holidays, I wrote.

On vacations, I wrote.

In the bath, I wrote.

On airplanes, on the way to writing conferences, I wrote.

At writing conferences, instead of attending important "networking" events, I wrote.

In the audience during panel discussions at writing conferences, I wrote.

In summers, I wrote for twelve to fourteen hours a day.

In staff meetings, in church, in line, at the movies, I took vigorous notes, for the next day's writing. I removed unnecessary information from my brain in bulk and moved it to cold storage, such as where food items may be acquired or what bills are.

I found literary agents online, sent them my stories.

*Be my agent?* I said, attaching a copy of the one story in *Oxford American*, which I felt made me seem famous and beautiful.

*It's very humorous*, they said, emailing back, *but I'm afraid it's not for us.*

And I said, *Don't be afraid.*

Soon, I found myself at a conference at the University of Mississippi, where I read a story for a large audience, and they laughed, the way I had always dreamt of making people laugh. Immediately upon my reading the last line, the audience applauded vigorously, and I felt that perhaps I could go ahead and die, this was it, I had done it, melted brains in my homeland, and a man ran up to the lectern leading a woman by the arm.

"Harrison, I'm Bob," said Bob. Later, I would learn that this man was Bob Guccione Jr., founder of *SPIN* magazine, son of a notorious pornographer, and also the kindest man in the magazine industry.

"Hi, Bob!" I said, still at the lectern, gathering my notes.

"This is Debbie," Bob said, introducing me to a tall, smiling woman. "Debbie's going to be your agent."

"She is?"

"She is."

Debbie handed me a card.

A week later, Debbie was my agent.

———

The way it happened is this: The next day, after we'd met at the reading, Debbie and I had lunch. We ate chicken salad, and she worked her Jedi powers on me, like good agents do.

"What are you writing?" she said.

"A collection of essays," I said.

"Why essays?"

"Because it's an American tradition to write a book nobody will ever read," I said.

She looked disappointed. She was fearless about showing me her disappointment. All the best mentors are.

"Your book is not a collection," she said.

"It's not?"

"No."

"Why?"

"Nobody reads them."

"I read them."

"Do you?"

"No."

———

Debbie read a few more of my stories and signed me. I was going to be a fixer-upper.

"Let's talk about your book, which is not a collection," she said, via telephone.

"So what's my non-collection about?" I asked, curious. She seemed to know everything.

"Your father," she said.

And I was like, "LOL."

## WHAT THE TEN BEST STORIES IN MY COMPUTER WERE ABOUT

1. My father
2. My father
3. My father
4. My father
5. My father
6. My father
7. A prayer breakfast
8. A studious armadillo
9. An old man who wears no pants
10. My father

I ignored this list and instead focused my energies on telling everyone about Debbie, because everybody wanted to know.

People asked, "Oh, you have an agent?"

I said, "Yes, why do you ask?"

They said, "Because you just brought it up."

My wife would ask, "What's the weather going to be like today?"

And I said, "I don't know. We should ask my agent."

At restaurants, servers would ask, "Would you like to hear the specials?"

And I said, "I bet my agent would love to hear the specials. We should call her."

I told everybody about Debbie, friends, enemies, strangers, Mark. I told them how she'd once been a book editor and in fact had discovered Tom Clancy, when she bought his first novel, a little book called *The Hunt for Red October*, and how Tom went on to publish seventeen novels, which would go on to sell 100 million copies, many of which would be turned into films, which helped monetize his very name into a global brand of retributive American justice through superior violence and likable characters, which turned into first-person shooter games and board games and immersive theme park experiences, which turned into his being able to afford buying a $16 million apartment and a stake in the Baltimore Orioles. The implication here, of course, is that I was very likely the next Tom Clancy, just based on feedback from many people, all of whom were my mother.

I didn't necessarily want to own a baseball team, but I did want to pay off my school loans, which we'd been attacking with nearly $1,000 monthly payments for what seemed like eternity, while it just stood there hovering before us, stolid and cold, a Typhoon-class submarine.

Also, my wife wanted those extra toilets I'd promised her. I'd almost run roughshod over our marriage and my family and everything that meant anything in pursuit of this dream, and it was time to make it rain toilets. We needed a bigger house, she felt. I ran the numbers and noted that we had approximately one uterus per 250 square feet.

———

What I didn't tell people about Debbie is that she, like all the dream makers, made me do hateful things, such as question everything about my work. I did a lot of reflecting and praying in those days. These were new and more specific prayers.

I prayed, *Should I write a funny novel about college football, God?* And God was like, *Boring.*

I asked, *Should I finish the story about the armadillo?*

God was like, *I just sharted.*

So I asked Mark.

"The stories about your dad are so good," he said. "Didn't you say Debbie loves them?"

"What about the armadillo one?" I said.

"It doesn't seem relatable."

"Armadillos are very relatable."

I could hear Debbie over my shoulder at every moment of the day. There they were—the good angel and the bad angel and a tiny little Debbie, telling me that my book was about my father, which was the stupidest thing I'd ever heard. I wrote down a list of themes in my least terrible work.

Manhood

Fatherhood

Masculinity
Virility
Men
Mannishness
Fathers
Dads
Husbands
Sons
Men
Sons
Armadillos

Hmm. Curious. This armadillo would not relent. Perhaps I should write about this feisty little armored mammal? Pop was feisty, too, and was appearing more and more in everything I wrote, manifest and hovering, the ghost of Hamlet's father. Everywhere I looked, there he was.

"See?" the tiny little angel Debbie said.

I sucked it up and decided to finish the armadillo story, and another unicorn story, and a 25,000 word essay about a pair of shoes I once cherished.

I simply could not write about Pop. No. Those were wicked and tangled thickets I dared not enter. Instead, I reread my brilliant armadillo novella, which was about a young armadillo who did not want to be an armadillo and so ran away. He hated everything about being an armadillo, the chicken feet, the ridiculous shell, the distant relation to sloths.

And then I was like, *My God, this armadillo is me.*

And God was like, *You are literally the world's dumbest man.*

Okay. So. It would be a book about my father and me, called *The World's Dumbest Man.*

No, not that. But close.

———

Next, Debbie made me write a proposal, which is a very long brochure for a book that doesn't even exist, where you have to say ridiculous things like: Not since [name of really successful book from a few years ago that everybody remembers and which was made into a film] has a [name of genre] so [adverb + verb] the experience of [nominative phrase].

For example: Not since Alan Jackson's *Book of Fancy Hatbands* has a memoir so fully explored the experience of having a mustache.

That summer, I sat down and wrote a brochure for an imaginary book about my father, which was turning out in my head to feel like a book about the South, which was a little worrying. Write a funny book about the South and the next thing you know they're making you do a ribbon cutting at a new Cracker Barrel and inviting you to speak at the Dukes of Hazzard Museum. I did not want to be a "southern writer," the same way many gay writers do not wish to be "gay writers" and many Christian writers do not wish to be "Christian writers," whatever that is, God forbid.

I wanted to be an American writer, free to write about my father, sure, but also to write about marmots or Jupiter or the history of buttons. Was Mark Twain expected to represent all people with flourishing white hair?

And yet, the South was my home, for better, for worse. I'd

already written one story about the South, and several, actually, maybe all of them. What the hell.

"I am not a southern writer," I said to Katherine, an artist friend who sometimes did illustrations to go with my stories.

And she was like, "Why are you such an idiot?"

The good news was, there is much fine literature to draw from in the American South, many inspiring works, like "She Thinks My Tractor's Sexy" by the esteemed agrarian poet, Kenneth Chesney. I made a vow: Nobody in my book would carry baskets full of chicken or cold jugs of sweet tea. There would be no sexy tractors. Instead, I'd write about the venereal diseases the children give one another after driving their non-sexy tractors, or the morbid obesity and the tooth decay caused by the chicken and the tea.

## WHAT THE SOUTH MADE ME THINK OF

- Blood
- Love
- Meat
- Hot
- Sex
- God
- Sport
- Racism
- Violence
- Misogyny
- Wealth

- Woods
- Poverty
- History
- Slavery
- Air conditioning
- Oppression
- Depression
- Secession
- Biscuits

Biscuits are funny. But racism? Racism is a big scary thing. How does a white boy from Mississippi write about his racist father in a loving and funny way that is honest and doesn't forever poison the well of their love?

This is where the humor comes in handy. It's not mere icing, a sweet little thing you add around the edges to make a story more fun to eat. It's also a way of knowing, a heuristic to get you into the side door of your theme. When everybody else charges headlong at free market economics, the two-state solution, when fertilized embryos become human, or why white southerners are so nice and also very racist, the funny writer goes in the back door, totally unprotected and unguarded, to steal the golden calf.

While finishing the proposal, Debbie also made me commit additional acts of perversion, such as sending letters to famous people asking for blurbs to put in the proposal. I felt like a medical fundraiser all over again, asking strangers to give me things that I might not deserve. But I sucked it up. My shame and fear were being burned away in layers. I wrote real letters

and mailed them, including handwritten notes by my precious daughters, in crayon, shamelessly pleading, to:

Famous Funny Nonfiction Writer Who Shall Not Be Named (no response)

Famous Funny Fiction Writer Who Shall Not Be Named (no response)

Famous Funny Film Critic Who Shall Not Be Named (no response)

Famous Comedian Who Shall Not Be Named (no response)

David Sedaris (Who replied with a typed letter explaining that he can't do it, sorry, he's been asked this twice a day for the last one hundred years and can only do it for friends now and also why in the hell isn't my agent doing this for me and here's his editor's name at Little, Brown and Company, if I want to email her and say he sent me.)

George Saunders (Who replied with a much-delayed email saying sorry he took so long but no he can't do it, for the same reasons Sedaris wouldn't, but really just keep writing and it will happen, for he believes in me, even though he doesn't know me.)

Ira Glass (Who replied with a handwritten postcard from his intern saying no for the same reasons as above but including a signed headshot of Ira for my daughters.)

Mike Birbiglia (Whose brother and cowriter, Joe, replied with an actually really kind and thoughtful blurb.)

Bob Guccione Jr., founder of *SPIN* and *Wonderlust* (Who sent an amazing blurb because we met that one time and he is very kind.)

Curtis Wilke, author of *The Fall of the House of Zeus* (Who sent an amazing blurb because Debbie asked him to because she's his agent, too.)

Beth Ann Fennelly, author of *Heating and Cooling* (Who sent an amazing blurb because she heard me read once and seems more angel than human.)

Tom Franklin, author of *Crooked Letter, Crooked Letter* (Who sent an amazing blurb because he's married to Beth Ann and he sounds like my uncles and seems like he would pick you up at the train station at three o'clock in the morning, even if he hadn't been drinking.)

Neil White, author of *In the Sanctuary of Outcasts* (Who sent an amazing blurb because he also wrote a memoir about the South and kept saying I had amazing talent, and having people in my life who tell me I'm amazing is very important to me.)

There was one other, a famous funny writer I won't name by name, who sent me an angry email telling me I possessed the writing skill of a bucket of chum because I wrote things like "the writing skill of a bucket of chum." This unnamed super-famous writer then commenced to diagram several of my chum-like sentences for me right there in the body of the email and just got really angry at me for some reason. Then the next day he sent another email in which he praised my writing and sounded like maybe he'd gotten back on his meds. Very

odd. Years later, I met this famous man, at an event where we were the two featured writers. The subject of my blurb request did not come up. I bought him a drink. He seemed to be on his meds.

It feels weird, asking people to say nice things about you so you can tell others what they said, like airbrushing compliments you've received on a T-shirt and then wearing that shirt to a job interview, which is actually not a bad idea.

If I had been asked to supplicate myself for blurbs a few years ago, I would have laughed, because back then, I had dignity. But I no longer had dignity. I had been robbed of this quality by debt, and by my daughters. If Debbie had told me that I could get a book deal by removing my pants and riding a unicycle down the cereal aisle, my only question would've been: Should we film it for the website?

It took a total of three months to write the book proposal, which was 114 pages and 36,795 words long, longer than *The Old Man and the Sea*. I was the old man. My book was the fish. My wife and daughters were the boat. God was the water. Debbie was the hook.

Summer was over, fall happened. I taught my classes and pretended like my life was not about to change. Tom Clancy died that October. Debbie was on CNN, discussing him. It was thrilling, seeing my agent on television.

"That is my agent," I said to the children. "There she is."

We recorded her on TV and watched it over and over again like the moon landing. That's what it felt like. We had landed on the moon, or were about to.

A few days after Thanksgiving, Debbie called.

"We've got an offer," she said.

# CHAPTER 10

———

*There are known knowns. These are things we know that we know. There are known unknowns. That is to say, there are things that we know we don't know. But there are also unknown unknowns. There are things we don't know we don't know.*

—SECRETARY OF DEFENSE DONALD RUMSFELD

ONE KNOWN KNOWN IS THIS: IN 1984, TOM CLANCY SOLD *The Hunt for Red October* to the Naval Institute Press for $5,000. Another: In 1987, Donald Trump sold *The Art of the Deal* to Random House for $500,000, half of which he paid somebody else to write it for him. This is not uncommon, for celebrities to pay others to write their books for them, certain celebrities lacking the requisite tools to write their own books, such as time, or souls.

Both aforementioned books sold in the millions, which means both books made tens of millions. Most books by a major publisher sell an average of nobody knows how many

copies. A thousand? Ten thousand? If your book sells in the millions, you will never have a car that doesn't smell new, ever again, if that's what you're into.

In the 1990s, David Sedaris signed a two-book deal with Little, Brown and Company in "the low five figures," which could mean $10,000 or $40,000 or some other number. His third book, *Naked* (1997), sold in "the low seven figures," which probably means one-point-something-million dollars. Two, maybe?

More than a decade later, Random House paid Lena Dunham $3.7 million for *Not That Kind of Girl*, and then paid Aziz Ansari $3.7 million for *Modern Romance*. Simon & Schuster paid Hillary Clinton $8 million for *Living History* and Knopf paid Pope John Paul II $8.75 million for *Crossing the Threshold of Hope*. These are all famous people, it should be noted, and everybody buys books by famous people, especially if the famous people write the book themselves, because these famous people, in addition to souls, have what's called a "platform" from which to say things, while most of us are down with the groundlings. The Pope could write a diet book called *Running Up Golgotha: Behold the Body of a Lowly Carpenter in 40 Days and Nights* and it would sell in the millions, easy, because a famous human wrote it.

When Debbie called to tell me about the offer, she did not say the word *million*. I know; I listened super hard for it. She was calling about a "pre-emptive offer," she said, which meant I had twenty-four hours to accept or decline it.

"You can't breathe a word of this," she said. "It's got to be confidential."

"Like eBay," I said.

"No. Not at all like eBay."

"How much?" I said, bracing.

"A hundred thousand," she said. "You have twenty-four hours to accept or decline."

Did she just say $100,000?

"Say it again," I said.

"A hundred thousand dollars," she said.

Galaxies reeled inside me.

This is a lot of money to anyone, or at least it was to me, whose father was born with no indoor plumbing and rode a mule to town, a real one, not imaginary. The sound of the number, *hundred thousand*, riffled through my heart like arcade tokens. I wanted to share the sound of these words with my wife, but worried. Lauren had grown up in want, too, her father as vexed as mine, a childhood of evictions and hurried cross-town moves in borrowed cars to another new rental. This was not just money. This was the first paragraph of a new chapter in a new story. The words *hundred* and *thousand* might make her eyes go spiral. She might demand I take it. But I wanted more. No, I would not tell Lauren.

I told Lauren.

"Holy crap," she said.

"I know," I said.

She was right. This crap was holy. Her eyes went spiral.

In one six-figure number, every ridiculous and impossible thing we'd done together cohered into this vision of paradise. We held each other for so long it upset the children.

That night, we made sweet love. Actually, no. We got out the calculator and decided what we could pay off first.

"I don't think we should take it," I said. "We can get more."

"Are you sure?"

"No."

"We're going to be rich," Lauren said.

"What are you thinking?" I said.

"Bathrooms," she said. "A stove with a real vent."

"A vent would be nice."

"A vent would change my life," she said, getting a little weepy.

"Vents in every toilet," I said. "And college for the girls."

"Vents and college. And toilets," she said.

"Goddang it, I love you," I said.

Should we hold out for more? How very odd and thrilling, finally to have the privilege of being the one to say *no*. You hear a lot these days about the power of yes, and yes will get you far. But be not fooled by the happy yessing of your office retreat's spiritual leaders. *Yes* is the air in the carburetor that starts the engine of your dreaming, but *no* is your choke. *No* is what pays the mortgage every month, what keeps the budget in order, what keeps the mule going straight. The right *no* at the right time takes just as much courage and imagination as a *yes*.

The risk, of course, is that the next offer would be far lower than $100,000. It came down to who was more desperate—us, to get money, or them, to get my book. If they perceived my potential refusal as overly haughty, they might decide I was too big for my britches and lower the offer, to show me who really had the biggest melon at this county fair.

When does confidence in one's talent bleed into vainglory? So much of art is submission—to contests, juries, magazines, editors, self, truth, the volatility of the imagination and the everlasting duress of the human condition and the animating spirit of the universe. But isn't it also true that so much of art is an act of ridiculous bravado?

Look at me! Look what I made! Look what I can do! Be dazzled by my technique! Be enchanted by this beauty I have manifested for your delight! Be illuminated by these truths which are not self-evident to you but perhaps are to me! Tickets can be purchased at the door! No flash photography, please!

These two vexing poles of art—the meek and the haughty— are found in all creative dreaming. The former is required to make art; the latter to sell it. Part of me wanted to say, *Yes, please, let us take the offer and also volunteer to wash the feet and cars of everyone at HarperCollins, should they desire it, yes, please, thank you.*

The other part of me wanted more money.

Lauren and I sat down. We prayed about it, which we almost never do, honestly, because she always starts laughing, and because I always end up saying something inappropriate mid-prayer, like, "Jesus, take the wheel."

But not this time.

"Make us wiser than we are," I prayed. "Give us wisdom, so that we may see the right fruits of our labor, so that we may have vents for our bathroom facilities and stoves."

And I said, "Amen," and looked at my beautiful, funny wife, this woman who had hitched her harness to the mule of a dream that had dragged us into sloughs of shit and want.

"Do you trust me?" I said.

"I do," she said.

I called Debbie.

"We'll pass," I said.

We gave it up just like that—$100,000.

"What did we just do?" Lauren said. "Oh, no."

And I said, "Jesus, take the wheel."

———

"Your life is about to change," an editor from Simon & Schuster said.

We spoke on the phone, while I was in my truck, in a parking lot, after class.

He told me what books he'd edited, and I knew them, had heard the great goddess herself, Terry Gross, interviewing the authors of these books.

I spoke to editor after editor of every major publishing house, and minor ones, also. It was amazing, I won't lie. When you've spent the last decade working up the courage to tell yourself you're amazing, even when it seems that the world is going to the prom without you, and then one day people who can see One World Trade Center from their offices call and say you're amazing and ask if you would be their date to the prom, they got you a corsage and everything, it's hard to process. I grew several inches taller that week.

"Everybody loves the book," Debbie said.

"I haven't even written it yet."

"I know, it's amazing," she said.

"The humor!" editors said.

"The story!" they said.

"The relationships!" they said.

"*The World's Largest Man*," they said, "Great title. Just perfect!"

"Slap me," I said to Lauren.

She slapped me.

Debbie came back with news: A dozen publishers would be bidding on the book. A dozen. I could die. I did die. I called Mark.

"What the fuck," he said.

"I know," I said.

"What the fucking fuck."

"I know."

The auction was set for a Thursday.

I flew down to New Orleans to do some writing workshops for high school students, and Mark used his endless supply of free plane tickets to join me and sprawl across the hotel room. He wanted to be there when it happened.

Debbie called.

"It is finished," she said.

She told me the number.

I rolled off the bed.

Mark fell out of his chair.

I called Lauren, who fell off the back of the couch.

I called my parents.

"Who bought it?" Mom said.

"HarperCollins," I said. They had been the first to offer, and the last.

"Is that a good one?" she said.

I tried to explain that my book had just been purchased by a company who also published Gabriel García Márquez, C. S. Lewis, Annie Dillard, Richard Ford, Dostoevsky, and *Hammer of the Gods: The Led Zeppelin Saga*.

*To Kill a* Mothereffing *Mockingbird.*

I tried to explain that HarperCollins was the publisher of *Uncle Tom's Cabin*, the most popular book of the nineteenth century, a book that started a war, according to President Lincoln. Would my book start a war? Fingers crossed!

"Well, how much did you get?" Pop said.

There was so much I wanted to tell him, and I didn't know how. I would have to tell him these things in my book, which I now had to write. He would find out what I really thought and felt about him, and us, and everything else that mattered.

We would have to talk it out. That was fine. I was ready.

I'd done it. I'd sold a book for more money than my father had ever imagined any of us might see, this side of a drug-related felony.

Should I tell Pop how much they were paying me? I'd tell him. I told him.

"Oh," Mom said. "Oh!"

"Heck, son. That's a fine skill!"

And he laughed. He laughed wildly. We all did.

# CHAPTER 11

*They, no matter what the motivating force—death, love or God—made jokes.*
—NATHANAEL WEST, *Miss Lonelyhearts*

BACK IN SAVANNAH, NOT LONG AFTER WE GOT NEWS OF THE book deal, while carrying a sack of groceries down a sidewalk, my father died. I cried for three months. I looked at my book contract and saw how much money they were paying me and cried even more. This moment—when I saw with my own eyes, on a sheet of paper, how much someone was going to pay me for creative services rendered—was the closest I had ever come to that impossible twinkling juncture in space-time in which the dream potentiates from abstracted fantasia to incarnate life-reality. For educational purposes, I will tell you how much they paid me, because it seems silly not to—$305,000. I wanted my father to see the check, to hold it, but he would never hold it.

It's not a lot of money, if you're used to money, if your mother's a surgeon or your father owns many luxurious properties, but if you're me, then this money is a boon of the mythic kind, granting the powers to transport you from one place in life to a whole other. It means your children will have a qualitatively more abundant reality than yours, if you can put the money to work. If you can make good on the promises the money was meant to seal.

We had no generational wealth, is what I mean, neither Lauren nor me. Years earlier, her father had vanished like a David Lynch character, never to be heard from again, and her mother's long illness used up what money was left. When Pop died, after a lifetime of toil, the bourgeois mirage hanging there, just out of reach, he owed hundreds of thousands of dollars to Bank of America, with no house to show for it. Mom turned out to be the wealthy one.

"I never had reason to spend any of it," she said, in the days after Pop's death, as I studied her retirement savings, with relief.

"You'll be fine," I told her. "You'll live comfortably enough to get your eyebrows waxed whenever you want."

"I don't need much," she said. "Everything I need is gone."

Her grief would carry on, for years, an endless bolt of indigo stretching out as far as she could see. He had been her protector, and she had been his. What was left for her?

"Go finish your book," she said.

But how do you finish writing a funny book when its central figure has just flown to his mansion over the hilltop? It wasn't supposed to end like that.

"So this book is about us?" Mom asked.

"Yes."

"Who's the star of this book?" she asked. "Me?"

She still had her sense of humor, even in grief.

"Sharks," I said. "It's about sharks."

"And me?"

"Yes. You and sharks."

"Are you going to reveal all our family secrets?" she said.

"I'm going to tell everyone that you have no eyebrows."

But there was nothing in the book about her eyebrows, or about anything, for there was no book. Debbie had sold it on proposal, and the book was only half-finished. The hard part, the ending, lay hiding inside the chaos of grief. Debbie sent lilies for the funeral, but they felt like flowers to grieve the death of the dream. I had wrested my destiny from the angel of the Lord's monstrous terrifying hand and had come away with something I didn't want. Could I finish a hilarious and captivating book, even when sandbagged with mourning? It had been impossible enough to create the magic when everything was fine: Could I make the magic when everything was not?

"Don't worry about the book," Debbie said.

But I worried. It wasn't just a book: It was a declaration of love and meaning to and about everything that was important to me, my father, mother, wife, children. It's not like I'd been writing a science fantasy thriller, with robotic dragons and elf droids and topless witches. I was living inside this very real human comedy, and the story had now jumped the rails and was heading to Sad-ville with a full head of melancholy steam.

It was spring of 2014 now. I was thirty-eight years old, twenty years since my brain-melting vision. Had it been that long? I was now chair of liberal arts at the college and getting up earlier, staying up later, stretching every spare moment to finish the book. I started writing at home to help Lauren more with the children, who had begun defecating around the house in teams.

The children sometimes toddled in and found me weeping at my writing table. This was real weeping, funereal weeping. I was mourning something deep inside that had been hiding there for a long, long time.

"What's wrong, Daddy?" they said.

"Nothing," I said. "I'm just writing."

"Why are you crying?"

"It's just a very funny book."

The weird news about my grief is that it was now, or would soon be, absolutely public. This is what happens when the book you're writing is about the man you're now grieving, and everybody wanted to know about this book.

"Tell us!" they said.

"Wow!" they said.

"You're going to be famous!" they said.

"So, when's the book coming out?" they asked.

"When will the book be finished?" they asked.

"When's this thing going to be a bestseller?" they asked.

They were happy for us, obviously, but then I remembered that the book was about a dead man whom I'd long wanted to die, for reasons I was writing about in the book, and who

I now wished was alive. How do you smile, when all this is happening inside you?

"Aren't you excited?" people said.

"About?"

"Your book!" they say. "You must be very excited!"

Which felt like, *You don't look excited. Why aren't you excited?*

Excitement? No. Grief was the predominant tone of my heart, grief, and gratitude, and caution. Is a mother excited the baby's going to come out? Yes, yes, of course, so she can take a bath in a vat of gin. What will she say in the days before the baby comes out of her uterus? She will not say: *I am so excited.*

She will say: *God, get the thing outside of me, please, Jesus.*

I felt like a pregnant mother who'd just been told her baby girl was in fact, according to the sonogram, a buffalo. It was time to push the thing out, whatever it was.

———

What my friends and students really wanted to know was how much money I made, but I didn't tell them, because I have "class" and also because I did not really know, yet. When the first of my book advance checks arrived, I smelled it, a check for $65,000. The original check had been for $76,250, and after Debbie's share, the rest was mine.

The way a book deal usually works is, you get a few payments. A small book deal, say, $50,000, might be doled out in two payments, half when you sign the deal, half when you hand over the book to the publisher. A rare plump deal, say $2 million, might be paid out in six installments. Usually, it's three or four checks you get—one when you sign, one when you deliver the manuscript, another when the hardcover ap-

pears, and the last one a year after the book comes out, which you can use for therapy, because things didn't turn out quite like you thought they should.

Mine was parceled out by HarperCollins in four payments.

Twice a year, they send you a bill for exactly how much money your book has not made and thus how much you owe them from the money they paid you. If you don't earn back your advance, then you probably don't get a paperback and most definitely probably do not get a second book with anyone, anywhere, because there's this secret database, housed somewhere in a mountain in coal country, which records book sales for everyone in the industry to see, so said Debbie, who revealed all this to me slowly, over several months, because if she told me all at once I might have lost consciousness.

That summer, as I continued to write and weep daily, I took the first $65,000 check to the bank. This part lifted my spirits. My father had been at enmity with banks for most of his life, so it felt great going in with this piece of paper. I rode my bike, and walked in sweating through my T-shirt like a delivery boy with a sack of tacos.

"Can I help you?" the lady up front asked.

"I would like to open a savings account," I said, like a twelve-year-old.

I sat down and handed her the check.

"Excuse me," she said, stepping away.

Immediately, I was assaulted by kindness from no fewer than three male managers who swept me up out of my chair and into an office to discuss investment opportunities. I don't always feel like Jay-Z, but that day, I felt very much like Jay-Z that day.

"What sort of work are you in?" they asked, taking turns looking at the check.

This was my first experience of being perceived as wealthy, and what I learned was, everyone treats you like a victorious general, offering meat and drink. It was a feeling my father never experienced. He was built for it. At my age, he *looked* like a victorious general. But he never got pampered by bank managers. It would have suited my father, his swagger, the heft of him.

What had kept Pop from sitting in the chair in which I now sat, sweating and smiling? Why had I chosen to ride my bike here? Perhaps I'd wanted to surprise the bank. Pedigreed men had judged my father all his life, his way of talking, his hayseed logic. I wanted them to judge me, too, my bike, my gamey odor, the salty rings on my cap, so I could apologize for my appearance and then hand them the check and go all *Pretty Woman* on them.

—

I did not cause a scene. I just smiled quietly, thinking of Pop. I do not believe the dead look down on us from an observation deck in paradise. They've got plenty to do. At that very moment in space-time, I like to think that Pop was riding a large black rhino across an alien steppe, throwing spears at an abundance of meat.

In my shoes, Pop would've bought something useful with that money, like a Pershing tank, or a freshwater hydrofoil. But I was not Pop, and I'd learned all his lessons, even those he taught through failure, and the lesson was: Don't spend money you'll never see again, if you can.

I pedaled home from the bank, thinking about money. Was it possible I had escaped this demon that hounded my father? Might all my children and their children and the never-ending line of demented progeny I will sire from now through the sunset of human history be free of the bondage of debt that had fettered the movements of my family at every step? Was this first check the seed of generational wealth for my children?

Grief flew off me like vapor, off and away. I felt quite free and happy.

Soon, I got an accountant named Forbes, who explained how much of that money was mine and how much was not, as so ordered by the government, and suddenly I felt quite libertarian.

"Let's do something nice for ourselves," Lauren said.

Our first big purchase was a new set of drinking glasses.

That night, we went out to dinner.

I fed my wife steak. She likes meat, this beautiful tyrannosaur.

Afterwards, happy and full of meat, we ventured upon a magical land called Target. I bought some new socks. Lauren bought a bra and new glassware. We got the girls some panties. Lauren took my hand on the way out of the store.

"We're rich," she said.

"We are," I said.

Money's not everything, but it can remind your loved ones that you love them, sometimes. I closed my eyes, asked God to keep us away from Target.

———

That summer, I went to a barn in Montauk, New York, to finish the book, spending the month of August with a painter, a photographer, and two other writers, at an artists' colony,

which I worried might end up being some sort of nudist situation where everybody had orgies while discussing phenomenology, but mostly what we did was make salads and work quietly in a large and airy former horse barn near a market where a tomato cost thirty dollars.

I'd always coveted such a life, surrounded by artists, shop-lifting produce. I finished the book at the barn and sent it to Cal, my editor at HarperCollins, who looks exactly like you think an editor should look, with thick editor eyeglasses and lots of shiny black Connecticut hair and a voice like a disc jockey on some obscure college town jazz program airing at midnight. Cal had worked in New York publishing since the dawn of man, they said. He interned with Johannes Gutenberg and edited Florence King and Jess Walter and Roxane Gay and Rick Bragg. He knew the South, I felt.

"Where's he from?" people asked.

"New England," I said. "*South* New England."

If you want to know what a book editor actually does, here's what they do:

Imagine your book is a pretty black dress.

You put it on.

You show it to Cal.

*What do you think, Cal?* you ask.

*Love it. Beautiful,* he says. *I am dying it's so beautiful.*

Then later, at dinner, he says, *I also love red. Do you love red?*

And you go, *Sure, red's fine.*

And he goes, *Wouldn't it be weird if your dress were red?*

And you go, *Um.*

And he goes, *No big deal, let's order!*

Then later, you buy the same dress in red and he sees you in it and he's like, *Oh my god, you look perfect. Don't you love it?*

And you do, you love it.

Sometimes, you hear about editors who have to sit at the writer's bedside with a bucket of Merlot and a handgun and a bouquet of roses and call for a priest. But in my case, it was just a couple of phone calls and an email or two, one meeting in person, maybe a month of rewrites. Cal was very good at his work.

"These are not the paragraphs you're looking for," he said.

"You know, I was thinking about changing these paragraphs," I said.

If you're as fortunate as me, you'll find people like Debbie and Cal, these sextons of human culture, tending the sanctuary of civilization, sweeping the floors of your dream, helping it gleam like polished marble. They are a gift. They hover slightly above the earth.

The wildest thing happened after I turned in the manuscript to Cal and returned to Savannah to a happy reunion with my family after a month away. We ate Cuban. We had cake. We retired to bed, sated and content. The next morning, I woke early, as I always do, and walked to my desk, sat down, opened the computer, and what I saw stunned me.

A blank page.

The writing was finished.

There was nothing to write or revise. All was done. The surging tide of the dream that had risen and ebbed within me, sloshing back and forth day and night, heaving me to the desk every morning, it was gone. Just like that.

# CHAPTER 12

*He was haunted by the specter of Talent and on some days
he really believed he had it—but mainly he forgot about it,
and focused indefatigably on self-promotion.*
—WILLIAM MONAHAN, *Light House*

NOW THAT THE BOOK WAS FINISHED, I KNEW IT WAS TIME
to show it to Lauren, because while it was about my
father, it also turned out to be about other people, including
her, and more specifically, her reproductive system.

She'd been in my stories before. Back then, she was fine
with it. She was always saying these funny lines, and it was too
good not to use this stuff. She was feeding me good intel about
the world. So I used a funny line in a story? She didn't care.
That's how it starts. With innocence. With generosity.

What I wrote about her and us and our sexual war games
was not lewd, but it was, well—

*A lot*, she said, via text, after she read it.

*I know.*

*A lot.*

*I love you!* I said. *You smell pretty, I bet.*

We talked about the difficult chapters, where I laid our marriage bare for all the world to laugh and wince at. Truth is what I was after, and I was hoping my wife knew that.

"But this part," she said, pointing. "This part seems a little too true."

And she was right. I softened the edges, where I could, which actually made the book more humane and funnier, which blew my mind. There she went again, softening me. My lovely non-reader wife turned out to be an amazing reader and editor.

"Thank you for letting me say all this," I said.

"Now go buy me a house with more bathrooms," she said.

## MY WIFE'S REACTIONS

- What She Did Not Say
    - ★ "I love reading about myself!"
    - ★ "Thank you for making me famous!"
    - ★ "It is fun knowing the world knows things about our sex life!"

- What She Did Say
    - ★ "It's better than I thought it would be."
    - ★ "You made me sound mean."
    - ★ "Three bathrooms."

Next was my mother's turn.

"What's it called again?" Mom asked.

"*The World's Largest Man*," I said.

"*The World's Biggest Man*," she said.

"Largest."

"*World's Tallest Man*."

"Largest."

"Don't treat me like I'm an idiot," she said.

"Do you have dementia?" I asked.

"No."

People who want to write about their families think their families will care, will be obsessed with the book to the point of madness, but no. False. It might take your mother several months to remember the title because she has recently suffered a traumatic brain injury owing to prolonged exposure to Facebook, as mine had.

"I'm not letting you read it until you remember the name of it," I said. "What's the name of the book, Mom?"

"Don't be silly."

"What is it?"

"I don't have to answer that question."

"Tell me."

"*The Largest Man in Town*," she said.

"No."

"*Big Man on Campus*."

"No."

"*Big Man in the City*."

"Nope."

"*The Planet of Large People*."

"That's it."

It made me a little sad that my own mother could not remember the name of the book, but then this is the same woman

who promised and failed to read my dissertation so many years ago and who, when I bring it up, finds reasons to begin dusting other rooms of the house.

"And when does it come out?" she asked, that winter.

"Spring," I said. "May."

"That's so far away."

"It takes time."

"May?"

"The month."

"May."

"Yep."

The next day:

"When does it come out?" she said.

"May," I said.

"Really?"

"Really."

"May, you say?"

"The one right after April."

"Don't be ugly."

"Have you recently fallen?" I asked.

Finally, when I thought she was ready, I handed her the manuscript, which felt like presenting her with the jewel-encrusted skull of Saint Albert. I fully expected messages at four o'clock in the morning about why I didn't find more opportunities to describe how beautiful her hair is in the morning light.

"My goodness," Mom said, taking the book in both hands. "So this is it."

"Promise," I said. "No text messages about factual errors. It's too late for that."

She was still grieving Pop, and his memory rose up like smoke from the pages. I was afraid the book would ask too much of her, might ask her to realign structural elements in the cathedral of her memory. Her hagiography of Pop had already begun.

It was winter now, 2015, the year of the book's release, barely nine months since Pop's sudden exit from the story. His death certificate and the receipt for the funeral costs still lay in an envelope on my writing table. I felt treasonous. His death had transformed the memoir, providing a powerful end to the book. Part of me knew a gruesome thing I could not tell my mother: His death had made the book better, profounder, not only the final chapter, but all of it. His passing had pulled out truths from me I'd been hoarding—how I'd hated him, wanted him to die, even fantasized about it as a boy. I wanted to unmake the book, to rewrite an ending where he didn't die, where I could hand him a copy the way I now handed my mother a copy.

The first night she had the book, she did not call. I expected it at any moment, a tearful jeremiad via text and phone call.

*How could you?* she would say.

*Why did you?* she would say.

*It didn't happen like that*, she would say.

She was implicated in some of the sin of the book, too. She might stop talking to me, I knew, might want to throw herself on a pyre or in a river. She is full of feelings. She listens to a lot of Susan Boyle.

The next morning, a text.

*I just love it*, she said. *I read it three times.*

*In one night?*

*Your wife let me see it three months ago,* she said.

———

That winter, Lauren and I used the book money to get out of our tiny underwater house and into a slightly less tiny above-sea-level house with a porch and five ceiling fans and three toilets, one toilet just for Lauren, which almost made her cry. Plus closets, so many, in which she could hide from the children, should they ever discover the location of her toilet.

The house sat on a wide street in an old neighborhood with a playground, where my daughters could walk to school. Lauren worked at their school now, teaching ballet. They walked, and I rode my bike to work. In these small and measured ways, we now had a much larger new life. Lauren moved through the new home with bright and happy eyes, touching all the ancient doorknobs, which promptly fell off.

"I love this house," she said.

Houses meant nothing to me. Vessels. A place to put the tub, that is all. No, this was hers. I owed her at least this much.

I had an office now, with windows. Light entered the windows from opulent new angles. Alien faucets abounded. Nooks were many. Lauren and I had to have a strategy session just for deciding what to put in all the closets. Every day, she rearranged the furniture and leered at it from doorways, suspect. I came home from class to find her nailing, always nailing. Tiny hammer, *tap-tip-tap*. Tiny nails, always in her lip. Tiny pictures appeared on walls. She was colonizing this virginal land for us. She lit many candles.

$305,000. What the book sold for at auction, way before taxes.

$327,500. What the new house cost, after improvements.

$472,402. What my children's college educations will cost, just based on an estimate on a website I looked at just now.

$39 trillion. What the new house will cost us with interest.

In many ways, it was a luxurious new home, with many luxurious features, such as a bathroom mirror that transformed, with the mere touch of a hand, into a luxurious "secret" medicine cabinet. I helped Lauren hang curtains and watched with pride as the girls did cartwheels in the new grass. I hung a swing in the new tree, which I hoped would be in many family photos that I would one day touch, on my deathbed, in holy wonder.

The book had bought these four walls for us. Well, two of them. One solid load-bearing wall. The other three, they'd be paid for soon, just as soon as America learned my name. It was a peculiar season, an intermediary state. Word of the book had gotten out. Everywhere I turned there were congratulations.

"I saw it on Facebook," they said. "So, you're like famous now?"

"I think if you have to ask if somebody's famous," I said, "that means they're not."

People at work and church who never spoke to me before, spoke now. They knew I wrote about my life. Many expressed their desire to appear in a story, so that they might share in a bit of my non-fame. That winter, a local minister, Eric, approached

me at a restaurant, where I sat with my wife. He sidled up, as though we had secret news to discuss.

"You wrote a book, I hear," he said, his voice dropping low.

"Yes."

"Am I in it?"

"No."

"I heard other people are in it."

"You heard right."

Eric's a funny guy, one of those cheery self-effacing ministers who seems like his real calling is to wear clown makeup and craft balloon animals for dying children. I tried to get a read on him and could not tell if he was serious.

"Listen, put me in a book, will you?" he said. "What do I have to do?"

"You don't want him to write about you," Lauren said. "He'll say true things."

"I should do something zany," he said. You could see him wanting whatever weird sensation fame wrought, could see it burning in his eyes.

"If you die tragically," I said, "I'll put you in a book."

"Is that what it takes?" the balloon animal preacher said. "Death. Okay. I'll work on that."

He congratulated me on being a soon-to-be-famous author, and bounded off. I just stood there. I couldn't tell what was a joke anymore.

In the days when the book was finally finished, proofed and flash-frozen and off to the printer, I sat down at my desk, forlorn. Technically, my dream had come true, hadn't it? I'd

written a book. But the book had not yet melted brains, or very few. It wasn't out for several months. Now what?

I would hurl my name up into the atmosphere of the frightful American zeitgeist, so people would learn my name. I made lists of every magazine I'd like to see my name in and what stories I might write for them. I tried to imagine somebody asking Flannery O'Connor to pitch a listicle in advance of *A Good Man Is Hard to Find*. She'd have called for an exorcist.

The dream now demanded new skills, which involved writing snappy emails to editors. A peculiar sensation. The parts of the brain devoted to wisdom-seeking and art, and those devoted to self-promotion and commerce, are not the same parts. They are on opposite sides of the skull. You can't not think about commerce, so long as you remember that commerce is not art. They serve different masters—one, truth; the other, prosperity. Both are good, but they are not the same, odd as that may sound to a generation of children who build their own promotional websites in middle school.

I decided to pitch many magazines, via email and regular mail and prayer chain:

- *Outside*
- *Esquire*
- *GQ*
- *The New Yorker*
- *New York Times*
- *The Atlantic*
- *Harper's*
- *ESPN the Magazine*
- *O, The Oprah Magazine*

- *Ugh the Magazine*
- *Oxford American*
- *Garden & Gun*
- *Horse & Hound*
- *Christianity Today*
- *Rastafarianism Yesterday*
- *Messianic Jews of Tomorrow*

"I love it!" Debbie said that January, when I told her about the pitches. I've lived my life trying to please people, for better and worse, and Debbie's constant affirmations were a healthy nectar that freed up my wife from having to love everything I ever did.

"Glad to hear it," I said.

"Love, love, love it!" she said.

"I'm hustling."

"You are. You are hustling. I love it." Then her tone changed. Debbie wasn't all love. Sometimes, she was grave. This, too, made her a good agent. Her love went dour. "There's something else we need to talk about," she said. She said it like I was in trouble, like someone just learned I'd made it all up, the whole book.

## CHAPTER 13

*He had whatever the opposite of paranoia is. He thought*
*everybody liked him and took a deep personal interest in*
*his welfare.*
—CHARLES PORTIS, *Gringos*

YOU ARE BEING SUMMONED TO NEW YORK," DEBBIE SAID.
"To discuss things."

"What sorts of things?"

"Matters."

"Ah, yes, matters."

"Questions," she said.

This is one thing you learn about having a dream: One is
often confused by the dream-doulas. In every journey, they
are many, from the young editorial assistants reading over
the unsolicited stories I mailed to magazines to the literary
agents and book editors who sit high over Manhattan streets.
These dream-doulas, many of them, at the advanced levels of
the dream, when money begins to flow, know the danger in

revealing too much to the dreamer about what they're going to ask him to do next. They don't want to spook you. You must be handled gingerly, warmed to the bright lights about to shine. At every step through the dream, I found myself stunned with the rococo glory of it all. All this time, I'd been hurling myself up the mountain, and in an instant, forces beyond my control—via the good offices of HarperCollins Publishers—now lifted me and carried me up the mountain.

"Don't worry," Debbie said. "They just want to make sure you're not crazy."

"Oh, fun."

"We have some things to make sure of, too," she said, explaining that one of our goals for the meeting was to find out how HarperCollins was going to make me, in her words, "a hot young author," which seemed difficult, as I have never been hot, according to a recent survey.

I figured I needed some goals for the meeting, too, even though I still wasn't sure what was actually happening in the meeting. Was I in trouble?

Here's the deal: If you have to attend an important meeting with important people, where you believe they might tell you your dream is actually not going to happen, because you didn't do your dream right, because, maybe the legal team has identified some worrisome chapters, and they're really very sorry, but you have to give the money back and let the bank take your house, then it's important to prepare. Make a handout. Better write some objectives. You can bet the important people who called this meeting have objectives. Walk in there without objectives and you're liable to agree to anything. I've walked into mysterious meetings as carelessly as a schoolboy

on summer vacation and come out with whole new job titles and unnecessary root canals.

Also, you will need to dress thoughtfully for your mysterious meeting. The good thing about being a creative person is that you can dress differently than regular people. You can take risks. Maybe an ascot? An ironic headpiece? A live animal? You want to be memorable, but not detained for questioning. What I wore to my mysterious Manhattan meeting was Levis, a blazer, a shirt with buttons, a down parka, some experimental hiking boots I bought on Kickstarter after drinking Nyquil, and a sweater I bought back when I was fat, which still fit, because I was still fat.

———

The city was all White Walkers and skanky berms of last week's sooty ashen ice, but it was fine. It was possible I overdid the insulation, as I could have easily boiled a baked potato in my armpit, should that have become necessary.

Debbie and I had lunch and walked in the blizzardy air to 195 Broadway, and then up to the lobby of HarperCollins, which looks exactly what heaven should be like, bright, clean, full of books and comfortable furniture and people who seem intelligent and kind. I touched all the books to make sure it was all real and was then shown to a meeting room, equally bright and clean on this gray winter day. My frozen brain thawed and alerted me that I might be entering an altered state of reality.

Feelings of euphoria commenced.

People passed in the hallway, looking in, to see who they could see.

*That's Harrison Scott Key,* they whispered.

*Which one?*

*Him. That's him.*

*He looks just like his publicity photo.*

*He's so funny.*

*He is. I know.*

*No. I mean he really is!*

*I know!*

*And he's so hot and young and author-like!*

*I know.*

This is what physicians refer to as a *hallucination.* It didn't happen.

Next came the part of the meeting where everyone flattered me, starting with a woman to my left, Executive Vice President of Cultural Appropriation, perhaps, a lady who smelled like leather and peaches and had probably fired an assistant via hologram.

"We love this book," she said.

What book did she mean?

"It's just amazing," she said.

My book?

"Thank you," I said.

"Everyone here is very excited."

"Great!" I said. "Me, too."

"I loved the chapters about hunting," another woman said. "So fun!"

"Thanks!" I said, my eyes beginning to well with untrammeled joy. It kept going, one by one, everybody saying something nice about the book—a publicist, and another publicist, someone from the racketeering department, a few

interns, some assistants. My ego expanded to unsafe levels. I was not this amazing. And yet, wouldn't it be rude to call them liars, about how amazing I was? I decided to return their compliments.

"I loved the humor," one said. "Beyond hilarious."

"Thank you," I said. "I love your shirt."

"I loved the pathos," said another.

"And you have a lovely smile," I said.

"He's funny!" they said.

And I was like, "I am!"

"I loved how you almost got divorced," said another.

"So did my wife!" I said.

"My favorite part was the racism," they said.

"Mine, too!" I said.

And then I saw it: My book. There, on the table. Is this what new mothers feel when they first hold their babies? Do they smell them, like I smelled my book? Did they desire to lick them, as I very much wanted to do to my book, like a cat?

The meeting kept going, but I was not in it. I flipped to a page, read a line. Yes, I wrote that. Another page. Yes, I wrote that one, too. I counted all its fingers and toes and chapters.

"Harrison?" Cal said.

"Yes?"

"We were just discussing book promotion."

"Yes, of course, sorry."

I pulled it together, presented everyone with a box of pralines I'd brought from Savannah so they could be fat like me should they desire it, and then I passed around a stack of neatly typed handouts regarding my proposed book tour.

I asked, "So, like how many cities can I go to on tour?"

They said, "We see a lot of great opportunities for you to blog!"

I had no interest in blogging. But blogs were going to make me famous, they said, where my illuminating post about "Ten Favorite Hairless Cats of Southern Gothic Literature" would be seen and read by dozens of avid readers.

Dozens!

I asked, "So, like, who books the travel?"

They said, "We love these pralines!"

I said, "Can you get me on *This American Life*?"

They said, "I could eat a hundred of these! So good!"

I said, "I was thinking about publishing an open letter to Terry Gross."

They said, "Please don't do that."

The room got quiet. I had a praline.

———

I flew home that night, more confused than ever. I was now in the maw of a great and powerful machine and felt the sudden tremors of it surging awake.

I had a publicist now, courtesy of HarperCollins. We'll call him Phillip. Great guy, Phillip. Publicists like Phillip are the necessary flanges in the machinations of fame. They make your image and name ricochet around the universe of global consciousness, largely by emailing media contacts, with whom they communicate via a series of carefully placed exclamation points. Phillip said he was emailing everybody about my book, and it seemed to be working. I had begun to see pictures of my distended *Goonies* face everywhere.

"I saw something about you in a magazine," people said, all the time, everywhere.

"You are all over the Internet," people said.

"You must have a good publicist," people said.

Telling you that you must have a good publicist is a nice way for people to tell you that you're not very talented. I mean, your friends like you, they do, but they don't really think you're amazing, because if you were, you probably wouldn't be friends with them. They know this instinctively.

I'd finally gotten some bites on all my pitching. Four or five magazines emailed back and said, "Sure, fine." Some even agreed to pay me. Compensation for magazine pieces, I learned, abides no set of earthly conventions. *Outside* paid me $1,000 for a story, the *New York Times* paid $150. Many paid nothing, but I wrote those stories anyway, to keep my name ricocheting around the thunderdome of public opinion.

It was a lot of work for what felt like an unquantifiable end, like having sex for money with people who might be strangers but might actually end up being your wife, except instead of money, most of these magazines pay you in exposure, which is a non-transferable form of currency that is not accepted at most grocery stores.

One day, I received an email from an editor at a soft-core pornographic magazine called *Southern Living*, the world's only magazine that dares you to swoon over fruit-based sheet cakes. (One can find a full description of this amazing magazine in the DSM-5 under "Deviled egg fetish.") I was very excited as I read this email, because as the editor explained, this very popular magazine had decided to feature me on their website,

alongside many yam-infused tablescapes. She said they were about to publish a list titled "50 Southerners to Watch Out for in 2015" and wanted to know if I would like to be one of the people everybody should be watching out for. I very calmly explained that I would pose nude on a bed of plump squash, if they wanted. I would do anything.

I sent them everything they required: the high-res photo, a quote full of pathos and irony, and a link for readers to preorder the new book.

"I'm going to be in that magazine!" I said to my daughters, in line at the grocery store, pointing to the cover, with its many headlines about soups and stews.

"Is your book about crockpots?" Stargoat asked.

This was my first national publicity for the book, and I was very proud. I could feel the potentialities of fame whirring inside me, little atomies of celebrity ready to burst forth.

The day the list was published online, I was not on it. Wait, what?

I looked again. Nope, not on it.

Again. Nope. Okay, so.

I wrote an angry email to *Southern Living* and deleted it.

I wrote a funny angry email and deleted that one, too.

"Never email angry," I tell my students. So, I took the edge off with fifty margaritas and wrote another email, this one less angry, kinder, gentler, margaritier.

"What happened?" I asked. "I thought I was on the list."

"I guess we forgot you," the editor said.

They felt terrible, they said, and offered to put me on another list.

This is one of the fun things you learn about publicity: It's all imaginary. All of it. They can just wave a wand and invent whole imaginary lists.

"40 Southerners Under 40 Pounds"
"50 People Who Like Rice Sometimes Under 50"
"60 Writers Who Write Books for People Over 60 But
   Who Are Under 60"

"What new imaginary list would I be on," I asked.

"Fifty Best-Dressed Southerners," they said. "Will that work?"

I had not known that *Southern Living* was a humor magazine.

"Absolutely," I wrote back. "Thank you for this opportunity."

On a typical day, I generally look like a drifter who's murdered a professor and stolen his clothes and gotten thrown by a twister high up in a tree. But whatever. I had a dream to keep dreaming here.

Word soon got out. I was one of the South's Best-Dressed Humans. *The Savannah Morning News* picked it up, put a big color picture of me in the paper. Strangers who recognized me honked as I rode my bike to work. I could feel the first tender kiss of fame on the lobes of my enormous ears.

And yet, at church, everybody seemed confused.

I walked into the sanctuary and faced the stares of a wall of elders and deacons.

"I don't see it," one said.

"You look terrible," another said.

"It's very confusing," an older man said, squinting his eyes at my shoes, unpolished, the laces fraying. He looked like a man passing a gallstone. Like his feelings were hurt.

"You must have a good publicist," he said.

"I do," I said. "His name is Phillip."

I walked with my family to a pew, wondered what my posture should be. Do I hold my head high, proud of all we'd accomplished so far, or do I hang it low, in humble preparation for the battle that was to come? It felt like God was smiting me, in slow motion. I could feel my soul shifting a little, blurring into something new. The dream was evolving.

# ACT IV

---

## My Meteoric Rise from Obscurity

## to Slightly Less Obscurity

# CHAPTER 14

*Our crowd consisted of approximately three-hundred Margaret Atwood fans, with the remainder of the crowd being my fan.*
—GEORGE SAUNDERS, "A Brief Study of the British"

THE DAY YOUR BOOK COMES OUT, THEY CALL THIS YOUR PUB Day, a reflection of how much drinking usually happens to make this moment possible.

On Tuesday, May 12, 2015, precisely eleven years, five months, and twenty-six days after I announced to my wife that it was my dream to write a funny book, it was true: The book was now alive and for sale in real life, soaring like a great happy bird through the Internet and bookstores across America. It had only taken 4,195 days. I rolled quietly out of bed and walked soundlessly to my desk and breathed deeply and opened the Internet to find no urgent messages from Debbie congratulating me on queues that had formed outside surprise midnight

bookstore parties. No religions had been formed in honor of my characters, and no presidents of fan clubs had delivered any remarks via YouTube, for there was no fan club. Odd.

Twitter. No blue checkmark, yet.

Amazon. No reviews.

There's this secret page on Amazon called Author Central, where you can see how you rank up against other people trying to sell books on Amazon, which turns out to be most humans on the planet. On my book release day, my book was ranked number 35,777 among all printed materials for sale on Amazon, including *Lolita* and *The Picture of Dorian Gray* and *Glengarry Glen Ross* and *Don't Fill Up on the Antipasto: Tony Danza's Father-Son Cookbook*.

What did all this mean?

It meant I was now my own social media intern. I spent three hours checking tweets, tweeting, retweeting, hypothesizing how I might generate more retweets. An inspirational post about believing in yourself, alongside a photo of a seagull, for example, seems capable of making Twitter users highly excitable. Should I do that?

I would spend the next year pondering this question of how "not-me" I should pretend to be in order to draw more attention to the "real-me" of the book. Thus began the season of my life in which I would post about my book at least once a day, such that I might be unfollowed by many friends on social media, whom I don't blame, not a one—I'd have grown tired of me, too. I did grow tired of me. I would have unfollowed myself, had that option been available, which it wasn't, I checked. I tried outsourcing my online presence to a Bengalese firm specializing in the field, I did. But I had captained the ship of

my ambition this far—might as well keep going until we reached whatever New World we sought.

What did I seek, now? It is instructive to remember that not a single European was looking for America, before they found it.

———

Two days after I was officially published, we launched the book at the SCAD Museum of Art. They call it a launch because, as with a NASA rocket, all the friends and families cheer and there's champagne and explosions and occasionally mourning. It was divine. In one blinding flash the book was in space, and space is beautiful. Friends handed me giftwrapped bottles of alcohol, and I learned why writers die of cirrhosis.

I felt the crack of the starter pistol in what suddenly seemed like a race, between me and Tony Danza and every other author of books with words. The way I was going to win this race was via the world's largest book tour. Phillip and Debbie and I had discussed this, a couple months before the book launched.

"How many cities are you thinking?" Phillip said.

"Fifty," I said.

Although that was a lie. Seventy is what I was thinking. A hundred is what I was thinking. My plan was to visit every city where I'd ever lived and also any American city with a mayor or running water or enough oxygen to support human life. It had been exactly twenty years since I'd experienced the divine revelation of my fate, to create explosions of fiery comic wonderment in the hearts of my fellow pilgrims, and now that the book was done, that fire needed somewhere to go, and where it went was on the road.

I could feel the fire trying to tell me something, even as I made a very long list of cities I wanted to burn to the ground with comedy. My father was in the fire, I knew. At the time, that is all I knew. Later, I would know more.

I sent the list of cities to Debbie and Cal and Phillip.

"You don't really want to go to all these places," they said.

"Definitely."

"Birmingham?" they asked.

"My wife used to live there."

"Greenwood?"

"My grandmother's buried there."

"Austin?"

"Brisket."

"What about Charlotte?" they said. "Do you actually know anyone there?"

"No," I said, "but I will."

———

The first official tour event took place at the South Carolina Book Festival in Columbia. Mark drove over from Atlanta, for moral support.

"There will be many famous authors here," I said. "Please come."

"What if nobody shows?" he said. "Will you be sad?"

The thing about book festivals is: People do show. They might be lost, but they show. They will wander in, hoping to discover a cooking demonstration of some kind. They could put a sign on the ballroom door—"Alopecia and the Novelist: A Tribute to Joyce Carol Oates" | 2:00–3:00 p.m.—and readers would flock.

The night before the festival, we went to a VIP author party, a phrase that Mark hooked into like a lamprey.

"We're looking for the VIP Author Party," he said to the man at the hotel desk.

"Is this the VIP Author Party?" he repeated, to the man holding the door for us.

"This feels pretty chill for a VIP Author Party," he said, as we sampled the prodigious array of pita wedges before us. You could tell it sort of blew Mark's mind that this was happening, that one of us had become potentially famous, the way we'd wanted to, so long ago.

Just then, a beautiful woman came running toward me, trying not to spill her Chardonnay. She seemed anxious, eager, almost, dare I say, excited?

"Are you Harrison Scott Key?" she said.

"No effing way," Mark whispered. "Five minutes at the VIP Author Party and you're a sex object."

I turned up the wattage on my smile. Perhaps I already was famous. I reached for a pen.

"You're him, aren't you?" she said.

"How did you know?" I said, curious.

"You dropped your name tag," she said.

———

The next day, we walked to the convention center and I entered the VIP Author Lounge in a commanding stride, to be greeted by an empty room and a young man lighting the Sterno jelly.

"Where's all the famous authors?" Mark said.

Just then, a famous author entered. I won't say who. You've heard of him.

I stood up, introduced myself, and made the mistake of telling him I was a big fan of his work, which meant we could now never be friends. The imbalance of power was too extreme. Authors, like other humanlike creatures, can only be true friends with people who do not fawn over them. I knew I'd blown it.

He shook my hand limply, surveyed the muffins, and departed.

Again, we were alone.

"That was fun," I said.

"Do you want me to go kick his ass?" Mark said, ever the loyal friend.

"It's fine."

"We should at least go to his panel and jeer," he said.

"Let's eat."

Like conquering lords, we grazed on the VIP author salad and a generous fruit cup.

Two hours later, I did my first reading. It went fine. Everything felt quite normal, honestly. Touring would be a snap. The next day, our panel convened before a full audience, mostly because one of the panelists had written many bestselling historical romance novels. I could tell they were bestselling books because their covers featured such key elements as antebellum homes, oak trees lining driveways leading to antebellum homes, oceans, inlets, the backs of beautiful and mysterious women's heads looking through avenues of oaks and to the various oceans and inlets beyond.

This bestselling author was quite funny and charming and smelled of powdered sugar and money. She was a pro, you could tell.

"She's good, damn," Mark said, after.

We wanted to mock her book covers, but this woman was slaying it. You had to respect it. Every grandmother in South Carolina lined up to get a selfie with the lady.

"She's destroying you," Mark said, as he sat beside me at the book-signing table, later, and watched her line snake through the convention center.

"It's not a race," I said.

"I thought you said it was."

"I was wrong."

"Because she's totally winning."

"People will come to my line," I said.

We waited for people to come.

People did not come.

Then two people came, a woman and her daughter, about twelve.

"She loves to read," the mother said. "She's homeschooled."

"I've never heard of you," the girl said, proudly.

"Thank you," I said.

I signed her book, and they disappeared around a corner.

My first fan interaction was over.

An announcement reminded us that the convention center was closing in five minutes. Across the wide hall, the darkness descended by rows, and Mark wandered off to the VIP Author Lounge to collect turkey rollups for his suitcase.

And so it was that the fire of my ambition thrust me across America. I was living a dream, and like a dream, the story of that summer unfolded with a Jungian logic. I woke to find my-

self at bookstores in the Carolinas, Georgia, Florida, Alabama, where I discovered the hard truth of bookstore events, which is: Nobody comes.

Any author will tell you this is what happens, but you think, *Not me! It shall be different with me!* But it's not different, and it's fine, because in the first few weeks of the tour, all the touring actually did pay off: My Amazon ranking soared up the charts, from number 35,777 to number 33,907. Which is fine, it's fine, it is, because when you go to bookstores, they always purchase a few copies of your book, to have on hand when you arrive, and this is why you go, really. You don't go to meet fans. You don't have fans.

Bookstore owners and employees are dream doulas, too, like agents and publishers: They want your book to sell, for they also have mortgages and a belief in art and truth. For many, their bookstore is their dream, and it's a wondrous thing, to see the companion dreams overlap in this way, even as I was shocked that so few people's schedules were overlapping with mine, at my book events.

I'd walk into the empty bookstores an hour before my event and wonder where everybody was, trying to pretend I wasn't wondering where everybody was, grateful that the bookstore had invited me in the first place. Some of them made flyers, which I appreciated, a lone flyer, tacked to the wall, where everyone in town could see it, should they choose to come into the bookstore and squint while standing very near the flyer.

At one shop in Alabama, during the early weeks of my tour, I entered and introduced myself and thanked them for hosting me for the reading.

"We don't really do readings," the manager said.

He didn't say what they did, instead of readings. Screamings, perhaps?

## THE FIRST SIX MONTHS OF THE TOUR THAT PHILLIP AND I PLANNED

- Austin, Texas
- Baton Rouge, Louisiana
- Brooklyn, New York
- Charleston, South Carolina
- Charlotte, North Carolina
- Dallas, Texas
- Decatur, Georgia
- Fairfax, Virginia
- Fairhope, Alabama
- Fayetteville, Arkansas
- Greenwood, Mississippi
- Jackson, Mississippi
- Little Rock, Arkansas
- Memphis, Tennessee
- Miami, Florida
- Natchez, Mississippi
- New Orleans, Louisiana
- New York, New York
- Oxford, Mississippi
- Raleigh, North Carolina
- Richmond, Virginia
- Sewanee, Tennessee
- St. Augustine, Florida

- St. Petersburg, Florida
- St. Simons Island, Georgia

And who would pay for all this, again? Phillip agreed to pay for some of the tour out of the cryptic HarperCollins treasury. How much, he wouldn't say. I explained that I could sleep on the futons of friends and family, if that helped. He agreed to a dozen hotel rooms, two rental cars, two plane tickets. That was all he could do, he said, which seemed generous, although I had nothing to compare it to. The rest of the money would come out of my remaining book advance monies, sitting in a non-Swiss bank account, accruing non-high interest.

"It's an investment," I told Lauren.

"In what?"

"In my ability to convince people to put on pants and leave the house," I said.

"How will you do that?" she asked.

"I am going to put the *power* back into PowerPoint," I said.

———

A couple of weeks into the tour, I found myself at Page & Palette in Fairhope, Alabama, a sort of platonic ideal of a bookstore, with a big room full of books and a whole other room just for readings and many lavish appointments, such as chairs. I set up a projector and a screen, and people came into the room, and kept coming.

*Fifty people? Sixty, was it? More?*

*Was it happening?*

*Why had they come?*

*Wine.*

*They were giving out free wine.*

Nobody tells you how crucial rosé is to the publishing industry.

They introduced me, and I tilted the microphone closer to my face, its metal arm groaning like some ancient bird, and I showed them my PowerPoint, and people laughed in all the right places, and they didn't stop laughing, not even when I read a passage about my father dying and I sort of wanted them to stop. In that moment I knew: I'd turned a corner in my calling and was on the other side of something now. I had wanted to make others laugh, and here they were, laughing, applauding, standing, even crying. Was the dream real now? I thought it had been real when I got the money, but no, not then. Was now it? Is this what I had longed for, all those years? Had my quark finally burst into joyful luminescence, creating rich human feeling in the world? I wanted to assume it was my brilliance that had caused these tremors of feeling but then I thought, no, it was probably the wine.

Afterwards, when I entered a restaurant for a late dinner with my cousin and her fiancé, a table full of elderly women, one wearing a lobster bib, stood and applauded.

"Well done!" they said.

"Bravo!" they said.

"We just love you!"

In this situation, the temptation, of course, is to believe you are as important as these people are pretending you are, which makes you believe you have superpowers, which is how actors end up on CNN discussing carbon emissions and attempting to divert tsunamis via telepathy.

"Remember where you come from," Pop had always said. "Remember your name."

What was my name? I couldn't remember. Kanye West? Dwayne "The Rock" Johnson?

*Don't get above your raisin*, is something I heard said often, as a boy in Mississippi, and I heard it in my head now, a chorus of aunts and cousins and grandmothers and Sunday school teachers, their heads floating in the celestial heavens above me. *Where was my raisin?* I wondered. I was above it now, surely.

# CHAPTER 15

—

*In painting, you have unlimited power. You have the
ability to move mountains. You can bend rivers. When I
get home, the only thing I have power over is the garbage.*
—BOB ROSS, *The Joy of Painting*

THERE'S A PRETTY CLEAR PATH TO BECOMING A BESTSELLER IN
the United States, which is to write a diet book, or a book
about angels, or a diet book for angels. The other way to write
a bestseller is to be Tori Spelling. The woman is prolific. Best-
selling celebrity memoirs do have their uses, I guess, especially
in developing nations, where they can be read aloud to patients
before surgery, in place of anesthesia. At least, this is what I
thought; but then I read a few pages of several of these books
one day when trapped in a used bookstore during a severe
thunderstorm and I was like, *Well, damn. Some of these celebrity
memoirs are not so bad.* Turns out celebrities are people and have
feelings, too, which was upsetting.

What I am trying to say is that if you're not Tori Spelling or an actor or musician with some free time and a desire to diversify your creative revenue streams, then becoming a bestseller is a trifle more bothersome. How does one get known, so as to be further known? And then how known does one have to be to be on the bestseller lists, which will only increase the "known-ness" of the known?

This is what we do know about how bestsellers are determined: the *New York Times* and *Publishers Weekly* keep a small band of sightless actuaries chained to radiators in their basements, analyzing data gathered from booksellers and distributors, which is then doctored by Tori Spelling.

After the glorious triumph at Page & Palette on the rich briny waters of Mobile Bay, where I signed what felt like five hundred books and was photographed by strangers and cheered by the elderly, I careened north for events in Tennessee and Mississippi and back to Alabama and Georgia and South Carolina, shaking my head at the wonder of it all. Fame is a remarkable thing. You think you know what it is, and then it whispers in your ear and you're like, *Oh.*

Fame coos, *Hey there, buddy.*

And you're like, *Wow, you're even prettier in person.*

Fame says, *You are really good at this.*

And you're like, *Oh, you flatter.*

Fame says, *No, I mean it. I want to marry you.*

And you're like, *Oh, stop it. When?*

I began receiving calls, letters, emails, dispatches from distant nooks and crannies. I got one letter from a Florida state correctional facility, and it thrilled me knowing that my work might be shining light in a dark place. The inmate said he en-

joyed my story. He also said we should hang out when he was released from prison, and then he asked me to help him sell some paintings. He did not say why he was in jail but I think it has something to do with paintings.

---

Per Amazon, the book had risen from number 33,907 to number 6,306 in a single week. Phillip the Publicist was calling and emailing more and more.

*New bookings!*

*Guest blogging!*

*Print interviews!*

*Radio interviews!*

His exclamation points were having a very positive effect!

Audiences grew. I'd begun taking countless selfies with people I did not know and would never see again.

"Get in here with us, Mama!" these strangers would say.

I'd snuggle up to Junior and Mama and whomever else, grinning. I was now being contacted by readers in foreign countries, such as Scotland and Texas. I was very big in Denmark, according to one person I didn't know from Denmark. My ego was moving now across the turning hulk of the planet Earth like the British fleet. My little phone could barely hold power in those heady days, so many messages I received.

*Heard you on the radio,* they said.

*Dude you were just on NPR,* they said.

*All Things Considered!!!* they said.

*When are you coming to Austin?*

*Come to Chicago!*

*Seattle!*

*L.A.!*

My book continued to climb the rankings, such that, if this publicity continued unabated, I might very soon live among the top one hundred authors on Amazon, with Stephen King, George R. R. Martin, J. R. R. Tolkien, J. K. R. R. Rowling, and Nicholas P.T.S.D. Sparks. Also on this list are a surprising number of human people I'd never heard of, who wrote joke books and children's books and books about men who shape-shift, mostly into sexy bears and sensual mountain cats. That summer, a man named Terry Bolryder sat triumphantly among the top one hundred authors on Amazon. His titles include:

- *Bear to the End*
- *Bear to the Rescue*
- *Bear to the Bone*
- *Bear-ly a Hero*
- *Remem-Bear Me*
- *Big Strong Bear*
- *Big Bad Bear*
- *Big Sexy Bear*

It makes you question everything you think you thought you knew about how the book business works, when you read a list like that.

In 1984, not long after Debbie edited *The Hunt for Red October* and before it was made into a major motion picture starring Alec Baldwin and Sean Connery, Clancy's book lay dormant in boxes in the back room of the Naval Institute Press, where

Debbie then worked as a young editor, not long out of the University of Virginia. She convinced her publisher to publish the book, and they did, because she said it was fantastic, and it was. But how would the world find out about it? What do you do?

Clancy, about my age at the time, was still in Baltimore underwriting small policies for boat insurance and term life. After a decade of writing novels in his spare time, he'd finally got one published, but it was no bestseller. Why? Because nobody knew about it.

"Word of mouth," Debbie always said. "That's how you sell a book."

Which was another way of saying "small advertising budget."

*Tom!* she must have said to him, in 1984. *What this book needs is word of mouth! People are going to read your book and fall in love with the highly specific technical descriptions of submarine propulsion and will tell all their friends.*

The book lay dormant, at the bottom of the ocean of publicity, and then: And then! Somebody gave a copy to the leader of the free world.

It could've ended there, because you know they've got this storage closet under the White House where these gifts go, a hundred yards deep—golf clubs, commemorative wine keys, monogrammed dishtowels—but somehow, they got Clancy's little submarine book to President Reagan and he read some of it, and one day a journalist asked what he was reading and he told them. They printed it in a magazine, and today the studious insurance man is now one of the bestselling writers in human history, alongside Dr. Seuss and God.

This is not to say Clancy had no talent. He had more talent than the Rand Corporation has ways to end human life. I'm

just saying, if you don't have a sitting US president to tell the free world how talented you are, your book might not float. It's not the fame that you want per se, but the thing the fame gets you, which in my case was some new window treatments for Lauren. This is why fame matters. It is the substance of things hoped for, the evidence of things not seen.

What I needed was famous people to christen me. It could be Dave Chappelle or Bono or Dora the Explorer. It didn't matter. If somebody posted an Instagram photo of Meryl Streep batting away a hornet with my hardcover, if Vladimir Putin called my book a book for babies, then that's it: I would be a bestseller. *Go get you some curtains, honey!*

But if nobody famous talks about your book, there's a very large chance it will live forever on the sea floor of the American consciousness, cold, dark, forgotten, filled with the skeletons of ambition and a mortgage you'll have to pay off in monthly installments, like some kind of indentured servant, or your parents.

It's shocking to the meritocratic American mind to see how the lead role in the drama of your success, to some extent, is played by Luck. The storyline of the American dream says that you are the protagonist: You call the shots. You take the raw materials of your DNA and life experience and develop a work ethic, a furious dedication to cultivate and shape your own talent and life arrangement in order to manifest your inmost vocational desires, such that you spend decades summoning the storm of your dream, only to find that at the witching hour, whence comes the time for your success to go national, you find yourself sitting in a hotel room really hoping Rihanna decides to wear your book on her head at the Met Gala.

For the time being, while patiently praying for God to compel Reese Witherspoon to post an inspiring Instagram photo of my book resting peacefully next to a rosewater-infused breakfast smoothie, I needed something to occupy my hands, and so what I did was work very hard to encourage very intelligent non–Reese Witherspoonians to compose other thoughts about my book via interviews on the Internet and the radio, as well as an obscure means of communication referred to by paleontologists as "print media."

The hazards of interviews are many, especially when you write a funny book. You are expected to be hilarious, and if you are not, you will feel you have disappointed the interviewers. You can hear it in their voices. You will have to toggle back and forth from one state of being to the other with frightening speed, which will make you seem, at best, high.

The interviewers might ask, *How did you learn to write humor?*

And you might say, *Once I realized that the essential quality of comedy is incongruity, both syntactic and dialogic, everything started to click.*

They might be really interested in this content, saying *Ah!* and *Oh!* and *I see!* as you say it (which is what you hope for), and you feel great about this, but then you realize you are very likely boring everyone listening and should immediately cease attempting to make actual points. What they need from you is hilarity, punctuated by moments of non-hilarity, also known as poignancy. They need you to be insane.

*What's been the biggest challenge on your book tour?* they ask next.

You have to be funny now and not intellectual, so you say, *Probably the diarrhea.*

You wish you hadn't said it, you do, but you did, you said it, and now everybody's associating your book with bowel movements, and you can't change that.

———

Most times, the interviewers have not read your book and don't know how to hide this fact, like an eager student in English class who lost his paperback of *Moby Dick* but feels compelled to offer his thoughts on whales, be they white or more traditionally blue.

*The World's Largest Man*, a journalist might say on the phone.

*Yes*, you say.

*About your father.*

*Yes.*

*So he must be very tall!*

Silence. So much silence.

Maybe you say, *It's a metaphor.*

*Got it*, she says. *So how tall are* you?

*I'm taller than many people and shorter than many others*, you might say.

You don't know where to go with this. Is she really this misinformed about the occasionally metaphorical nature of book titles? Does she believe *Moby Dick* is about an actual penis named Moby? Does she believe *Jaws* is about facial reconstructive surgery?

*Can we start the interview over?* she maybe says.

*Yes*, you maybe reply.

You might also do the kind of interview where they haven't read your book and don't seem to like you very much, which you assume is because your book is about vile primitive things like hillbillies and death.

*So, what does your father think of the book?* one of these reporters might say.

Now, how should I answer that? Because my father was dead, and the man's death is a significant element of the story, its crowning moment of truth-telling. It's like a minister had shown up to my father's wake and asked, *So how's your dad? Is he here? Has he tried these sausage balls?*

What can you possibly say?

Every night when I stood in front of a new audience, the book felt, in my ears, like a eulogy to the man who made me, and to the place that shaped us both. And here I was being interviewed by a probably well-meaning and likely underpaid journalist who didn't seem to care much about any of it, whose job was to fill a few minutes between "Travel with Rick Steves" and a program on the resurgence of the pale-throated sloth. I tried to keep my sense of humor, but my father really was dead and I missed him and was tired, so tired, and lonely from traveling. That might be why I planned such an exhausting and exhaustive tour: I wanted to see my father again, every night, at every reading, in the stories we lived together.

"Does your father like the book?" one journalist asked. "Does he find it funny?"

"Yes," I said. "It killed him."

## HOW TO SPEAK TO JOURNALISTS

- Do Not Say
  - ★ "Why are you so angry?"
  - ★ "Did you even read my book?"
  - ★ "I bet my sister could whip your ass."

- Do Say
  - ★ "Great question!"
  - ★ "This has really been fun!"
  - ★ "I have a signed headshot of Ira Glass!"

All summer, every time the phone vibrated, a thrill juddered through my heart. What if it was *The New Yorker*? *New York Post*? *Fresh Air*? *Los Angeles Times*? It might even be *The Late Show with Stephen Colbert*. I began having dreams about doing a song bit with Jimmy Fallon, where Questlove and I played percussion on a series of deer skulls, and when I woke up, these dreams did not seem silly at all. Everything seemed perfectly possible, in this new reality. I was learning, in fits and starts, how to talk to the world about my success, especially journalists: Even when they seemed to not have read the book or even read a summary of the book, even when they asked what my deceased father thought about it, I tried to express gratitude, hospitality, curiosity, humor. I was surprised how difficult the interviews were.

I still wasn't prime-time ready. But I was getting there, grasping, in pieces, how to create Driveway Moments, which is: Tell a story. Be vulnerable. Use your manners. Reach through the radio and grab a fistful of the world's chest hair and tell them

you love them, that you're just like them, dammit, because you are. You're not special. It's not about you. You're not the star of this show. The star of any interview should be truth, and the roughshod human stampede toward it. That's why you tell a story. You're trying to let others know how you did it, so they can, too.

Interviewing, it turned out, was also a lot like writing. It took work to make it look easy. I found myself listening to *Fresh Air* with a renewed and attentive vigor. Dang, some of those people were *good*. They made it sound like just talking, but they were not just talking. They were confessing. They were testifying.

I drove, and did my readings, and got better at everything, improving by degrees, but still, no calls from *The New Yorker*, none from Terry Gross. I prayed about it, trying with every interview to assassinate the jackass inside me and resurrect him into a vibrant anecdotalist.

And then, an email from Phillip. The subject line: *Wow!*

It was a major review by a major newspaper, known to readers the world over as the *Oakville Beaver* of Burlington, Ontario.

*Hey, look!* he wrote. *You're international.*

# CHAPTER 16

*He wanted to better his condition until it was the best. He*
*wanted to be THE young man of the future, like the ones*
*in the insurance ads. He wanted, some day, to see a line of*
*people waiting to shake his hand.*
—FLANNERY O'CONNOR, *Wise Blood*

MY RELATIONSHIP TO THE WORLD WAS CHANGING. I NOW
received electronic messages from strangers who knew
more about me than I'd known about myself five years ago.
Older women looked at me with sly grins, knowing the inti-
mate secrets of my marriage bed, such as the code word for
intimate relations that my wife and I use, in front of the chil-
dren. These lecherous women said this word to me at the
book-signing table.

"Ha, ha," I said.

"Ha, ha," they said.

Eek.

"What does your family think of this book?" audiences everywhere asked. The way they asked it, you could tell they were a little incredulous. Some seemed to believe that my family should have hoisted me up on a woodpile and set fire to it.

Had I spoken ill of the dead? I'd written things about my father, grandparents, an aunt, a second cousin, several great uncles, most of whom were now deceased, and I'm not sure I'd have said some of it so directly, so specifically, were some of those good people still alive. Was it necessary, for example, to refer to one of the dead people as a hussy, which was how the woman was described to me by several eyewitnesses? This particular character had been my father's first wife. I didn't know her. But then one day you find yourself doing a book event in a place where she might be buried, and you remember: Oh, wait, these are real people.

Of course they're real, but they don't seem real when you're writing. They are in your imagination, these literary versions of real people, moving and behaving and misbehaving, and you're trying to get it all down, the way you heard it.

Sometimes, when working on the book, I'd come up from the deep waters of composition and find myself shocked at what I'd written, about neighbors and loved ones, and I told myself it was fine, for I composed in a genuine belief that I was panning through mud for some shimmering nugget of truth that might live longer than any of us. So maybe I called someone a hussy in a story. It's fine. I'd done it in the service of a higher truth, I think. I hoped.

———

In Memphis, at Booksellers at Laurelwood, a dozen relatives showed up to the reading, which pleased me greatly—cousins, first and second ones, distant, near, an aunt, some man who said we were related, and some other man who said he was kin to that man. They arrived all at once, the lot of them, as if they'd ridden up Highway 61 together via hayride. They travel in herds: These were my people, and I loved them very much. Some I hadn't seen in a decade, others, at the last family funeral two or three years before. These were the characters of my youth, many of them, of Sunday dinners and Christmas Days. My plan was for my family to love the story and not, for example, to shoot me, or storm out, or raise their hands at the end and say:

*How dare you, boy?*

Or, *You ought to know better.*

Or, *That's not at all what happened.*

This reading in Memphis was the first moment it hit me: This might happen. Somebody might stand up and contradict what I'd written, declare it was lies, all of it, or the best parts.

I feel very certain that every memoir is a performance around the dinner table, and the table is peopled with family and friends and strangers, and the strangers are there to gawk and learn and the friends are there for moral support and the family members are there to set the record straight, should anyone like to know what really happened.

This was my fear, and maybe I wanted it to happen. Maybe I wanted one of them to stand up and utter some odd fact that did not fit my narrative. Some of them took issue with how I'd portrayed the family, I had no doubt. When you tell stories

around the dinner table, it's as much a deposition as it is a tale. Everybody's got a case to make. The best storytellers lay it out like evidence: *Look, here's what I saw. This is my testimony. Here's the dookie that went down.*

All these questions flared up in my heart as I stood there at a Memphis bookstore, in the city where I was born, to read a story about my family. These were no longer mere tales of a boy from a faraway place; these were true stories about a true family, many of whom truly stood in back with arms folded, pending judgment. Perhaps I had made us sound a little too white trashy for their taste? Perhaps I had bespattered the family matriarch and patriarch in the telling? Were they going to hog-tie me and drag me off to some hollow and cleanse me of my unrighteousness?

One lobe of my brain said, *You wrote with love, they know this.*

The other lobe said, *You discussed incest.*

I suppressed this internal dialogue and finished to modestly thunderous applause, I felt, and then sat down to sign books. It had gone well. I skipped the incest. Nobody stormed out.

And then, a few moments after I sat down at the book-signing table, things got weird. You know how sometimes the quality of sound in a room changes, everything goes quiet, vanishes as abruptly as if someone had turned down the knob, and you worry that someone's behind you with a claw hammer?

There I am, signing books, head down, trying to focus, when all the room's noise ceased in one chilling instant. I looked up, pen in hand, my tiny inconsequential sword, and saw everybody looking at me.

"What?" I said.

The loose throng of family and friends and strangers fell back, and out of the crowd stepped a woman, who slid a copy of my book across the table.

As is my habit, I opened the book to sign it and engage this book buyer in a brief polite exchange, but when I opened the book I saw something that slammed the door on my heart: There, lying across the title page where you sign your name, was an old photograph, its colors washed out, amber, yellowing: My father, cutting a cake. A photo from his first wedding, when he was still a boy. I'd never seen this picture, had only heard the story of it whispered. The lady in the photo, the young bride, fifteen years old, was in my book. Until that moment, I had believed she was dead.

I looked up at the lady. The room held its breath. The people knew what I did not. I am certain those members of my family who were present must have recognized her. They may have invited her, for all I knew, to see what would happen.

"Do I know you?" I said.

"I'm the hussy," she said. "From your book."

———

She was tall, with short hair the color of white gold, same as in the photograph. She'd run off and left my father and in so doing had forever altered the course of his life and, of course, mine. Their marriage, so reported my mother, nearly ruined Pop's life, his prospects, his heart. This woman was one of the villains of my parents' love story. I was told that she is, or was, a succubus, a monster, hair-sprayed evil. When Mom spoke of this woman—my mother, who has been known to pray for

neglected houseplants—she grew brittle and tight. One heard thunder in the distance.

And yet, as soon as I saw her, I felt the bite of conviction. I shouldn't have been so cavalier with the truth. Real people, even weirdos and evildoers, apparently, had feelings. My lust for comedy had burned too hot.

Summoning all my reserves of grace and good manners, I looked at this woman who could have, under different genetic circumstances, been my mother, and said, "Well, you don't look like a hussy to me!"

She had a cocked grin, the lips twisted a little. Had she experienced a stroke? Oh, Lord Jesus in heaven, had I besotted the reputation of a stroke victim? She pushed the book closer to me, as though I might not sign it. My heart was bathed in shame.

"You must get your brains from your mother," she said. "Your father sure was dumb."

She said it right there in front of my father's little sister, my father's niece, his first cousins, my second.

They laughed.

*They laughed.*

I did not.

I heard thunder in the distance.

—

Hadn't I written my book, in part, to lay bare the complexity of a family I'd never quite fully understood, and who, with every story, every remembered moment, showed itself to be more original and full of love and truth and pain than I'd thought possible?

Isn't that why you tell stories, to understand the thing you're telling?

It was not until I'd attached the 356-page, 89,452-word manuscript to an email to HarperCollins that I really got it. A book is not a report of something that happened in the past, whether that past is real or imagined: The book is the thing that happened. The writing *is* the action. The art is the knowing. Which is why you cannot write what you know. You can only really write what you want to know, and what I wanted to know was:

Who is my family?

Who is my father?

Who am I?

The very act of making is a kind of question. You don't have to know you're asking the question to make great art. The world is full of artists who have no reasonable idea why they're doing what they do. The people who raked the Nazca Lines into black Peruvian topsoil probably did not read much critical theory, and fine: The heart is smarter than the brain. But at some point, if you end up thinking for long periods about your own art making, you will probably need to know what it is that powers the making, and what I think it is, is a combination of 5 percent talent and 95 percent curiosity. A desire to make, and by making, to know. You paint a painting to see what the painting will look like. If you knew before you started, why would you need to paint it?

Not money. Money's why you go into commercial real estate. Money's a courtesy the world throws at you to allow you to keep asking questions they are too busy to ask, given their vast treasuries of wealth, which have a way of filling one's day

with a whole different set of questions, such as, *Would you like to see my boat?*

———

I had spent more than a decade, nearly a third of my life on Earth, tunneling deep into the mountainside of memory, my rucksack loaded with questions, seeking what few precious gems of knowledge and wisdom might be hiding there, placing each gleaming insight into the pack on my back, climbing up the tunnel and then back down, deeper and deeper, every morning, every weekend, my lungs filling with blackness, fingers raw and worn, my family wondering where I've gone and when I'll be back, while I sat in the dark, hunched with pickaxe and chisel, seeking the light of truth about my father and me, who we were and why and what we became and where we go now. And I had found the gem, the greatest one, I believed, and had carried it out by mule and train to the world, and in one hateful utterance—"Your father sure was dumb"—the woman at this Memphis bookstore, my father's first wife, who's probably very nice on your average day, took my questions and what treasures I had pulled from the earth and kicked them down into the endless tunnel and collapsed everything and laughed about it.

I didn't know how to react: Everybody was still giggling. Part of me wanted to refuse to sign this woman's book.

And God was like, *Chill.*

And I was like, *I want to shame this lady.*

And God said, *She's an idiot. Sign her book. Move on.*

And I thought, *I want to grow to enormous size and shoot lava from my fingers.*

And God said, *You cannot shoot lava from any part of you.*

*Can I slash her tires?*

*You have people waiting,* said God.

Indeed, I'd called her a hussy in my book, and she probably wanted to spew lava on me, too, because if you write a book about real people and enough people read it, this type of thing is bound to happen. I couldn't go getting sensitive now. You mine for precious stones, you get a little dirty.

I stood up and hugged her and tried to make it a real hug, which is hard for me.

"Thank you for coming," I said. "It means a lot."

"Oh," she said. "I wouldn't have missed it."

———

That same weekend in Memphis, I stayed with my older half sister, Tanya. We share a father, but not a childhood. She was not in the book.

One of her greatest accomplishments happened when I was ten and she was seventeen and called our father to tell him she had just married a man who was twenty-seven, at which point my father sat speechless for thirty minutes, a world record. He put the phone down, and quietly explained to my mother what Tanya had done, and then he sat there in the recliner and stared out the window like a man who'd learned exactly what he'd just learned.

Finally, after half an hour, he spoke, a man rising out of a coma.

"Tell us about him," Mom implored, trying to snap him out of it. "Where does he work?"

"McDonald's," Pop whispered. "He works at McDonald's."

Tanya and the older man's marriage worked, for a time. She was not with child, as was suspected. Eventually, they had two sons, then divorced. The boys had grown up with their father, far away. The children were adults now, off somewhere in Texas. I had these two nephews I didn't know at all, and a sister I also didn't really know. Family's weird like that.

My sister was mostly alone, at night, on holidays, and maybe for the first time in my life, that seemed sad to me. It had taken writing a memoir to recognize feelings that had been lying there, waiting to be felt my whole life.

Tanya is funny, in many ways, thoroughly and completely guileless, probably the most perfectly transparent human I've ever known who's not under the age of seven. No thought is secret with Tanya. She's like those Antarctic jellyfish whose central nervous system you can see. The good news is, she won't lie to you, which is also the bad news. For example, the day she arrived in Savannah for Pop's funeral, she walked into Mom's apartment, my mother's eyes red with endless weeping, and looked around and said, "Oh, God, I hate those blinds."

This is what we love about Tanya.

When I arrived at her house in the midst of my tour, not having seen her since the funeral a year before, expecting, I don't know, an embrace, a smile, something after my long drive on a hot June day, in which I'd driven hundreds of miles with the windows down, she opened the door and said, "You look dirty."

"I just drove five hundred miles with the sunroof open," I said.

"I hate sunroofs."

I'd forgotten how much she likes to hate things. We caught up, discussed all the things she hates in addition to sunroofs. When I asked about local coffee shops, where I might get a little work done, she informed me that she hates coffee. I asked if she had any beer, to which she replied that she also hated alcohol of any kind, especially beer.

"What about wine?"

"Oh, God. I really hate wine."

"Do you hate joy?" I asked.

"What does that mean?"

"It's a joke."

"I don't hate joy," she said.

"Coffee and wine bring me joy," I said.

"Jazzercise brings me joy," she said.

———

I tried to put her in the book. She was there, in a few chapters. Debbie said to take her out, said it was too distracting, this minor character with a different mother who lived in a different house across town. So I took her out. I cut my half sister out of family history. It felt cruel. But Debbie was right. Tanya's story was not that story.

"Are you recording this?" my sister said. "Is this going to be in your next book?"

"Maybe," I said. "Can I write about you? You wouldn't mind?"

"I don't care," she said.

"I will make fun of you," I said, "but I will try to do it with love."

"Maybe it will help me get a man."

"That's the spirit."

"I love hot guys."

That's one thing she doesn't hate—hot guys.

We spoke about her love of hot guys, and where hot guys might be located.

"Probably not at Jazzercise," I said.

She was married at seventeen. She was now forty-seven. I knew it must be hard.

"There's always church," I said.

"I tried church," she said.

"I bet you hate it."

"I do."

I couldn't argue with that. Churches can be frightening places, full of friendly old people.

We went for a walk together in the unshaded heat of an early evening. I generally find brutal heat to be a tonic, a cleanse. I like it. I needed it, after the psychological torments of my turbulent and emergent fame. It struck me in that moment that I'd never walked anywhere with my sister, really. Ever. Maybe Opryland, once, eons ago? I felt deeply and strangely happy, walking with her, talking about her marriage, about that day she called Pop to break the news. She told me everything. I said a little prayer of thanksgiving that art had made this moment possible.

"I like walking," she said.

"I'm surprised," I said. "I would assume you hate to sweat."

"I don't sweat."

"Oh."

"I hate not sweating," she said.

All of us are looking for something—success, greatness, hot guys, thin hot pagan guys, girls, readers, bestseller news, fame, glory, riches, sweat. Maybe these are all just different names for love. I had begun to miss my family.

———

The day after my reading in Memphis, Tanya gave me a thick stack of pages.

"This is my memoir," she said.

"You wrote a memoir?"

"It's about the foibles of being single," she said.

"There's a big market for foibles."

"It's probably crap," she said. "I hate writing."

"Of course you do," I said. "Can I quote the funny parts in my next book?"

"Sure."

What might I find in there? Something terrible about her or our father? Would it reveal sexual abuse? Demons? Dark secrets? In that moment, frozen terror surged through my heart: Is this what it felt like to be one of my family members, knowing a book had been written about us? It was a little terrifying, for I knew my sister would not lie in it.

Later that day, when I was alone, I began reading it.

I had underestimated my sister.

It was, without a doubt, the most beautiful memoir I have ever read.

She wrote just like she spoke.

## SOME OF MY FAVORITE LINES FROM
## MY HALF SISTER'S MEMOIR

- *Men are sexual beings.*
- *Not all men are perverts.*
- *I gladly accepted the gifts because bras and panties are costly.*
- *The very first date was with a biker guy who was handsome and had celiac disease and spoke about why he was eating only the meat on his hamburger. One guy had really pretty blue eyes but could not converse for anything plus he had a criminal record. They supposedly did background checks on each one of us, Hum!*
- *I met one guy without ever seeing his photo, which will never happen again. He told me he was attractive, but he was not. Who told him that, his mother?*
- *I'm never interested in looking at their penises.*
- *It's their nature to want stability and be loved, not just fornicate.*

This book was a marvel of unvarnished truth. I told her she should title it *Don't Look at the Penises!* Perhaps Debbie would be interested? It could be a Broadway musical, even, rollicking and cautionary. Her trademark candor permeates every line. It took me twenty years to write like that. Why had she written it? For the same reason anybody writes anything, I guess: She was just trying to talk to someone, to be less alone, to ask questions, to find the gems of wisdom in her own dark earth, to determine the answers to life, the universe, everything.

There in her driveway, on my way to another book event, in another city, in another part of the state, I rolled down the window to let out the stale hot air.

"Goodbye," I said to my sister. "I love you."

I had never said this to her before, but something about her book made me want to say it. I felt like I understood some little piece of her, for the first time. We were not so different. I also hated things and wrote them down in a book, for others, the way she had for me.

"Love you, too," she said.

We hugged through the window, and I drove away.

# CHAPTER 17

*You will become way less concerned with what other people think of you when you realize how seldom they do.*
—DAVID FOSTER WALLACE, *Infinite Jest*

MANY YEARS AGO, WHEN WE LIVED IN NEW ORLEANS, MY wife met Jude Law. She and her sister were driving down Magazine Street and there he was, a god, those eyes blue as glacial melt, and that face, threatening to overheat the polar ice caps, globally warming the loins of our planet, *People's* Sexiest Man Alive.

"Stop the car," Lauren said to her sister.

He was in town filming *All the King's Men*, if I recall.

This gesture of visible desire was quite uncharacteristic of my wife, who rarely chases anything that has not been recently united with margarita mix. But there she went, calling his name out like they were lovers.

"Jude!" she said. "Jude, is it you?"

She hotfooted it half a block and found herself lifted off the ground, carried toward Jude Law by the tractor beam of his chin. She hovered there, staring, wanting, and trying not to touch his face, like he was Jesus. She got his autograph. She may have volunteered to bear one of his children. The details are spotty.

This is one way to measure a certain kind of worldly success in publishing or film or professional sports: Are strangers getting lost in your eyes on the street? Are people accosting you in public and demanding you provide evidence of having met them, commanding you to pose for a selfie or provide an autograph, a lock of hair, or one of your fingers? It varies by fan.

Two months into my book tour, minor variations of these incidents were growing more common, selfies, autographs, sweaty handshakes. I had even been chased down the street, in Sewanee, Tennessee. I was walking topless, and the various young musicians of the Sewanee Summer Music Festival stared, because they believed I was dying of some rare skin disease, which I might've been.

"It's a fungus," I said to passersby. "It's harmless."

From nipples to navel, my torso looked like a map of the Lesser Antilles. I normally would've been clothed, but my nipples need light and air to thrive. Just then, as a coterie of young flautists appeared to laugh and point at my skin malady, I heard a voice exclaim, "Harrison Scott Key! Is it you?"

The voice came from the mouth of a comely young woman, stopped in the middle of the street, in a small blue car. She got out, carrying a copy of my book.

"Yes?" I said, wishing I'd brought along a towel or at least an oriental folding screen to cover myself.

"Will you sign this?" she said, trying not to look at me.

I signed her book and she departed.

The flautists stared with more respect, I felt. I waved, and they moved on.

———

Walking back to the Sewanee Inn, I felt altered, my body aquiver with the potentialities of being adored. I needed to stay humble, yes, of course, for the meek shall inherit the earth. Was it possible to be accosted by a fan on the street and remain meek? I was merely trying to get the book wedged into the hard blackjack oak of America's unconscious, so that it might live there forever and contribute to whatever interior and imaginative life this nation yet nourished. Could one do that and also inherit the earth?

I called Lauren to tell her.

"It's just like what happened to you and Jude," I said.

"Jude did not have fungus," she said.

"I love you," I said. "I miss you."

"Don't let too many sexy girls see your fungus."

I had to explain to her that my fans were mostly librarians with bad teeth, which was actually preferable. Librarians asked the best questions, seemed the happiest ones to be standing in the book-signing line.

I was growing quite familiar with the heft of a Sharpie. Bookstores and auditoriums had become, somehow, over the course of the summer, as if by magic, reliably half-full. Never

before had I been presented with so many gifts! How kind America turned out to be! Shirts, hats, rice, chocolate, wine, whiskey, scotch, rum, beer, tomatoes, squash, hot peppers, hot sauces, books, paintings, concert tickets, gift certificates, cigars, bowties, neckties, cash prizes, rugs, mugs, a commemorative pen with my name printed on it. I found it all remarkable. Often these gifts were homemade, pottery pieces and embroidered handkerchiefs and leather belts with my name already branded into them, which made me believe the people who made them probably had access to tanning chemicals and a dungeon. This is one of the most exciting parts of being famous, meeting people who wish to embalm you for their terrarium.

Having fans was terrific and terrifying, I have to say, and I made great efforts to have meaningful interactions with each one, even when they said unexpected things in front of the book-signing table, like the nice lady who leered down at me and explained how my dead father sounded like a child abuser and probably belonged in jail.

"Thanks for reading!" I'd say.

I met many interesting readers that summer, readers galore, readers too wild to be believed, who insisted I come shoot hogs on their land, offered me marijuana, implored me to buy whole or term life insurance—whatever my needs were—readers who invited me to Pilates, handed me mixtapes, pamphlets, unpublished manuscripts written in a genre they called "Christian thriller," which I assumed must be a story about the risen

Lord and his disciples driving around in an RV solving social justice mysteries.

I shook hands, high-fived, became a hugging machine, wrapping my arms around men, women, children, those I remembered and those I didn't, as well as complete strangers who were merely shopping in the bookstore and had wandered too close to the Hugging Area.

Hugging became so deeply enjoyable, in part, because it served as a distraction from the more impossible task of signing books in a manner that befit my tender newborn reputation as a prominent author who simultaneously exudes wit and pathos on demand, which is impossible, as I do not generally exude both wit and pathos without strenuous effort and a shot of something flammable, which then ruins my penmanship and ability to spell. Nevertheless, I tried. I wanted to be a kind, attentive, non-celebrity author by personalizing as many books as possible, which proved to be one of the great unforeseeable difficulties of my new daily experience.

## STANDARD AUTOGRAPH

*To Rita,*
*Best,*

*Harrison*

** OR **

*Darren,*
*Fine meeting you!*

*Harrison Scott Key*

## PERSONALIZED AUTOGRAPH

*Rita,*
    *I can smell you from all the way over here!*
*XXOO,*

                                     *Harrison*

**★★ OR ★★**

*Darren,*
    *You look pretty good for a burn victim!*
*Try aloe,*

                            *Harrison Scott Key*

Not that people enjoy being called a burn victim, but in that particular case, Darren had just told me he'd been out at the pool all day and actually had a pretty bad sunburn, while Rita had apologized for reeking of barbecue because she'd been smoking chicken for a softball fundraiser. So it wasn't cruel, what I wrote, I hoped? I wanted each autograph to be a little performance, and I found this increasingly difficult, the longer I stayed on the road, when fatigue worked its magic.

Occasionally, I found myself confronted by potential threats of violence.

"Hey, um, yeah," a vaguely familiar man asked, at a bookstore in Alabama, when it came his turn in line. We'd gone to high school together in Mississippi, I knew that much, but that's all I could remember. "I got a question about that mean dude in that one chapter," he said.

"You mean the dude who tried to whip my ass?" I said.

"Yeah," the man said. "That was Ricky, right?"

"It depends," I said. "Are you Ricky?"

"Ha, ha," he said, which could mean *yes* or *no*.

"Who am I signing this to?" I said, hoping to hear his name.

"Calvin," he said.

"Are you Calvin?"

"Why the hell you asking me that?" said Calvin or Ricky. "Now sign it! And make that shit funny."

"Sign something good," everybody said.

"Go fucking wild!" they said.

"Make it personal!" they threatened.

"Perform!" they said. "Dance, monkey!"

Quick! Take out a piece of paper and write something clever on it while a person you haven't seen in a quarter century stands over you like a prison guard and declares loudly for all to hear that one time in chemistry you pretended to make a phone call with her shoe, which you have no memory of and can't imagine your ever being so cavalier about infectious disease that you would hold the shoe of another person to your head.

Quick!

Be funny!

Write it longhand! Make it pretty. Do it while your body is so depleted of necessary nutrients and sleep that you wouldn't be able to remember having lost your virginity to this poor woman in a baptistery. Go, do it, now!

"Who should I sign this to?" I said.

"Carla."

"Is that you?"

"It is."

"Where are you from, Carla?"

"Actually, could you sign it to my brother, Ed?" she said. "He'll relate to your story. He's in prison for attempted murder. He's my brother. Well, he's not my brother. But we did used to be engaged."

Quick! Write a funny quip to incestuous Ed, in jail for attempted murder. Go! Do it!

I found interactions with old friends and acquaintances both more fun and also more threatening, as these exchanges were occasionally filled with surprise information, for example, "Dude, in college, you were kind of an asshole."

And I'd say, "Really?"

I did go through a rough patch there for a few decades, and I was slowly beginning to see just how rough the patch might have been.

"You were a real jerk to me," some old pal would say.

"You were mean," they'd say.

And I'd have to think about it.

What I wanted to say was, *The ass in this situation does not seem to be me.*

But what I said was, "Man, I'm sorry. I really am."

And they'd say, "Congrats on the book!"

And now I'd have to sign their book and say something nice.

What I'd want to sign was, *I remember when you were nice.*

But what I'd sign was, "You look pretty good for a burn victim."

The truth was, I *didn't* remember them, because maybe I *was* sort of an ass in my earlier and more vulnerable years. And that's when the irony washed over me like a warm summer rain. In my book, I had attempted raw naked honesty, and these people had perhaps noted this and were simply returning in kind. Truth tellers get truth told to them, also. Had I learned nothing from the hussy? All this foolishness, I could see, had become the mechanism of my sanctification. In the Christian religion, *sanctification* translates literally as *God kicks your head repeatedly like an angry mule in labor*. It is a trial, this mule, and this tour was my mule.

I took the offerings of whiskey and the kind congratulations and the manuscripts and the declarations of my shortcomings as a human and I said, *Thank you, mule*.

## TWO WAYS PEOPLE INTERACT WITH YOU AT PROMOTIONAL EVENTS

- What New Fans Say
  - "We just love you!"
  - "My book club was so tickled!"
  - "The chapter on marriage saved our marriage!"

- What Old Friends Say
  - "You a bald motherfucker now, ain't you."

I was tired, and thrilled, and sleeping in an endless cyclotron of hotels and guest rooms and friends' apartments. I recall one especially drugged night that summer, as I slept in an

apartment on Monuments Avenue in Richmond, Virginia, the home of an old friend, Daniel. At three in the morning, a great tumult of noise erupted and a man stood in the doorway of this bedroom, japing and cackling.

"Hey! Hey you!" he said, as I slept. "Are you Harrison Scott Key?"

I felt hot acid in my hands and feet. The tour was whipping my ass and I now wished to return the favor to this man's ass, or perhaps his head, by removing it from his neck and hurling it into the street. He kept calling my name. I was dead asleep five seconds ago, remember, my soul emptied out, the insides of me haggard and ashen, to match the outsides.

The grimacing man seemed to believe all this was hilarious. I had to fly out early to another city, to prepare myself psychically to be told once more I was long ago an ass by people who were clearly themselves also asses and I needed rest to prepare for all this ass-to-ass action. I did not know this man. Daniel's friend, I guess?

I may have said some things to this fool that may not have been kind. I may have declared his mother to in fact be a she-goat, his father a pederast. All the stowed away anxiety of this damned tour erupted in a volcanic moment at this howling man in the doorway as I hurled insults in preparation for a ground assault. I was shocked at what came out of my face.

I may have said, *Shut the fucking door or I will break your ass-face.*

He shut the door. I wedged it closed and went back to sleep, assuming my friend Daniel must now be dead somewhere, at the hands of this meth head. Sometime later, the meth head kicked open the door again and I rose and prepared to swing

at him and as I did, he stuck a Nerf gun through the crack and shot me in the face.

The madman cackled. I saw him no more.

I lay there in the dark in this unfamiliar apartment, chest pounding, sweating, in a bedroom where Daniel's young son usually sleeps, the room filled with Legos and Millennium Falcons and such, an oscillating fan hurling air at me in the dark. What was happening? I didn't behave like this.

The notion came to me, as notions often do, in the twilight of failed sleep: I had not written a word in three months. I'd been checking the Internet instead, trying to get and measure my fame. I needed to write. I was art-hangry. I'd been unable to process the meaning of everything that was happening. Events and faces and scenes shot through me like rays of raw energy. Life was passing through me, falling away all around me, and I had no way of catching it, to understand it, to stop time. I prayed a prayer to be more human, to enjoy this grueling stretch and not transform into some kind of were-author, and somewhere before finishing the prayer, I fell asleep.

The next morning, as I left, I found a note in Daniel's handwriting. "He just really wanted to meet you," he wrote. "He's a huge fan."

# CHAPTER 18

*I'm just like anyone. I need love, and water.*
—PRINCE, in his first TV interview

IN SUMMERS, WHEN I WAS A BOY, MY FATHER WOULD WRITE these sweet little notes for me in the morning, left on the kitchen counter.

> *Boy,*
>> *Spread gravel*
>> *Finish sod*
>> *Kaiser blade dog yard*
>
>>>> *Pop*

It was like a little love haiku. He wrote me one every morning.

> *Boy,*
>> *Wash the eaves*

*1 part bleach, 3 parts water*
*Do it right this time*

Pop

Like parents of every generation since the dawn of human-kind, I am sure he felt a certain urgent disappointment in what he perceived was the luxurious sloth of my daily existence.

*Boy,*
    *It's some mold on the bricks around foundation*
    *Use rest of bleach*
        *Happy birthday*

Pop

By the time I could hold a shovel without hurting myself, around age ten or eleven, my older brother, Bird, three years my senior, had already achieved escape velocity from our little penal farm and spent many summer days elsewhere, often up at the Pearl River, where I imagined him surrounded by a half-dozen swamp angels smelling of coconut and Coors Light. Work will do that to you, let the imagination wander to impossible scenes. There seemed to be a toxic knot of something inside me, I couldn't say what—anger, maybe, frustration, a nascent worry that perhaps life had no meaning. Whatever it was, this feeling, this metaphysical nausea, was hard for me to comprehend as a boy. Sometimes I think it was guilt, for what, I don't know, or maybe it was worry that God would wipe us all from history, should he see fit to do it. I wanted to do my duty, in case I should be called to account for it.

Working like a draught animal helped me process my feel-

ings of dread and create meaning where my mind told me none was. Work helped me make sense, I guess, and I had to make sense fast, for all the work had to be done before Pop got home. I'd eat a piece of toast and study the list, dreading it, but knowing that I would do it all, and be deeply satisfied I had.

"You better start before it gets too hot," Mom would say. "Happy Birthday!"

I sweated and slung the blade and laved the brick. My mind would spin off into new galaxies as my body was dying, overheating, and I just kept going, and there was anger in it, and I'd push past the anger and get to this weird place where all the physical exertion became a kind of purifying tonic, and I pushed and pushed, knowing Pop would be home soon, and the hotter and harder I pushed, the more the toxic thing inside my brain got melted, and in lurches and leaps a peace would overcome me.

Mom would bring out a fat glass of tea and ask me to lie down.

Part of me wanted to work so hard, I'd die. I thought it might be nice for Pop to see me dead, after all that work. It would serve him right, for parenting. I'd lie down on the driveway, feeling dead in the frog-hot Mississippi summer, covered in grass and abrasions and cow dung and chemical burns, and let the stored-up heat of the gravel work its magic on me while the sound wall of cicadas put me to sleep, a hand towel over my eyes.

I'd hear him pull up and stir myself to a sitting position.

"Looks good, boy," Pop would say.

I came to love this hard-won feeling, this sacral burning, of pushing the body and mind as far as they would go until a

holy thing happened. It's possible that this is why I became an artist, the pursuit of this psychosomatic exhaustion, of a beautiful thing finished for my father, but only after great suffering.

———

By midsummer on tour, I had begun experiencing unfamiliar tremors, physical and spiritual. The work was not finished. The holy thing had not happened yet, and I was starting to see what I was after, with all this running: There was guilt in it, absolutely, a wicked survivor's guilt, that the book I'd written about my father had won, for me, adoration and treasure. This ridiculous and improbably long tour was a sacrament, a means to resurrect him, and a kind of death wish. I would work myself ragged, to just this side of dehydration and heat exhaustion, the way I had as a boy. Maybe it wasn't God I feared, but the thing I thought my father was—a spirit, hovering over me, expecting me to work until I could not.

I'd driven what felt like ten thousand miles, hugged ten thousand torsos. I felt like a man gripping the wing of a plane five miles above the earth, happy, exhilarated, near death at every moment. Death, or some kind of apotheosis, felt, it's hard to say—imminent. Lauren would call this a panic attack, but I wasn't panicking: I simply felt as though demons were hovering over me, preparing to suck my soul out of my skull with a straw.

"That's a panic attack," Lauren said, when I described it to her via text.

My dream was trying to kill me.

I needed a fat glass of water. I needed to lie down.

But I could not.

"Are you okay?" an interviewer asked, at a radio station in Jackson, Mississippi.

My head was on the table.

"I'm fine," I said into the Formica. "I'm just dying."

The man sounded worried.

"Are you sure you want to do this now? We can reschedule," he said.

But no. I had a talk to do that afternoon, at Lemuria, where everybody I'd ever known in the great state of Mississippi would be waiting to congratulate me and perhaps explain what an asshole I'd been to them one day many years ago, at which point I would be compelled by the never-ending need for sales to thank them for their honesty and friendship and then pretend nothing hurt and hustle to the next town to do it all again, when everything hurt.

I was a professional. I did my interview.

But I needed cool. I needed water.

*Hydrate*, the blog had said.

In my experience, the coldest place in Jackson in summer is the Waffle House on Northside Drive, where I oft spent afternoons reading, and I soon found myself dying in a booth while the staff occasionally prodded me to see if I was still breathing.

"I'm alive," I said.

"We just checking," they said.

Lemuria was up the hill, a few hundred yards away. I needed a hospital bed, a cave.

*Please don't let me die*, I prayed, head still on the table.

I was praying to Terry Gross. She was my god now, this beautiful brilliant little demiurge with a haircut like a crimini mushroom and a laugh like fondue chocolate.

My prayer was that I might create enough psychic tremors in the cultural seismographs of WHYY in Philadelphia, where Gross and her microphone hovered slightly off the floor, to get an interview. One call from Terry and I could stop all this foolishness. Thirty minutes with this incisive inquisitive probing fairy beast lady would send the book into the ionosphere. If I could make her laugh, the book would be a bestseller. If she could make me cry on air, the book might get elected president. I'd seen it happen. Just having the title of one's book spoken aloud by her voice on the radio can send a book up the Amazon list by a molecular recombination licensed by NASA for sending supplies to the International Space Station. Do a good interview with Gross and when you leave the studio they hand you a roll of stickers that say *Now a Major Motion Picture.*

## MY BOOK TOUR ITINERARY, ROUGHLY

**6:30 a.m.** Wake. Think about writing. Don't. Check email for messages from Phillip regarding overtures from *Fresh Air.* None.

**7:30 a.m.** Pack. You are missing all your underwear.

**8:30 a.m.** Drive. As you are driving through the South, your healthiest breakfast option is to stop at a convenience store and eat all the napkins.

Everywhere, you seek fruit. *Apples*, you say.

*Apples?* the man says at the counter. *No apples.*

*Bananas, oranges, anything?*

*We have Hostess Fruit Pies*, the man says.

Drink juice; smoke your breakfast. You will die. You are dead.

**9:00 a.m.** McDonald's. Buy a sausage biscuit and throw it out the window a mile down the road, because you don't want people to congratulate you and think, *He must really like sausage biscuits.*

**10:00 a.m.** Miss your routine. Miss your family. Miss that sausage biscuit. Call your wife. Say, "Good morning."

"Everyone has diarrhea," she says. Those without diarrhea have gone feral. She is running out of migraine pills. She is dying, too. The girls shout into the phone, which your wife has left with them for a few minutes while she moves to Iceland.

**11:00 a.m.** Think of all your friends in neckties sitting at desks longing for adventure, of pulling off on dusty rural highways to urinate into the carcass of a rotting armadillo. You are living the dream.

**11:30 a.m.** Remove shirt. Feel like a boy with a kaiser blade. Think of the great authors of American history, a silent chorus of judgment declaring that authors aren't as hearty as they were in olden times, when Hemingway slugged every third audience member just to demonstrate his overwhelming virility.

**2:30 p.m.** Check into hotel. Go for walk, which is unfortunate, as this hotel is on a highway where people only walk if they are out of gas. People honk. Some throw garbage.

**4:30 p.m.** Note that two people have favorited the tweet about tonight's event and both appear to live in Germanic nations far from here.

**6:00 p.m.** Enter bookstore. Meet Eric, sales rep for HarperCollins, who has come to see you and calls you "Bubba." Do event. Feel holy and alive. Hydrate. Drink water that may actually be Riesling. Drink so much you are sure it is not water.

**10:00 p.m.** Have first real meal of the day with Eric or whomever is kind enough to invite you to dinner, the HarperCollins money having run out long ago. Ingest tamales, pizza, catfish, onion rings, steak frites, bourbon, all the Pinots, cheesecakes, bread puddings, yellow cake, chocolate cake, gelato, burgers, curried rice bowls, leaves, grass, small children, an array of family pets.

**12:00 a.m.** Tell everybody you have to leave, no more food, no more drink, please, while everyone looks at one another in astonishment. Why would you leave so soon? THIS IS YOUR PARTY.

**1:00 a.m.** Check Internet. Photos from event and subsequent revelry are already live and accreting comments. Fall dead asleep as a baby on the rich and full teat of loving mother. Prepare to wake again in five hours and do it again.

If this sounds like fun, it was.

If this sounds awful, it was.

"Isn't it amazing?" everybody said, of the tour.

"Aren't you having so much fun?" they asked.

And I was, because every day feels like a wedding day, full of beauty and meaning and poetry and delicious foods and alcohol and crotch sweat and dumb show, and you spend all day in physical discomfort while being petted and then at some point you sweat a lot and dance like you're on fire and drink and don't eat enough and hug many old friends and have a grand time and die a little because it's all so much, and your dress is starting to smell and you can't locate any of your underwear, and at some point, you are certain, one night, during one of these weddings, you are going to run from the altar screaming because your face is melting off, but man, it's fun!

I reminded myself that I was doing it all for Terry. I was calling to her through the atmosphere the way dying whales do.

You hear, from time to time, about musicians canceling tour dates for nebulous reasons, usually "respiratory infection" or "vocal strain," which I always assumed was code for "injuries associated with vacuuming powdered Adderall off the thighs of a woman who's seen things nobody wants to see."

After my experience on tour, I knew: This was not always the case. Some of those celebrities were simply dying in Waffle House toilets. In these moments, throughout the fiery season of my crackling infant celebrity, as I trembled and palpitated behind locked doors while eager and mostly non-insane fans queued up at that very moment, I hid myself away, leaned against disinfected walls, sweating, dizzy, cold, desperately longing to be home with my people, *The Office* reruns in my eyeballs and a daughter's head on my shoulder. I slid to more than one bathroom floor that summer, praying not to die, not yet. I tried hard

to remember, to summon the image of Harrison shuffling into his shoes at five in the morning on a dank and lifeless Monday before a dank and lifeless workweek so long ago, the friendless, breadless, boneless aquatic bird I had been, falling through the sky of this dream wilderness. I had made it so far, and now the dream was real. Why couldn't I stand and enjoy it, the asses and the hugs, the adulation and remonstration and atmosphere of mostly forgettable hysterics, every piece of this madness, the whole insane carnival of it?

But I could not. I sat on the toilet floor. I needed to sleep for a thousand years.

And then, I heard a voice.

*Do not be afraid*, said the voice.

And I knew, it was an angel of mercy. Our Lady of Perpetual Questions.

*Is it you, Terry?* I said.

*Rise, my son*, she said. *For behold, I bring you glad tidings of great joy which will be for all the people who have made arrangements to be here this day, a Thursday, which is difficult, as you know, having children and many commitments, as they do.*

I rose, washed my face in cold water, and departed this august house of waffles, obtained a banana from a more urbane convenience store, and also Advil and Extra Strength Tylenol, which I chewed like a wild animal, to get the precious tincture working, washing it all down with a gallon of tepid water from a battle-scarred Nalgene. I drove to Lemuria, up the hill, my hometown bookstore, and sat in the parking lot, trying to quiet the mind.

My phone rang.

A New York number. I answered. It was one of Phillip's assistants at HarperCollins.

She said, "How's it going?"

I said, "My organs are shutting down."

She said, "Oh. Okay. Well, *Fresh Air* wants to do an interview."

# CHAPTER 19

*Woe to you who laugh now!*
*For you shall mourn and weep!*
—LUKE 6:25

WHEN YOU'VE GONE UNPUBLISHED FOR SO LONG, STRAINING every cell in the sloshing meatsack of your corporal vessel to create something new and beautiful while the best years of your life drip off the eaves of your soul like dirty rainwater, it's a little unreal to know you're going to get to share your story with 4.5 million listeners, which, based on a highly complex algorithm, comes to a total of approximately nine million individual ears.

I texted Mark the news.

*Liar,* he said.

I texted Lauren.

*Woah!* she said.

And Debbie.

*Wow!* she said.

And Mom.

*I have another sinus infection*, she said.

An email from Phillip, two days later, explained that NPR wanted to do a pre-interview, to make sure I was not insane. I tried to imagine what the interview would be like. It is public radio. Anything can happen. One minute they're discussing domestic terrorism and the next minute they're giving away tote bags. It wouldn't be easy: Our Lady Gross doesn't just bring you on her program and knight you with her ten-decibel Neumann studio mic. She asks tough questions. She's not afraid to call you a terrible person in a really nice way. You have to tell her your inmost secrets and allow her to say, *Wow, I had no idea you were so full of darkness and evil.*

Why would *Fresh Air* listeners care about my book? Well, the book was about people, and many NPR listeners are people. But I needed more, a hook, an affiliation to things other people cared about. Maybe race?

The book was most definitely about the South, shot through with descriptions of what racism looked like to me as a boy. Being a reasonable white person from a place like Mississippi, especially if you live around reasonable people from other places, means you get to spend most of your adult life being asked to explain the unexplainable, to elucidate the marriage of liberty and bloodshed that your homeland gave flower to, and all the tragicomic alien weirdness that comes out of that flower.

Mississippi is a bounteous kingdom, birthplace of American music and American literature and American terrorism. Elvis and Jim Henson and Archie Manning and Emmett Till and Medgar Evers, and the people who murdered Emmett Till

and Medgar Evers, too. It is a glorious and violent place, frightening and wild and radioactive with human pain.

"Isn't everybody down there a racist?" a man on a Chicago street asked me one day long ago, when he saw my Magnolia State tag.

"Yes, everybody," I said. "Some of us can also juggle."

———

Did America really need another white guy on the radio explaining how racist he wasn't?

I spent the next week listening to every *Fresh Air* interview for the last six months. During that time, among many historians, journalists, showrunners, film directors, et al., Gross had interviewed the following super-famous people, which was blowing my mind, that I was about to be among their number:

- Neil Patrick Harris
- Larry Wilmore
- Benedict Cumberbatch
- Bradley Cooper
- Bob Odenkirk
- Michael Keaton
- Colson Whitehead
- Larry David
- Philip Glass
- Adam Driver
- Billy Crystal
- Toni Morrison

She had also interviewed a number of celebrity memoirists, including Gloria Steinem, actor Illeana Douglas, *Portlandia*'s Carrie Brownstein, Patti Smith, and designer Donna Karan, as well as a few prodigiously talented non-celebrity memoirists, such as Chris Offutt (*My Father, the Pornographer*), George Hodgman (*Bettyville*), Steve Osborne (*The Job*), and Sally Mann (*Hold Still*), and as a result, everybody was now talking about these non-famous writers' books.

Terry, if I may call her by her first name, had become for me an object on which to fixate doggedly, lost as I was in this great miasmic ether of my book tour. So much of self-promotion, that necessary adjunct to creative success, is swatting at an invisible flying mammal in a very dark cave. Nobody really knows how to make contact with the flitting creature of fame, and so you throw everything you've got up into the air, hoping to make contact, wildly, desperately. Looking back, I can see how the voice of Terry Gross gave me something to echolocate and search out, in the darkness, as I flailed blindly across America.

———

The pre-interview call came from a producer I'd heard many times on the radio.

"Harrison?" he said.

"Yes, hi!"

The half hour flew by. We discussed the book a little but eventually, as I feared, conversation turned mostly to themes that really lived at the margins of my story, such as race and the Confederate battle flag, dammit.

"Blah, blah, blah, systemic oppression of a people blah, blah," I said.

*Stop it*, I told myself. *Be funny! Tell your story! Talk about your father!*

"Blah, blah, ideology blah, blah, signifier blah, blah, mass media," I said.

*Good lord, man! Stop it! What are you doing?*

"What some people don't seem to understand blah, blah, blah," I said.

*Stop being boring, you boring jackass!*

It's like I'd taken a fatal dose of Dullbutrin. What I tried to say is that I had a theory, which is that the Confederate flag had become a universal American symbol of adolescent impudence, which I know, because many of those people tried to run over me with their trucks during my youth. The more these folks from back home think the flag bothers somebody, the higher they're going to wave it. Why? Because they can. Because bellicosity is in their blood. Because it's so easy to upset people who read Sontag. This is what I tried to say, in a funny and relatable way, but it came out all wrong, and then the pre-interview was over.

It's fine. It was fine. I did fine.

I checked my Amazon ranking. In two months, my book had climbed from number 35,777 to number 1,567, and I was about to skyrocket into the bosom of almighty bestseller-dom, once Terry said my name on air. All that work that my father taught me to do, all the hustle, was paying off.

And then a few days later, Phillip sent an email.

"They're going to pass," he wrote.

"What do you mean?" I wrote back.

But I already knew.

# CHAPTER 20

———

*Dreadful beyond dreadful . . [sic] no garbabe [sic] can would accept it!!*
—AMAZON REVIEW, *The World's Largest Man*

A S A RESULT OF MY TRAGICOMIC AND SPEEDY REJECTION BY the literary kingmaker known as *Fresh Air*, one thing was certain: My book would never become a bestseller. This, I saw, was the realization of almost every author who ever authored a book. Students would not be assigned to read it, Barnes & Noble would never place it among their high-traffic tables. The end was nigh. My dream to become a great American author had come true, or at least a good American author, or an author with American citizenship, which was fine, or would have to be, and now the Ferris wheel of my success was coming around and slowing down, to let me off.

It had been a good run.

What had happened in my audition? Had I been boring, as I feared? Yes, absolutely—boring, and irrelevant, and not at

all funny—which is how Phillip had pitched me, the funny author, oh, you must hear this man! And they had heard me, and had not been impressed. I should've been prepared, should've done three shots of Wild Turkey. How could I have been so insouciant and foolish?

So, I was rejected. It's fine. My career was over. It's fine!

But wait: Why was I so disappointed in my Terry Gross rebuff? What was my dream, again? Was it to write a book, or was it to get famous by writing a book? Was there a difference? Everything I'd ever prayed for had come to pass, and yet my ambitions felt unsated.

The problem with your dream coming true is you never quite know when it happens. It's right there in the nonfinite verb form of *dreams coming true*. Nobody knows when the moment actually occurs. When I was a boy and heard my parents fight over money, my dream was to make enough money to not fight over money. When I saw how unhappy Pop was in his work, largely a result of seeking and failing to gain riches, my dream was to be happy in my work and not seek riches. When I was older and saw how many Wet Wipes the children used in the span of a single hour, my dream was to seek riches.

This wish did not come true. They did not pay me enough money to quit the day job, working at the college. You have to write a lot of books for that to happen, apparently. Like, maybe five? Or get one turned into a movie that wins an award? I don't know.

I slouched through my tour, driving through the old American colonies, Georgia to the Carolinas to Virginia to DC to New York to the roof of a friend's Astoria apartment

building, staring at the hulking majesty of Manhattan, working my way through the three stages of Publicity Grief:

Disbelief.

Benadryl.

Public Nudity.

I put on a nice smile for all the nice people, whose numbers had suddenly plateaued. I walked through their cities topless, my fungus clearing a path, looking for anything—answers, direction, sunstroke. I felt nothing, was numb from the head down, walking barefoot through parks along Charleston Harbor and the James River and the East River, towel around my neck, a man without a cabana. I found moaning pleasant, like my parents, before me.

It would make me feel better, I decided, to read my Amazon reviews. I'd been ignoring these reviews for two months. They were just too personal, gushing with unchecked adulation and vitriol. Reviews help nobody. Everybody knows that. It's masturbation or masochism or both. I hadn't read a review in months.

I'm lying.

I'd been reading them every day. Because, I mean, if a tree falls in the woods, and nobody's there to give it five stars on a website that also sells toilet paper, did it really happen?

———

Reading these reviews was awesome and terrible, like opening a magic box that contained a new thing every time you opened it—a ruby, a square of chocolate, a mutilated kitten, a new phone, a cold beer, a bouncing beagle puppy, two mutilated kittens, a box of Popeye's spicy fried chicken, a scented candle. Nobody wants to see a dead kitten, a dead kitten hurts your

heart, but every time you click the link, the promise of a Red Lobster cheddar biscuit is enough to make you look in the box, and that is what I did. A lot. This was one of the terrifying delights of becoming an author, this ability to go on the Internet and find out exactly what people think of you. The heroin hits your bloodstream instantly.

*Wonderful*, one review read.

*Brilliant.*

*Stunning.*

*Defies categorization.*

*Fabulously wicked.*

*Heartbreaking.*

*Lots of crying.*

*Moved to tears.*

I tumbled through all this interstellar glory, celestial bodies of self-congratulation spinning out beautifully in every direction. Art is hard. It's nice to read nice things about what you feel is your life's calling, although not everything was a nice thing.

*Disappointing*, they said.

*Fecal matter.*

*Superficial.*

*Pathetic.*

*Awful.*

Imagine this. Imagine spending a decade painfully alchemizing every important question about yourself and your family into an epic work of art, at which point a man visits Amazon.com and declares, *Come on, man*.

Every time I'd read a new negative review, blood and hot oil rushed into my psychic brain pan. The eyeballs quivered,

my pants got real tight. What was wildest was how *I knew some of these people*. One was a former colleague, another was one of my wife's friends. One was a pastor. What the hell. Didn't they know I read these? Did they not care? What the what had I done to these people?

*Mr. Key needs a new editor*, they said.

*Seems like he's trying too hard.*

*Then the author gets married, and the whole book goes downhill.*

What a thrilling rush, to read such personally injurious sentences. The good reviews only dull your sense of self, an opiate, but these hateful reviews, wow. This is a lightning flash in the front yard. This is getting a pencil shoved up your nose by a neighborhood child you don't even know. It makes you feel alive.

The sickening truth: I'd said worse about my own work. I'd said worse about certain brands of cereal on Twitter. Somebody made that cereal. Somebody got up every morning and tilted the chalice of their everlasting soul into the important work of the manufacture of that cereal product, and maybe they'd read that tweet. Had I thought about that? Had I considered how much vitriol I'd leaked from my own Stygian heart into the zeitgeist?

From the Astoria rooftop, I called Mark, told him about *Fresh Air*.

"That sucks," he said.

I read the reviews to him.

"These people sound like they want to hurt you."

"Can you come on tour with me?" I said. "You can drive. It'll be like one of our old road trips."

"Will you pay me?" he said.

"I can pay you in memories," I said.

---

The thing you need to know about reading bad reviews of your book or your film or the new bar you just opened or your new dental practice, all of which can now be reviewed by any psychopath with Wi-Fi, is that they are not just hatefully reviewing your product: They are hatefully reviewing everything, writing epic one-star review essays, with numbered points, about the following:

Harbinger Pro Non-WristWrap Vented Cushioned
    Leather Palm Weightlifting Gloves
Westclox Travelmate Folding Alarm Clock
TheraBreath Dentist Recommended Dry Mouth
    Lozenges
Hello Kitty Flower Sheet Set

Why? Because they can. Because this is how it works now. My only advice to you, which I do my best to follow, is to try to forget that reviews exist. Be happy when a major paper reviews your book, send your publicist flowers, but generally put the reviews out of your mind, which you can't do. You won't. You're going to have to read them, the good and the bad. You'll want to go burn some houses down. You will. It's not a fun feeling. Once you've felt that feeling, you want to never feel it again.

When you do eventually read reviews of the thing you made, there's one bit of healthy advice I can give you, a balm

for the pain: Go read bad reviews of the books (or albums, or films, whatever) that you love. I promise you, nobody's saying anything about you that hasn't also been said about George Lucas.

## ACTUAL AMAZON CUSTOMER REVIEWS MATCHING QUIZ

1. DO NOT BUY THIS BOOK

2. Too many swear words!!!

3. What a rip off!

4. Don't be FOOLED!

5. garbage

6. Short on plot

A. *The Great Gatsby*

B. The King James Bible

C. *A Midsummer Night's Dream*

D. Fruit of the Loom Men's Basic Brief

E. Charmin Ultra Soft Toilet Paper

F. *The Adventures of Huckleberry Finn*

Answer Key:    1-A, 2-C, 3-F, 4-E, 5-D, 6-B

A work of art is a love letter and not everybody wants to fall in love. The heart has to be tilted in the right direction to see what beauty, goodness, and light are there. Sometimes the heart wants nothing but to make war with the art it encounters, because the heart is a confused place, because maybe the heart is just on Twitter a lot, who knows. Everybody's upset about something.

Some people hated my book. I hate many books, too. Hating books is actually kind of fun, especially when every-

body loves those books, and some people did love my book. They did. I had to keep reminding myself of this, as I sat on the apartment roof, a hundred million more book events to go.

I did my meetings in the city, did my reading in Brooklyn. I had dinner with Cal and his wife, Cassie, also an editor, and another editor, Laura, and her husband, Danny, and a funny writer named David, and before the meal I reminded myself to say a silent prayer of gratitude, that I wrote a book and was somehow now having dinner with editors and writers in a Greenpoint restaurant called Fire or Stick or Baby or Sack or Fig or something. My life was actually kind of amazing.

———

I found Mark at the bottom of the escalator at the Northwest Arkansas Regional Airport in Bentonville.

"You look like hammered shit," he said.

We drove to Fayetteville, Little Rock, Dallas, Austin, New Orleans, where audiences were modest and old friends showed up for hugs. We gave away coolers full of beer and handed out prizes and I tried my best to slay every audience, to give it all away to the good people who showed up. I saw Dayton, the old friend who used to be Rob, who also convinced me to do my first play in college. I saw Eliza, who'd edited so many of my stories for the *Oxford American*. I saw Brian, an actor-turned-bartender-turned-entrepreneur, and I saw Miller and Miller's wife, Jessica, old friends who had three or four dozen children, apparently, and drove them around in an old Lincoln Town Car limousine, feeding this horde of beautiful children buckets of yogurt and oats, like animals. It was all quite lovely, seeing

everyone, wondering at how anybody ends up with their own lives.

I saw Derric, a high school friend and former hip-hop-dancer-turned-community-banker who brought me a flask. "Something tells me you need this," he said. We hugged. The hugs were real, now. I had let go of something heavy. The pressure to be amazing was gone, and that release felt like heaven.

"How are sales?" friends asked, in each new town.

"My book has cancer," I said. "Pray for it."

In New Orleans, my cousin Emily threw a party. I held cold bottles of rosé next to my face, each new town, each mile on the odometer reforming my soul back to anonymity.

Mark and I drank warm beer and shot Lone Star beer cans with a pellet rifle in a parking lot beside a bar, as the hot dry wind of Texas blew through the pecan trees and made us feel ageless. We rocketed through summer as troubadours of old, transforming bookstore readings across the countryside into bacchanalias of literature and crowds of ten to fifteen. I felt happy and alive, for the first time in a long time, unfettered by ambition, unable to care that what I had hoped might happen would not actually be happening. Contentment is easy when you have no options. I had become vocationally covetous, desirous of acclaim for its own pitiful sake, which had burdened my capacity for joy and shackled my heart. I felt lighter now. At every event, every bookstore and bar where I had been invited to read, I encountered every human as a gift, haloed in light. I looked upon these people, old friends and strangers, like a thirsty wayfarer looks upon a benevolent innkeeper. Gratitude filled me like cool water from an unknown spring.

"Thank you for coming," I said, to everyone, shaking hands when none had been offered, pulling arms and chests close, embracing all who would allow it, full-bodied hugs that lingered and allowed us to exchange odors and heat, like good hugging should.

"Thank you for coming to our town," they said.

"Thank you for having a town to come to," I said.

"It's nice to meet a real author."

"You are the one who it is nice to meet."

"Okay."

"You didn't have to come here tonight," I said. "But I did."

"I guess that's true."

"Let's hug again."

"Okay, if you want."

In Austin, near the end of the tour, Mark and I stumbled down a grassy hill to the Barton Springs Pool on a hot bright day, and I invited the cold prehistoric water from deep inside a Texas aquifer to wash me clean. I laid on the carpet-soft hillside next to my best friend, drying, warm, eyes closed, seeing nothing but the blood orange sun through my fleshy lids.

"Thanks for coming," I said to Mark, lazing somewhere off to my right.

"It's fun," he said.

"Why don't you write a book?" I said. "If you did, we could tour together."

"We're already touring together," he said.

A few days later, I boarded a plane in New Orleans, bound for home.

The dream was done. I did it.

Sort of.

# CHAPTER 21

*Juan Ponce de León went to Florida in search of the River Jordan, that he might have some enterprise on foot, or that he might earn greater fame than he already possessed.*
—Memoir of Don Hernando d'Escalante de Fontaneda (1575)

I ARRIVED HOME ON A SUNDAY afternoon to find my former life in ruins. I'd been mostly gone since spring. It felt like a year, a lifetime. In the living room, Lauren had rearranged the furniture in creative and unfortunate ways, her way of telling me that I was dead to them. My chair was in a whole other quadrant of the room. I didn't recognize the place.

"Hello?" I said. "Hello? Anyone home?"

The house was in disarray. Fruit flies had colonized the breakfast nook. In the dining room, I found Effbomb (now six years old) drinking from a bowl of water on the floor, like a dog, while another child wailed in the hallway about how her panties felt on her body.

"I hate them," Beetle (now eight) said. "I am literally dying of hating my panties."

"Where is your mother?"

"These panties are hurting my feelings!" she said.

Upstairs I found Stargoat (now ten) sitting under a desk reading *The Pilgrim's Progress* with a flashlight like some kind of Christian terrorist.

I finally discovered Lauren in the bathtub, dying.

"I'm dying," she said, clutching her chest.

"Of what?"

"It's a heart attack. My third one today."

"You're not having a heart attack."

"I've had one every day for the last three months."

"You're very strong."

"I'm the strongest woman alive," she said. "Also, my face hurts."

"What part of your face?"

"The face part," she said.

"Face cancer," I said.

"Face cancer," she confirmed.

I didn't have the heart to tell her I'd have to leave again, that the tour was not exactly over, that the book festivals would soon be pitching their white wedding tents across the land and I would have to disappear again, in search of those tents.

"The children seem distraught," I said.

"They're broken," she said. "Something inside them broke."

"They're drinking from bowls and eating food off the floor."

"They're eating?" she said. "Good. That's good."

"I should do some laundry," I said.

"Welcome home," she said.

I gathered up the children and presented them with many gifts—T-shirts, candy.

"You look old," they said. Whole sectors of my beard were now white.

"Shave your beard, Daddy," they said. "Shave off the white. It's scaring us."

They embraced me, despite my haggard appearance, as did Lauren, when she finished dying in the bath.

"Read to us," the children said.

In those moments at home with my family, I felt, by degrees, my heart being stretched by some benevolent force, the walls of it sagging with gladness and exhaustion, making room for new dreams, while somehow also providing more space for my own. My heart hurt with happiness to embrace these children. I felt like a man traversing a permafrost desolation who'd closed his eyes beside a dying fire, knowing he would never wake up, only to open his eyes and find himself naked in a hot spring, holding a bowl of steaming ramen, my daughters the noodles.

Being apart from these people had worn the walls of my family thin. I thought of my deployed friends, Army folk, men and women who disappeared for six or twelve or eighteen months. It is a divine gift that any military marriage does not end in divorce. One has to be made of iron and mercy. I was no soldier, but had missed many moments. When you're not there, whether you're out stitching harelips or eradicating giardia or fighting the enemies of freedom or reading aloud from a book for strangers, history will write you right out of the story.

"Let's go out to eat," Lauren said, gathering new life. "Let's celebrate."

I wanted to eat at home, at my table. To touch it, lay my head on it, lash myself to it with the tattered remnants of my hopes and dreams. Over the next few days, I took the girls to the pool and let Lauren lie on the bed and stare at the wall, which is what her dream was, now. That first week back, she hid in quiet rooms like a cat.

I'd find her in the guestroom, the lights off.

"Are you okay?" I said.

"Quiet."

"What's wrong?"

"Where are the girls?" she said.

"Outside."

"Don't tell them where I am."

It was nice, not pretending to be famous anymore. Lauren seemed happy to have me home. Daughters are a lot of work, especially when they're constantly covering their bodies in Nutella and glitter like it's Burning Man.

"Don't ever leave again," she said, that first night home, in bed.

Our love was stronger than ever.

"I won't leave," I said, "for at least three weeks."

———

It was over, but it was not over. An archipelago of festivals and conferences stretched out to the end of the year and around the horn of an unknown continent and into the undiscovered land of this whole other year, which might contain a paperback, should HarperCollins deem it so, based on what data I could not say.

And so we would limp on, I guessed, the way those old conquistadors did, Pizarro, de León, de Soto. My mind turned frequently to these and other fearless Eurotrash, God bless them. What were they after? The fabled waters of a New World River Jordan that might grant eternal youth? A city of gold?

At some point, in all their many thousands of arduous miles over water and swamp and red dirt and piney woods, you know that they knew they weren't going to be finding these things. Maybe a little gold, sure. Maybe a nice natural spring in which to rest their searing flanks, absolutely. Gorgeous unfettered primitive beauty of a kind they simply had never seen before, with such creatures in it, yes, yes, but no age-altering geysers, no streets paved with platinum. When you see that the thing you're after is probably not going to be found, what do you do? I mean, they hadn't searched every square inch of the Americas, had they? Something had to be hiding just over the next hill, no?

My dream had come true, but also, the truth of the dream was now mutating, and I was not sure what to make of that. Do I keep going?

One ineluctable fact: Most conquistadors died on the road, on the way toward something they never quite reached. Perhaps every dreamer does. The dream just keeps evolving, birthing new and more complicated dreams, every new road forking into three new roads of joy and possibility and potential death. It's hard to know when to stop and celebrate with that beer.

I had worked for decades to learn to turn on the spigot of human laughter at will. Why would I voluntarily shut it off now? Isn't this the life I wanted? And so, I was off once more, floating like a ghost among the many book festivals of

our land, happy gatherings of authors and readers, piles of books under tents, green rooms hidden beyond velvet ropes, filled with room-temperature ham.

One thing you learned about festivals is, everybody thinks you're being paid to be there, but you're not. This is not Coachella. Almost nobody is getting paid to be there, except the bestselling authors of many dozens of books about subjects like murder, and also murder, as well as sex and murder. Some festivals pay for your room, if they enjoy a well-oiled fundraising apparatus. Some festivals give you an honorarium, enough to buy tacos from a truck.

If you go to festivals with a debut novel or even your second or third one, probably, you'll more than likely be spending a year or two buying your own plane tickets and hotel rooms and spending $200 for room service bread, which must be buttered with your own hands, which means each festival costs upwards of $1,000, which is a lot of money for a man whose family burns through panties like they invented cotton.

The upside is gift bags, filled with all sorts of luxurious giveaways, for example, gift cards for restaurants that do not open until several hours after you need to be back at the airport, and samples of cash crops and regional exports, like a pound of enriched parboiled rice, which comes in handy when bartering with local tribes.

The handlers are kind. They drive you places. One day, on my way back to Reagan International, I asked the driver, "Who's the most famous person you've ever driven?"

"You!" he said.

"Do you know who I am?"

"You are the Harrison Scott Key!" he said, looking at the sign with my name on it.

"You had to look at your sign to remember," I said.

"I drive many peoples."

He was from Cairo, he said.

"Do you read many books?" I asked.

"The Stephen King is very good for reading."

"Yeah, he's a good one."

"Do you write like him?"

"I use some of the same words."

"This is very good, maybe I like you, too!" he said.

When I got out, he waved.

"Thanks for the ride," I said.

"Goodbye, Robert!" he said.

I woke up one morning in another alien hotel room and a fevered panic, realizing with horror that I could not remember the color of my lawnmower.

Where was I? Los Angeles? Fairfax? Halifax?

The next night, on a ridiculously beatific autumn evening in a palatial courtyard in what turned out to be Nashville, at the foot of a large bronze statue of a nude Victory, surrounded by many authors, of which I seemed the newest and worst-selling, I could see, yes, so much is striving, that you work so very hard and so very long in solitude and madness to find your calling, your voice, your book, your publisher, your readers, that when it finally happens, it can be a shock to see how many more people have already done this, and done it better than you. It's like Sir Edmund Hillary and Tenzing Norgay had arrived at the top of Mount Everest to find themselves largely ignored by a cocktail

party in progress and then accosted by the mayor's wife, who wanted to know if they'd tried the pork sliders.

I walked home from the party, alone, sagging through the streets of Music City like a man in a Randy Travis video. At the hotel, I sat down with my book, its cover gnarly and rubbed raw from being tumbled about a hundred airports and Ubers. Pages had begun to fall out. I flipped through it, alighting on a passage, then another, startled by what I found.

"I wrote this," I thought. "This is what I wrote."

Some of the writing, I felt, was a little silly. I winced, a few times. Other times, I marveled. I could hear ambition and desire bulging up through every clause. I had wanted so badly to be great at something.

The book seemed heavy now, heavy as a man's casket. I thought of my father. The book *was* him, in a way. It was weird. Clearly, I was doing penance out here, on the road, and why? It was silly, how difficult I'd made things on myself. I was living my best life, and everybody knew it but me.

―――

I sat in airports in every time zone in North America and watched the faces of the people. Which of them had a dream? Who was living it? Who was almost there, but not quite? It is very difficult to tell who is happy just by looking, unless they were one of those people at the Atlanta airport eating Popeye's chicken for breakfast. The expressions I saw all around me told stories—hope, longing, a belief that some better future is out there, just ahead, at the next city, the next day. Sometimes, you think you see it, like a large bird in the trees, obscured by the spidery branches of panic and fatigue, there, yes:

A look.

Hope.

Confidence.

Faith.

Peace.

Fire.

You see it everywhere, on the faces of everyone on television, sidewalks, tarmacs, escalators, sports arenas, the faces of humankind striving for greatness—gold medals, research grants, green cards, the big sale, the white whale. Remember what happened to Ahab? I guess that's the lesson of so many stories. Be careful what you dream.

In October, in another airport in another alien city, I received my first royalty statement, via Debbie. The document was three pages of grids and tables. It looked like the lab results of a cholesterol test, featuring many interesting vocabulary words like:

*Subtotal of Deductions*

*Subrights Earnings*

*Payment Due*

*Payee Share*

*Advances*

*Unearned*

*Canada*

But how many books had I sold? How many books is enough? Enough to not be embarrassed when you visit your publisher's office? Enough to be able to purchase a jet ski without regret or shame? Nobody knows.

"Ten thousand," Debbie said. "That's a good target."

Even she sounded a little tentative, like she wasn't quite sure, either.

## HOW SALES WERE

- No. of Books Sold: 4,118
- Total Actual Earnings for Me: $11,770.84
- Which Means HarperCollins Paid Me: $0
- Because They'd Already Paid Me: $305,000
- Which Meant I Technically "Owed" Them: $293,229.16
- Which Meant, to Earn My Advance, I Would Need to Stay on the Road Until the Year: 2075

HarperCollins was not going to make me pay this money back, and there was more good news: My lawnmower was yellow! I remembered.

But what color were my children?

And when was my wife's birthday?

Everywhere I went, everybody asked, "Is your wife with you?"

"No," I said.

"Oh, I wanted to meet her!" they said.

They wanted to see what she looked like, I suppose, to see if I'd made her up. The book had made her more famous than me.

"We would be friends, I think," they said of her.

———

"You're a strong woman," they said to my wife at church, while I was off, somewhere, on the road. "How do you do it?" they said.

And she fed the girls and dressed them and managed their hair while I slouched in a chair in the sky somewhere over America, trying to pay for the house in which they refused

to get dressed, and then I'd land, and Oh, God, it's beautiful, it's autumn in Savannah, warm and cool and clear as glass, and they're all four waiting in the front yard, Effbomb on the swing, Beetle on the sidewalk, Stargoat next to Lauren on the steps, now running to the car squealing, "Daddy! Daddy!"

The Uber driver said, "You are a lucky man."

And I said, "I am."

The condition of the year was one of absence, of visiting, of being a guest, everywhere, even in my own home. Once, at church, an elder greeted me as a visitor.

"How are sales?" everybody asked.

Nobody asked if I was having fun, or if it was wild, living my dream.

What they asked was, "How are sales?"

"Selling many books?"

"Sales strong?"

"How are they, generally?"

This is one of the questions everybody asked. They wanted to know about numbers. They wanted to measure my success. Which is frustrating, and perfectly illustrative of the contradictions of the American dream, which is that you will want to quantify it, so that you can assess your progress toward it, and this is impossible, for the target will never stop moving. What they are really asking is, *Are you a victorious conquistador, or not?*

*Yes*, I would've said, had they asked.

Another question everybody asked was, "What's your next book about?"

"Writing another?"

"Will it be a memoir?"

"A novel?"

This, too, revealed another paradox of the American dream, that the urge to conquer and create and do something new will not let you sit still and enjoy what you have made. I didn't want to think about what's next, but people wouldn't let me not.

"How long did it take to write your book?" everybody asked.

"Nations rose and fell," I said. "Empires were founded and crumbled."

Sometimes, they asked real questions, the kind that go deep down.

"You wrote a book about having a father," one man said, somewhere in Virginia. "Are you a good father?"

And I said, "I am a terrible father. I haven't seen my children in years."

And everyone laughed, which is what people do when you tell them the truth.

I was gone every weekend that fall, and came home every Sunday night, and now I saw a look on my wife's face that I thought I'd never see again: She missed me. What a glorious thing, to see a woman who's seen you in all your ugliness and wants to kiss you anyway. Just a little one, right there in the yard, while the girls dig in your pockets for candy from the gift bag.

"What did you bring us?" they asked.

"Premium long grain rice," I said.

I stood with my wife in the kitchen next to the calendar and marked all the days I'd be gone, what I would miss, every weekend in September, October, November, February, March, April, May, stretching out to the edge of eternity, de Soto re-

fusing to stop, moving the hulk of a dying dream to a golden city that simply is not there.

"Remember how hard we worked for this," I said.

She was tired. I was tired.

At every turn, together, we had done the impossible thing, and climbed onto a new ledge to discover that a dozen impossible things were still required of us both.

It was cool now, fall. The backpack was heavier with sweaters.

"Don't you need to go to the airport?" Lauren said, jostling me awake at four o'clock in the morning. I'd slide out of bed and into my backpack and float to the airport in the dark. I would not be making my family breakfast today, or taking Lauren a cup of coffee, to say thank you in this ridiculous trifling way, thank you, thank you, for letting me make a dream real, for allowing it, nurturing it alongside me. No, I would be in a truck, in a cab, a Lyft smelling of dead things and mountain berry Glade deodorizer, miles away, preparing to cross borders into unknown lands like the mad conquistadors of old, heading to another airport, looking deep into the Georgia night and wondering where I was going or if I was already there.

# ACT V

---

## WHAT NOBODY TELLS YOU

# CHAPTER 22

—

*I think about all the encouragement I've received over the years. Are people just being friendly? Or do they hate me?*
—JACK PENDARVIS, *Movie Stars*

NOW WHEN I CAME HOME FROM TOURING, EVERYTHING WAS fine: The children were in the kitchen, conjugating their Latin. Lauren would be darning a sock, the cat reading a book. Was this a quiet rebuke, to show me how unnecessary I was to the operation of their happiness? Or was this a gift, to show they were appreciative of my enduring labors on their behalf?

"I want you to come with me," I said to Lauren, one night, as I unpacked for the eightieth time that year.

"Where?"

"On tour."

"We can't afford it."

It was true: The money was getting low. I'd been roving the continental breakfasts of North America like some lone dragoon in a Cormac McCarthy novel, stashing foodstuffs in

my pants for later. I could've had a whole other career performing in magic shows for hungry children, making chicken wings appear from my sleeve.

"We have a little money left," I said.

"Plane tickets are insane," she said.

"I am not going to beg you to come with me."

"Then don't."

"Please," I said. "I'm begging."

"The money," she said, pretending to be the responsible one, the way she likes to do.

"You're famous now," I said. "People want to meet you."

"I am not famous."

"My readers don't believe you're real. They want to know why you married me."

"Nobody knows that."

She played on her phone in bed. What madness was this, that she wouldn't come? For a decade, she'd been a mule to whom the children cleaved like Velcro. The woman couldn't find personal space if you gave her a pike and a roll of razor wire.

"What in the hell is wrong with you?" I said. "It's a vacation. You need this."

"Your mom can't handle the girls for three days."

"My mom will not let our children die."

"Your mom doesn't even know how to use our microwave."

"They'll be fine."

"The money," she said.

"Fine," I said, hurt. "Fine. I'll take Mom."

I owed it to my mother. Here was the woman who'd carried me in her womb, who'd provided half of the family's household

income as a schoolteacher, who'd driven me to the library as a boy. She'd made this dream possible, hadn't she?

Here was the woman who always said, "You have so much talent."

The woman who said, "So handsome. Your forehead is a little big. But so handsome."

———

"I'm glad you're here," I said to Mom, on the plane, a few days later.

"I think it's fun," she said. "My son, the famous author!"

"Don't expect hordes of adoring fans," I said. "Just so you know. This is how publishing works. You write a book and nobody comes."

"I'm sure people will be very excited to meet me," she said.

"I'm sure."

"I'm so proud of you," she said, patting my arm. "I just want you to know."

When the beverage service began, I asked for a tiny bottle of bourbon.

"What time is it?" Mom asked.

"Noon."

She studied the tiny bottle.

"Are you an alcoholic?" she said.

"No, Mother."

I poured the tiny bottle over ice.

"You're one of those alcoholic writers," she said. "I've read about it. All writers are alcoholics. Are you? You are."

"Can you get me a pillow?" I asked a flight attendant. "I need to asphyxiate this elderly woman next to me."

"You think I'm old," she said. "I could show you pictures of my friends. They look dead."

I closed my eyes and tried to sleep and thanked Jesus for giving me a mother who loves me and asks if I am an alcoholic, despite the fact that on many occasions I have witnessed her killing a box of California Red like it threatened her family.

At every book event she attended that year, she gloated over me as though I was a large prize-winning hog, marching me around the bookstore and presenting me to old school-mates, second cousins, support beams, doorjambs.

"Have you met my son, Scott?" she said.

I should say: Up until young adulthood, I went by my middle name, *Scott*, which my father preferred, because *Harrison* simply had too many syllables, which to him made it sound foreign. *Hank*, *Luke*, *Jack*, *Scott*, these names are brusque and artless, like a good American boy. At age twenty-three, the year I wrote my first play, I started using my full name, *Harrison Scott Key*, because a young creative professional with no talent needs a way to distinguish himself from other young talentless people.

Mom had initially supported this decision, at least a little.

"How fun, Scott!" she said.

"Harrison," I said. "That's what I go by now. It's a good writer name."

"You will be successful at anything you do, Scott!"

"Harrison."

"Oh, Scott, we're so proud!" she said.

———

Nearly twenty years later, my mother was very excited to get to call me *Scott* constantly in front of people who now knew me

as *Harrison*. She'd sit down beside me in the signing booth and commence to bewilder everyone.

"This is my son, Scott," she said.

"Harrison," I reminded her, as I'd been doing since the Clinton administration.

The thing is, it's very hard to pretend to be famous in the waning season of your first and perhaps only book while your mother is explaining to everyone in line that she gave birth to you and can call you whatever she wants and also when you were a baby, you had a staph infection around your rectum, the scars of which are still evident, should my readers wish to know.

"Call me *Harrison*," I'd say. "It's on the book. It confuses people."

"Why did you even change it?" she said, getting loud. Other people were staring, deliberating, were we fighting? Was this real? I didn't know. Did she?

"Oh, do you actually go by Scott?" readers asked, when Mom started this routine.

"No," I'd say.

"He's an alcoholic," Mom would say, to everyone standing around.

It was like a spiritual ATF raid. Do you see Billy Ray Cyrus chasing Miley around the VMAs going on about how she used to be Destiny Hope Cyrus? Did Sarah or Hagar or Lot go on breaking Abraham's balls constantly after his name change?

*You'll always be Abram to me*, they didn't say, as they fought off Gomorran warlords.

It's not like I'd asked her to call me *Sonja* or *Captain Peanut*.

"Harrison," I said, right there in front of everyone. "Say it. Harrison."

It's important to remember that this whole time, three or four people are staring, waiting to have their books signed.

"Are you ashamed of who you are?" she said.

"I'm ashamed of who you are," I said.

"Don't be so sensitive."

"One day you're going to need me to push you in a wheelchair," I said.

People would laugh at all this, while I entertained visions of rolling my mother's future wheelchair into light traffic. Was this her unconscious retaliation for my having written so transparently about the family? Was she seeking a hidden vengeance for my emptying out the psychic closets of our crumbling ancestral manse? Didn't she know I could drown her?

Yet she seemed genuinely proud. The joy that beamed from her face as she enacted these performances, it was obvious she was having great fun. I decided not to drown her, not yet. There was time still. America has many rivers.

At one bookstore, my mother sat there surrounded by a few old friends, and I stood up and drank from a bottle of water and began to speak. I decided to read from a whole new section of the book, something I hadn't yet auditioned for a live audience.

As I started to read, it dawned on me that the story I'd chosen contained quite intimate details and conjecture about my mother's emotional inner life, and there she was a few rows back, beaming. I could see it coming a few lines ahead and wondered if I should censor it. But my psychic torpor had diminished the capacity for complex problem-solving at high speeds, and there came the perhaps overly revealing passage

about Mom, and I plowed right through the delicate parts like a fat baby rolling over a sack of taco shells, and I hoped, prayed, that Mom enjoyed the attention, was flattered to be in a book, but wow, it was true stuff, real stuff, and as the laughter died down, I could feel everybody looking at the back of my mother's head and wondering if she felt it, too, this hot, bright, naked truth about her, just being spewed across a roomful of strangers by her son. And then we all came up through and out of the hole and it got funny again, and they laughed, and she laughed, and it was over.

"What did you think?" I said, after.

"I think people enjoyed it," she said.

"I mean, was it weird?"

"Weird?"

"To see all those people hearing true things about us?"

"I wasn't really paying attention."

"Mom."

"Son."

"I hope you had fun," I said, giving her a hug.

"I did. I always do. I just wish your father was here. He was so proud of you, Scott."

I guess, deep down, I knew she was calling me *Scott* because that's what Pop called me. She had let go of so much of him in these last few years, but not that, not yet. Every time she said it, she heard him saying it, too. That, and she liked tormenting me, because she's funny, because that's what funny people sometimes do. I'd said funny things about her, which meant she got to say them about me. This is how it worked.

I gave up correcting my mother, which is one of the things comedy lets you do. The woman could call me whatever she

wanted. I stopped asking her to stop. It kept things real, never too far from the hard, heavy earth in which everyone, in time, is buried. One day she'll be gone, too, and I'll desperately want someone to call me *Scott*, or an alcoholic, or both, and nobody will, and it might be a little sad. Funny things always are.

———

And then one day, at a bookstore, while she was making jokes in the audience, it clicked: *Wait. Oh! Oh. She is part of the act.*

I'd entirely forgotten the cardinal rule of comedy, that we must plunder the holy of holies of our own hearts first, seize the golden calves we've constructed and melt them down into gold, Jerry. Gold!

All that discomfort I felt about my name was an idol, representing the false god of my fame, a god which I now knew was perfectly imaginary. Mom's gentle pasquinade had exposed the idol. I suppose it was the last thing I was holding on to, as my little book became less and less popular. With this revelation, I could no longer pretend to be important. As funny and "real" as I pretend to be, like every good American I still lie to myself about so very much. My tour had revealed many of these lies, and I know these falsehoods will continue to be stripped from me until death.

Finally, I knew what to do. I'd come up to a microphone in this or that city, engaging in gentle comic banter with the audience, clearing my throat, about to begin, and she'd interrupt.

*Do you need some water?* Mom would exclaim, from the audience.

*Ma'am?*

*You've got phlegm.*

She'd be saying this from about six rows back, while everyone watched.

*I'm fine*, I'd say.

*You need a lozenge.*

*I don't need a lozenge, thank you.*

*Here, pass this lozenge to Scott.*

*Can somebody remove this woman?* I'd say.

*You just try it.*

*I can have you killed*, I'd say, into the mic.

*Then who would come to your readings?* she'd say, bringing the house down.

Something was happening, had happened. I was being transformed. The fame and glory I had sought dithered away, and the journey now beckoned me into even weirder new realities.

# CHAPTER 23

———

*Why do people go on cruises? Nothing good ever happened on a cruise.*

—LAUREN KEY

"HOW WAS IT?" LAUREN ASKED.

"She told everyone I was an alcoholic," I said. "Am I?"

"Do you want to be?" she said.

Lauren was playing on her phone, pretending I wasn't about to beg her to come with me, next time. She wouldn't even look at me, and so I got her attention the way I always got her attention, which was to take off all my clothes.

"I want you to come with me," I said.

"Why are you naked?"

"I am not dressing until you agree to come with me."

She said, "Nope."

*Nope* has always been a big thing with my wife, as well as every other woman in my life.

"Do you know what's for dinner?" I'll ask.

"Nope."

"Do you want to work on the budget?"

"Nope."

"Do you like my naked body?"

"Nope."

It was funny, watching her there on the bed, guessing at how this marriage had worked for so long. Being married to funny people is hard, and both of us were. Lauren could have married anybody, with that smile and those eyes and her gift with children. She could have married into old wealth or new money or fabulous genes, and she chose me, who possesses none of that. It is possible she believed I was naturally thin, but no. Even when I was thin, I was not thin. I was bald, and prone to fatness, and driven mad, even so long ago, by a dream.

We were and remain so different from one another. I noted small differences even during our courtship, how she did not care for books, or live music, or any music, really. She cared only for naps and babies and *Survivor*. She was full of wisdom and had no college degrees, while I was full of college degrees and had, it seemed, little wisdom.

I liked to drive through canyons, across spillways, over high bridges, while she refused to drive even an hour down the interstate. She had anxiety, could not drive over bridges, didn't even really like *looking* at bridges. The very fact of bridges upset her.

"Why can't people stay where they are?" she said.

"None of us would be here without bridges," I said. "They make civilization possible."

"Civilization is stupid," she said.

I liked to swim in deep water, and she did not swim at all. Not in the ocean, at least.

"Come on," I said.

"Nope," she said.

Her reticence only made me like her more, and love her. It took several years of marriage before she finally admitted why she will not swim in the ocean, or in any natural body of water. I'd believed it was some childhood trauma, some Jungian fear of the baptism metaphor, of death, and I guess it was.

"Skeletons," she said, finally.

"Skeletons?" I said.

"There's skeletons in the water," she said.

"Which water?"

"All water."

"There are not skeletons in the water."

"Think of all the shipwrecks."

"What shipwrecks?" I said.

"All of them."

"Like pirate shipwrecks?" I said.

"Pirate and non-pirate shipwrecks. Dead bodies. Skeletons. Dead people. They're everywhere, and you're just swimming over them. It's disrespectful."

At the beach, she'd sit and watch, while I played in the skeleton juice with the children. This was all part and parcel of her generalized anxiety, about face cancer and leg cancer and back-of-the-head cancer, the fear of abandonment, of death, of dying. The woman had a reason to fear. She'd seen death up close in all its pathetic terror and had been abandoned by her father, the one man in the world, besides me, who'd promised never to leave, and who left anyway.

This was why she did not want to leave. This was why she kept the house clean and safe, from intruders, from uncooked chicken, bridges, skeletons. Nothing would take her away from her family, especially not me.

———

I had my anxieties and weaknesses, too. The sound of babies crying made my body hurt. This sound, the crying sound, to Lauren, was a call to holiness, the sound of God summoning her to behave in accordance with her nature, to love, while the sound of my drinking beer made her body hurt, calling her to murder.

"Can you drink any more loudly?" she'd say. "You have to stop. I'm sort of losing my mind over here."

"I have to swallow," I'd say. "I have no other means to get liquid into my body."

"You sound like a wild animal right now."

I made messes. It is why I was born. The girls and I pull out skillets and Pyrex and saucepans and arrange a drum circle. We cook, build things, cut things. I let the children touch raw meat, while Lauren waits in the corner with a vat of Lysol.

In the days of yore, when the girls were small, we fought about this and so much else. A marriage, of course, is a series of compromises, which both parties make in exchange for genuine lifelong affection, sexual favors, and health insurance, but you can't compromise everything. I did not compromise my dream, and it almost cost us everything. She did not compromise her vision of a relatively quiet domestic life, and it almost cost us everything again. But some version of both of our dreams came true, and we came out the other side, standing. Things appeared

to have worked out, which is why I stood there, now, naked, asking her to come with me, so we could pretend to be famous together.

———

"The next hotel I'm going to has room service," I said.

This got her attention. You could see her calculating the angst of leaving her children alongside the possibility of someone bringing her small pots of jam.

"We don't even have a will," she said. "What if the plane crashes?"

"Then your sister will take care of the children. Or Mom."

"Your mother will lose them in the mall."

"They'll be very happy with the family who finds them."

She knew what it felt like to cry out for a mother and for nobody to come. She didn't have to say it out loud for me to know: It had taken me thirteen years to know it.

"It's impossible to have a conversation when you're standing there naked," she said.

"Why don't you get naked, too, and we'll be even?"

"Cover yourself."

"I can't hide my light under a bushel."

"You are the strangest man," she said.

"My body is a Disneyland," I said. "Remember?"

"No."

"I can make it a Dollywood."

"I don't want to go to Dollywood."

"We have fun rides. I can be your Smoky Mountain River Rampage."

I began whooshing around the room, naked, twirling, a listless raft looking for its paddler. This new tactic was working. Her resolve weakened. She laughed, almost against her will. My nakedness does that to people.

I stopped turning and landed on the bed, before her.

"I am the most attractive man in this house, you have to admit," I said.

"I have to admit nothing."

"You're practically the hero of my book," I said. "You're part of the act."

"What if I don't want to be in your act?"

"It was in our vows," I said.

She handed me a pillow and said, "Fine."

"Just put on some clothes," she said.

What happened next was pretty astounding: As soon as the children were moved beyond a one hundred mile radius of her location, she was transfigured. She touched my arm for no reason. We had brunch, without children, which, let's be honest, brunch with children is not brunch at all but more like trying to kill a snake with a broom handle while surrounded by people drinking mimosas, and this brunch–without–children was a revelation to her. She shone as bright as she did on our wedding day, when we were both children.

We rode bikes through unfamiliar towns.

We went to dinner.

No longer was I alone, sitting in a hotel room hunched over bowls of illicit granola like Gollum. She came on the road

with me once, then twice, then again, nice people in uniform bringing her pots of jam and bowls of fruit in bed.

How glorious it was to have this woman there, to see what we'd made together, the book, the laughter, and there were people again, somehow, they had begun to arrive at my readings, as though Lauren's presence, indeed, had been the thing to bring them.

Bookstores filled, ballrooms filled.

I took her to author parties, where guests approached with eyes big as saucers and clattering white teeth to see the woman in the flesh, the woman they'd read of in a book, to fawn over her. The people who did most of this fawning were women with tasteful reconstruction surgery and good skin. They laughed and got in too close with their hot meaty Sauvignon Blanc breath and called their friends over to fawn together.

Lauren saw them coming.

"Harrison! Harrison Scott Key!" they said, shuffling, jangling, dancing over.

"You love this," Lauren whispered.

"I used to love this," I said.

"You still love this."

"I like this."

The opioid jackals always begged to know what Lauren thought of the book, of having her every secret exposed to the world. She still had secrets they didn't know.

"Tell us, do you just love your husband's book?"

"It was better than I thought it would be," she said.

"Oh, God, you're too much!"

"She's too funny!"

"This woman!"

"My goodness, I love your sense of humor! Let's be best friends."

"I'm taking applications," she said.

These fans always laughed like a stitch of hyenas at everything she said. Lauren seemed a hero to these women, the funniest human in the building, especially if she had a little high-test gin and a backup migraine pill in her purse. This woman was so full of sadness and pain and love and intelligence that it could not help but turn into joy and light. It shot out her eyes and ears and that smile, that laugh.

Every time it happened, I'd step away, out of the light, to watch her go, and then come back into the light, come up close beside her, take her hand. She'd be on fire now, going on about what it's like to be in somebody's book.

"Some of it was pretty tough to read, though," Lauren said, once, at a book festival party, surrounded by the jackals. She squeezed my hand.

"I bet!" they said. More laughing. They had no idea.

I saw what I had not seen before: These women were skeletons in the water, menacing phantasms from the deep, threatening to drag my wife where she did not wish to be. The ladies were sweet enough, a little drunk and loud is all, but they knew secrets about her, us, our life, thanks to my rambunctious dreaming, and Lauren did not seem to know how to reckon with their knowing. This is why she had not wanted to be here, I think. But she was here. If my book, in part, had been a love letter to her, then her presence here, with me, in the bookstores and ballrooms of North America, was her reply. She would swim with me in the deep water, over the bones.

I took her hand, was part of the audience now. The ladies drew in close, and the loudest one brought up her hand, as if to prevent me from hearing a whispered secret she wanted me to hear anyway, and said, "So, Lauren, what's it like to be married to a famous author?"

My wife turned to me, her eyes dancing across mine, and a smile broke across that ridiculous Hollywood face that never didn't stop me dead in my tracks.

"I have no idea," she said.

# CHAPTER 24

———

*In the terms in which you set it, the problem is unanswerable; but in the Kingdom of Heaven, those terms do not apply. You have asked the question in a form that is much too limited; the "solution" must be brought in from outside your sphere of reference altogether.*

—DOROTHY SAYERS, *The Mind of the Maker*

I WANT TO TAKE THE GIRLS," I SAID.

"No way," Lauren said. "Are you crazy?"

When all this book nonsense started, I had not wanted to bring children, for how could one keep track of a child, wandering amidst the crowd? One would lose them. My wife would have me arrested. But now I knew: There is no crowd. There is no throng. The fans mob only the restroom. The five who show up scream only for more wine.

"I promise I won't let them die," I said.

"You'll forget them somewhere," she said. "They'll be abandoned at a rest stop."

She knew I was capable of placing the girls in great danger, by rolling down the windows for example, while the car is moving, or playing music at a level detectable by the human ear. The children might actually enjoy themselves. This, I knew, was her greatest fear.

"I am not your father," I said. "I am not going to leave them."

"I don't know," she said.

"You are not dying of any kind of cancer," I said. "You are not abandoning them, either."

"If they die, I will have you thrown out of an airplane," she said.

"I love you."

That night at dinner, we made the announcement.

They looked up. Stargoat, Beetle, Effbomb.

"Book tour?" they said. "Really? You would take us?"

Their heads fell off and rolled across the floor and out the door and into the driveway.

"We're going on a book tour!" they proclaimed to the squirrels.

"One at a time," I said. "Oldest first."

But the oldest, Stargoat, declined, as she, too, secretly believed I would abandon one of them at a rest stop. What was it with these women? My abandonment of them via this tour had turned them agoraphobic.

"Alright, Beetle," I said. "You're up."

She said yes. She likes rest stops. She wants to be abandoned.

"Where are we going?" she said.

"St. Petersburg, Florida."

"Yeah, baby!" she said.

"Do you know what they have in Florida?" I asked.

"Manatees! Sharks!" she said.

"Yes, yes, and also panthers."

"Panthers!" she said.

"Yes."

"Can you ride them?" Effbomb asks.

"We can try," I said. "In Florida, you can do anything you want. They have no laws."

"Woo-hoo!" Beetle said.

It is hard to tell what they believe and what they make-believe.

"This is a bad idea," Lauren said.

Maybe she was right. She is right a lot. But I have these little daughters in my charge, and their dreams will not come easy. They must be made to see fire in the world, to know it is real. We are trying to raise up fearless dream warriors here. That is why I wanted them with me. I wanted them to see what a dream looks like, in the wild.

———

A few days later, we shot down across the land of panthers and jaguars and war, Beetle and me, windows down, music up, sunroof open, past St. Augustine and Daytona Beach, the warm Gulfstream air jettisoning against our eyeballs.

"This is the best day of my life, probably," she said over the music in her truck stop sunglasses, explaining that her mother never lets her ride in the front seat.

I was unsure of the seating laws but feel they may have been updated since the Nixon administration. Where, specifically, legally, can children be carried? Beetle was inside the truck, which felt safe. I am vaguely aware of some sort of weight or

age requirement for sitting in the front seat, but who knows how much anything weighs, really, or how old children are? It's difficult to tell by looking at them.

She sat in the front, taking in the full-orbed glory of Florida through the windshield. Are children allowed to stick their heads out of the car? Beetle's head was now out of the car, like a dog, taking in mouthfuls of briny tropical air. Her joy, like that of a dog, is full and unbridled. No DVD player in the backseat can make you that happy. She was seeing parts of America she didn't even know were there.

"Dad, Dad, Dad," she said. "Look—horses!"

"Those are cows."

"Wow! Cows that look like horses!"

"Not really," I said.

We plowed deeper into the scrubby interior.

"Look!" she said. "It's rows and rows of vegetables!"

"That's called a garden."

"Yeah, baby! A garden!"

The drive was long, traffic got bad. The air changed, the light changed. She got quiet. We had two more hours to Tampa. Beetle was too elated to be cranky but tired, and the cows and gardens no longer interested her.

We would miss the author party, dammit. She would've loved that. Free food, all the cake she could want, where the lemonade flowed like wine.

She was fading. We needed a break.

But no, when your dreams come true, you cannot stop. Stopping is for the weak, the infirm, the unpublished, the dollar bin authors. Pop taught me that. And so we tilled through the brushy wastelands, the traffic thinning a little, the light low. I

didn't want to stop, but then I saw it—a celestial truck stop on a hill. We slowed.

"What are we doing?" Beetle said.

We bought enough candy to fill three or four piñatas. Beetle appeared to believe she'd won some sort of chocolate sweepstakes.

"This is the greatest day of my life," she said.

We played soccer, there at the truck stop.

This girl had more trophies than her sisters, collected them like others collect dolls, in basketball and soccer and gymnastics. She is made of rubber and enthusiasm, a champion whittler, designer of imaginary machines. Her talents are many—cutting, cooking, gluing, making, designing, building, whittling, farting, burping, crying, and farting while crying.

She has always seemed most inclined to a life of making, the first of her sisters to ask to hold babies, the one who cannot sit still, fearless on a bicycle, fearful of dogs, the licker of dirty things, the naked one somersaulting in the yard, who makes my wife most desire margaritas, given all the naked somersaulting in the yard.

"Can I at least take my shirt off?" she said, as we kicked the ball to one another.

I wanted to say yes. I don't know why. I did. The freedom in this child is heavenly.

"There are rules," I said.

"Fine."

Each of our daughters is chased by her own demons. Beetle is the most prone to displays of extremity, highs, lows. Many days of her life compete to be the greatest, or the worst, ever.

But on the soccer field, every redlining emotion dissolves into the ether. She is focused and blindered in the goalie position, nostrils flared, diving into the dirt without fear or pain.

Right there in an empty lot by the truck stop, we scrimmaged, and she forgot the candy, and I forgot the tour, the sales, the money, the time. We scored on one another in the dying light of an autumn eventide in the rare wild vastness of central Florida. It was the happiest I'd been all year, in this most volatile year of my life.

I held her hand and drove across Old Tampa Bay, delighting her with the lights across the water. This was her dream now. Everything enchanted, holding magic.

"What is this?" she said.

"This is a hotel lobby."

"What is that?"

"An ice machine."

I felt like Adam in the garden, naming things while God watched. Beetle stared, struck dumb with the existence of this machine whose single purpose is to manufacture ice for people just like her.

"Can I push the button?"

"Push it."

She pushed it.

She laughed maniacally as ice poured onto the carpet. A door opened. We ran away down the hall, laughing. We sat on the bed, ordered room service nachos and cake, took out a subprime loan on a salad. The next day, she wore my VIP badge as golf carts carried us about the grounds of this book festival.

"I've never been a Very Important Person," she said.

"You were born a Very Important Person," I said.

On Sunday, we woke at five in the morning and as we rocketed back across Florida in the dark, she vomited repeatedly on the floorboard and seat for several hours, until we got home.

"It was the greatest trip of my life," she told her sisters, without irony.

---

I did not kill Beetle, so Stargoat felt, yes, okay, this is safe.

She is the follower of rules, the acer of tests, who, when told to go play, finds a quiet chair in which to write notes of encouragement to her schoolteachers. She is studious. When she does not make the dean's list, she dons sackcloth.

She was ten now, my curly headed beauty, possessing many talents, including writing, acting, playing the recorder in such a way as to drive squirrels off the property, joke telling, reading books under tables and in closets, and explaining to her little sisters how they have disappointed her.

When she was five, she entered a school talent show with a brief comedy routine, in which she read from a page of jokes that she held so close to her face you weren't sure how she could breathe. When she was six, she entered and won a poetry contest with such powerful lines as, "Jimmy played the saxophone, and it sounded maxophone."

"That ain't even a word," somebody behind us said.

It was a proud moment.

She hugged Edna Jackson, the first female African-American mayor of Savannah, and I was, and continued to be, awed by the courage of this marvelous little child. I once

discovered in her room a notebook on which she had written, "My Top Secret Book of Scaring and Plans for Scaring."

And now Stargoat and I lit out for the edges of the earth, to another festival, once again in Florida, and she was not disappointed. She sailed through the saw grass, eyes as wide as Ponce de León's at every turn.

"Dad, they have popcorn in the lobby!" she said, in awe.

She held it up to the light like it be made of gold.

"Dad, they have extra toilet paper!" she said, in the room, picking it up, marveling, as if the hotel was El Dorado, that famed City of TP. She had found glory and majesty eternal.

"Yes, extra toilet paper is standard," I said.

"It's so beautiful," she said. "It's all so beautiful. It's the loveliest place I've ever been."

It was a Hampton Inn.

At the author party, she was doted on by many fine writers, including Richard Blanco, inaugural poet. I introduced her.

"He read a poem at the inauguration of President Obama," I said.

Her eyes grew wide that such a thing could be done, that a poet can read a poem while tens of millions listened.

"I read a poem at city hall," she said.

"That's quite a feat," said Mr. Blanco.

The next day, I read a story and did a talk, and then we drove home.

"Was it awesome?" Beetle said.

"It was amazing," Stargoat said. "Daddy was the least famous of all the writers."

Finally, it was little Effbomb's turn.

"Please do not let this one die," Lauren said.

We drove to St. Simons Island, Georgia, not far at all, but far enough to feel to this child as though she was at the very end of the earth. We pulled up to the library where I was to speak. She looked out the window toward the Atlantic, the boats nodding in the sun.

"What country are we in?" she said.

"The U.S.A."

"What language do they speak here?" she said.

"English, mostly."

"What does English sound like?"

The curiosity and earnestness at which these children take in the world is breathtaking. Effbomb has many gifts. She can still the storms to a whisper and wave a hand to silence a room. She is like Margaret Thatcher in a tiny little American body and then, in an instant, a thousand-year-old angel baby.

She was born to dance. If she hears a song, she will politely ask you to move, so that she can perform a dance for you, which you are to observe in respectful and grave silence.

"Don't look at me," she will say, dancing for you. "Stop watching me."

We checked into the English-speaking hotel, and Effbomb just could not get over it, the long empty hallways, the luggage carts. The English-speaking desk clerk handed her a map, drew a star on it where our room was.

"What is that star?" she said.

"That's the treasure," I said.

"I'm pretty good at finding treasure," she said.

She climbed onto the luggage cart, her chariot.

"You push," she said. "I will lead us there."

And she did, all three of my girls did.

———

Late that fall, six months after the book had come out, we got good news: HarperCollins would be releasing the book in paperback. They were not Old Yellering me quite yet. This good news kept us on the road even longer, allowing me to continue taking my daughters to new places that fall and into the next year, which was great, because Lauren got a promotion at the school and was now in charge of many things, such as other people, making her quite thrilled to let me take the people in our house somewhere else, and I did: I took them through tunnels on the Blue Ridge Parkway, roadside lakes, waterfalls, beaches, over the tops of mountains, into deep green basins where phones don't work, through old record stores and museums and hotels with ballrooms and heaps of bacon that made my daughters' eyes grow wide with disbelief.

"What is this?" the girls asked, beholding one of the grand visions of human culture.

"This is called a breakfast buffet."

"How much bacon can you get?"

"As much as your plate can hold."

A continental breakfast without children is a grim affair, adults slumping into chairs in the gloaming, but add children and the place becomes Valhalla.

"This is the greatest day of our lives," they kept saying.

The days were great, got greater. I was forty-one now and had begun getting paid to speak, which was wild, to get paid to

appear, which is something I'd been doing my whole life, just appearing, and disappearing, and reappearing via doors.

"What's your rate?" people asked.

"Five hundred?" I said, and they paid it.

"Fifteen hundred?" I said, the next time, and they paid it.

"Five thousand?" I said, and they did not pay it, or even call back.

I brought down my price a little, because I learned they only pay you more if you win an award, and I had not won any awards, but we kept at it, my family and me, on the road in so many new cities and glorious Holiday Inn Expresses.

"Can we make a waffle in the waffle machine?"

"Sure. We can add chocolate chips if you want."

"I can't believe it," they said. "I literally can't believe we can make our own waffles."

Sometimes I spoke in full auditoriums, sometimes in abandoned bookstores and haunted theaters. Nothing hurt anymore. The unplumbed chasm of loneliness down in me, in the place between my lungs, had been filled with three tiny people and my wife and mother and their endless surging love. I had felt so alone on so many days, for so many years, dreaming the book, and then writing the book, and then selling the book to a capricious and faceless American reader, lost in the hellscape of dreaming, and this fiery Sheol was now vanquished, gone, transformed into a harmonious green space of light and wonder and daughters. It didn't seem to matter that people didn't come to my readings, even when I gave out free beer and edible prizes. I no longer cared. I was having too much fun with my family to notice. Sometimes I brought Lauren, and some-

times I brought one daughter, and sometimes I brought them in pairs, and sometimes I brought them all, making them sit on different rows during the reading, to make the room look fuller, and then we went back to the hotel, so they could splash in the pool while I lay prone in the sun, drinking warm beer. They bought books at every store, volumes about dogs and sharks and adventure.

"Oh no! What's happening?" Beetle said, in the car one day.

"What is this?" Effbomb said.

"It's just rain," Lauren said.

"Daddy, what is this?" they said.

"Rain."

"Make it stop!"

"It's just rain."

"God makes it rain so we can have trees and grass," Stargoat said, trying to calm her little sisters down while also patronizing them, a gift all oldest children possess.

"But why is God doing this to us?" Effbomb said.

She hit the window, defying God. The wailing grew. Now even Stargoat was crying, as Effbomb had mistaken her face for the face of God and hit it, too. We slowed down and drove so very slowly, eschewing the strained hurry of interstates for the laze of rural routes and county roads, and the sun came out as corn and woods and chicken houses pressed up against the windows. We slowed more. I could now make out the scenes of my life in real time, as they happened, and it was a gift, a paradise.

"Daddy, daddy, what is this?" they asked. "Is this a city?"

"No, this is a gas station."

"Is that a zoo?" they asked.

"No, that is also a gas station."

Everything was beautiful and dewy and new.

"Look at all the towels!" Stargoat said, touching them.

"I know, I know," I said.

"They're so white," Effbomb said, smelling them.

"I know."

"The pillows are so soft," Beetle said, licking them.

"Please don't lick them."

"I need to lick them."

It came as a sudden happy surprise, this realization that seeing my children experience raw wonder was far more exhilarating than any dream, that the roar of an audience's laughter was a thrill that muted into the background of my daughters' awe at a continental breakfast. Their joy became my own. I had become as a child again.

In every new city, I watched these little dreamers dance on the beds and hoped in my heart that they might draw some enduring lesson from all this, to know that when their own roads darken, when they are being pulled and tugged and crushed between the overwhelming force of what the world expects of you and what you expect of yourself, that it's possible: A dream can be made real.

But it was me who learned, and what I learned is probably so obvious as to be upsetting, that this thing I had been searching for all my life was right in front of me, licking the pillows.

# CHAPTER 25

———

*There is only one thing I can do: listen to people, see how they stick themselves into the world, hand them along a ways in their dark journey, and be handed along, for good and selfish reasons.*
—WALKER PERCY, *The Moviegoer*

NOBODY TELLS YOU THAT NOBODY REALLY CARES ABOUT your dream. Not your mother, or your wife, or your children. They don't care if your dream doesn't come true. What they care about is you, and also the garbage, and when you're going to take it out.

Your friends might ask, *Hey, friend, how's that dream going?*

But nobody's going to be upset if the dream dies, and mostly they will not ask, because they will already know. You alone have to care, hard. A dream is a baby, and it will die, if you let it.

But if you nurse it up and make it real, even then, nobody really cares, and even if they do, their love for what you have

made blooms and dies like a roadside daisy. Their love does not endure. It is not eternally begotten. It's not their place to care: That's your job.

Oh, they talk, the neighbors and bloggers and people who ask for a photo with you, they talk as if your book is so good that it should be given to new parents at birthing centers and attached to tiny baby parachutes and dropped behind enemy lines. They speak like this, and you believe them. Thank them. But do not believe them.

Nobody tells you that the way publishers make money is: They launder it for foreign governments, and also, they have this secret weapon called *To Kill a Mockingbird*. Just one *Mockingbird* can fund thousands of debut novels and memoirs. It is the golden goose, this mockingbird. It, and *Harry Potter* and *The Hunger Games* and all the others. You are grateful to these books. They are the geese of literature, birthing eggs that can be transmogrified into book contracts for ugly ducklings, like you, like me, and almost every other author ever born, it turns out. Never again will you mock *Twilight*.

Thank every sexy werewolf you meet.

———

Nobody tells you that on any given day when you are to appear at a bookstore or festival, a surprising number of all your friends in that town will message you that regrettably they are unable to attend because a family emergency requires their attention. Many of them have to leave town for a family funeral, they will say. Everywhere you go, people die, it seems.

Nobody tells you that some bookstores will love you and exclaim with delight when you arrive, and other bookstores

will not give a fuck. They will be all out of fucks. They will go in the stockroom and check for fucks and find the stockroom bereft of even one remaindered fuck. Because most bookstores see a dreamer like you almost every other day, sometimes four or five a week, and it gets exhausting, treating you all like you're the most special author in the world, which is a lie. They're not. You're not. Be grateful they remembered you were coming.

You will be honored to read one of your stories at the War Memorial Auditorium, original home of the Grand Ole Opry, more than 2,000 seats waiting to be filled. You will walk out on stage, thinking of all the legendary acts that have stirred this room with their gifts, and you will see that only twenty people have come, and you will try to laugh and try not to cry. Nobody tells you that so much of dreaming is filling imaginary rooms with imaginary people.

Nobody tells you that you will perform in statehouses, sanctuaries, synagogues, city council chambers, train depots, school auditoriums, county fairs, casinos, in the ballroom of the Hotel Monteleone and on the grounds of a derelict French castle, and even at the annual meeting of the Georgia OBGyn Society, alongside horrific displays on transvaginal mesh and fetal scalp electrode placement. Why have they asked you to speak, again? Is this a joke?

Nobody tells you that sometimes your dream will feel like a joke.

And then one day a man walks up to you on the sidewalk holding your book. He will thrust your book at you, right there on the street, and ask you to sign it, and you do, and when you hand it back to him, he will say that your book made

him love his father more, which seems a miracle to you, that your ridiculous book amplified love in the world.

The man is older, and wealthy, you can tell, just by his shoes and the tailoring of his shirt, and he is weeping as he speaks about his father, long dead, and you marvel, thinking how your own father, brash and virile as he was, would laugh to know you wrote a book about him that made grown men cry, right there on the street, including his own son.

"Thank you," the man says, and you thank him, too.

You walk away, eyes a little wet. Wonder of wonders.

———

Nobody tells you that you will change, will cease reading reviews, that one day you will be able to go hours without checking your Amazon ranking. You will find yourself in the park, staring into the trees.

"I had a publicist, once," you will say to the squirrels. "His name was Phillip."

Nobody tells you that whatever your ambition compels you toward, to make books, buildings, clothes, advertisements, machines, life insurance policies, robots, robots who keep making sequels of lesser and lesser quality, whatever it is, the journey to greatness makes fools of us all.

Nobody tells you how you will once again love teaching, the thing you ran away from at the beginning of all this, because your heart was perhaps dispositioned meanly toward certain works of art for ridiculous reasons, inclement weather, missing buttons on shirts, your own quite obvious undeveloped talent, but the grace and generosity others have shown your foolish little book has opened up a River Jordan of unex-

pected charity inside you, and now you find your heart turning to a more generous bearing when encountering the work of others, to listen to what goodness and light they're after, and to find ways to help them toward that light, the way you help someone reach a book on a high shelf. That is your job now. To help others reach the high book.

Nobody tells you that you will look at your students and also your children with new eyes, that you will find yourself asking these little people in your house what they want to be when they grow up, and they will say:

"A scientist."

"A mommy."

"A dancer."

"A writer."

"A teacher."

"A chef."

"A BMX racer."

"A fibers artist."

"A firewoman."

"A drummer."

"A she-goat."

"A professional whittler."

"Someone named Linda."

Nobody tells you that your children will become as ridiculous as you are, that this is how it works. Your love for these ridiculous people makes you cry when you think about it, and you cry all the time now, during movies and songs and church and baths and while sitting on the front porch, as they ride bikes and ask to take off their clothes so they can do naked

cartwheels in the yard, which makes their mother cry for altogether different reasons.

———

Do what you love for a living, and you'll work every day of your life, and you'll never stop working, even when you should.

Nobody says this.

Nobody says that you will never stop wondering if your dream came true, because it's an unanswerable question. A dream cannot be weighed, or packaged, or touched with the hands and exchanged for Euros. A dream is a metaphysical reality, a quality of atmosphere, a way of being, a condition of life that you long for. I know that now. There was much I didn't know about my dream when I began. I hadn't known it would require so much effort as to make me feel like Willy Loman. I hadn't known the writing would require the stark nakedness of my soul. I suppose any dream requires some measure of soul-nakedness. It is not fun, descending down into the ugly tornado shelter inside you. Most people never even take the first step.

And I grew to love it, the clearing out of the darkness in me via writing, the painful and happy explosions of laughter that happened in me and which I hoped would inspire the same in others: That's what I wanted, a life where I could spend time doing that, a few hours in the morning, or at night, or all day. This urge to express ridiculous ineffable truths in language, as a way of making meaning in a world that often seems to lack all sense, it evolved, changed shape, took on bizarre new forms. Sometimes, my dream was to write, to maybe help heal others,

the way comedy healed me. Sometimes, it felt like a dream to be famous. Sometimes, it seemed like all I dreamed of was book sales and mortgages. Now, it appears that my dream is to help my children become she-goats and someone named Linda.

Nobody tells you how happy this will make you.

Nobody tells you that dreams change, grow feral in the night, the moon breaks through the clouds and they grow teeth and hair, and then the sun rises, and they seem sweet and precious and good again. My wife's dream to work at home with her children evolved, too, once the children were old enough to follow her around the house, and she dreamed a new dream, to work at school with her children, where they continue to follow her around, in addition to the children of others, as well as many confused parents, and I am happy this became her dream, for this is how we pay for their educations, allowing them to go to a school where everybody can read and nobody gets paid to write everybody's research papers, we hope.

My dream came true, it did: I can access the light inside me, what little there is, can take it in my palm and study it and make it into something funny and beautiful in words that can live on a page in a book on a table for anybody in the world to find, should they desire it, for a book, like any work of art, helps you find a bit of your own light, and my light is silly, and my light is sad, and on good days, my light is true, and I can shine it now, if I apply myself and stay hydrated. This was my dream, and it comes true every morning, somewhere between four and five o'clock, when the world hides under blankets and skeins of flesh, and I sit at this table, fathoming what cannot be

fathomed. Nobody tells you that a dream is not something you will accomplish, long from now. It is something you do every day. That is all it can be. That is all it ever was.

———

Maybe the most amazing thing nobody tells you is that an editor named Laura from HarperCollins will call you one day in late summer and say, "We have good news."

"Your book," she says, "is a finalist for an award."

"What sort of award?" you ask.

The one they give to all *The New Yorker* people, she says. *The Onion* writers won this award, and *The Daily Show* ones, too, and David Sedaris, and you laugh. Clearly, someone has made a terrible mistake. But also you don't laugh, because you secretly think, *I'm as funny as those yahoos.*

But then you think, *No. You are not.* They write for *The New Yorker*, whereas you recently had a story republished in the *Greene County Independent* (fifty cents), a weekly out of Eutaw, Alabama, although you didn't make the front page, which was reserved for a controversial story on the placement of an electrical pole near a water tower.

The award is called the Thurber Prize for American Humor, and you would very much like to win this prize, to place it alongside your baseball trophies on top of your bookcase, including the most special trophy you own, which you won when you were eleven, in what's called a "beauty and beau" pageant, which is something they do in the public schools of Mississippi to determine whom Jesus loves the most. The nameplate on this trophy reads:

## MOST HANDSOME
## THIRD PLACE

There were three male contestants.

This is my Most Hideous Boy Award.

Nobody tells you that one day, you will marry a woman who believes this trophy is hilarious. The very sight of it makes her rush to the toilet with abandon.

"Most handsome!" she says, weeping joyfully, catching her breath.

"That's very kind of you," I say.

"It's so sad."

"I am a revolting freak, thank you."

"Oh goodness, look," she says, holding her now urine-soaked crotch.

Whenever she's feeling down or needs a urine sample, she comes into my office to look at this trophy.

Nobody tells you that you'll come to love this trophy most of all, even more than the big tall BMX trophies, because this last-place trophy tells the truth. You are not a beautiful man, by conventional standards, never have been. You are broken and hideous and demon-riddled and you know it, and if you are even a little funny, this is why. How your wife can be so beautiful and so funny, this seems unfair, but beautiful people are broken, too.

This, you have learned also.

———

The Thurber ceremony will take place at Carolines on Broadway, a comedy club in Manhattan, where people like Dave

Chappell and Maria Bamford and Tig Notaro and Mitch Hedberg have performed, and where you will be reading one of your stories in one month, according to Laura. You are dying.

"It's a major award," your mother tells everyone, shortly before turning to you to ask, "What's it called again?"

Nobody tells you that the Midtown hotel you've promised your children is going to cost more than a reasonably priced family sedan, but you will not care, not even a little, because you are living in eternity now, and you are taking everyone, even your mother, because it will be fun to walk around New York with an elderly woman who whispers constantly, "Now, which one do you think is into jihad?"

And you go, all of you, you fly to New York, to ascend the dream ziggurat you have been seeking for so long. It seems you have arrived to something. Nobody tells you that at the top of this ziggurat is the Central Park Carousel and the Natural History Museum and the Met and the East Village, where your mother points out all the places where they would find bodies if this were an episode of *Law & Order.*

Nobody tells you that on the night of the ceremony, high up in a hotel towering over this city of dreamers, your children will encourage you like ancient holy orbs of fairy light.

"Daddy?" Effbomb says. "Which book is this award for?"

"I've only written one," you say.

"Good luck, Daddy," she says, patting your head as you put on your good shoes.

"It's okay," Beetle says. "If he doesn't win, they will still give him a prize."

"False," I say. "Besides, you are the prizes."

"You should brush your teeth," Stargoat says. "They seem a little yellow."

Nobody tells you that you and Lauren will walk to Carolines through the whooshing epileptic declarations of Times Square, walking slowly, because of her heels, that she demands you slow down, that she's been demanding you slow down since you were children. You are walloped at every turn by the humanizing qualities of this funny woman whose hand you hold.

You will pray, "Why, God? Why am I deserving of any happiness? Why have you blessed me beyond comprehension?"

You stop at a light. You have to wait. You hold hands and wait together.

"I'm starving," Lauren says.

Look at your watch. It is almost her feeding time.

Look at her, while she looks at the stoplight and calculates the necessity of eating the granola bar in her handbag now, or later, in the Carolines restroom. She touches her forehead, because she very likely believes she now has forehead cancer. You love this weirdo.

The light turns. You walk.

———

You enter the club, at the corner of Forty-Ninth Street and Broadway, and your posse is there. You have a posse. They don't know that they are your posse, probably. Nevertheless.

"Wow!" Debbie says, greeting you at the bar. "Can you believe this?"

"Thank you for everything."

Hug her.

She says, "Wow!" again. She says *wow* a lot. This is what makes her a good agent. Debbie just returned from Tuscany. Nobody tells you that one day your posse will include people who go to Tuscany and say *ciao* with a straight face. You love Debbie. You love everyone, including Cal, also of your posse, the editor from south New England, who is also in attendance. Cal has grown a beard and looks like an extremely well-read lobsterman. Hug Cal, too. Thank everyone you meet, even those who do not know who you are.

Over there, a rival gang, *The New Yorker* people. Go over there, meet them. Attempt to hug some of these coastal elites, as they recoil in horror. Get your wife a drink.

A man finds you, ushers you and Lauren into the room where all the famous comedians perform, and it's all curvilinear and lopsided, like the bridge of a starship designed by Frank Gehry, and you're on the front row of the starship. The end of your dream is about to begin.

And suddenly it has begun, all three finalists reading from their books, you and the other two, one at a time, a funny man who writes for the *Wall Street Journal* and a funny woman who edits for *The New Yorker* and you, a cracker whose father was born into some kind of awful country song, dragged across his own vexed ambition by a mule, a man who wrestled with the demons of money and education all his life, never not remembering the mule, or the plow, or the kerosene lanterns, and trying, ever and always, to forget, and not to forget.

All three of you are funny. Everyone laughs. All is in order.

And now it is time for the award, and nobody tells you that they will call your name.

And you will say, *What?*

And Lauren will say, *Go!*

And you will say, *WHAT?*

Nobody tells you that the look of surprise and joy on Lauren's face will be like all the treasure chests of an empire opened at once in the morning sun, that you will bound oddly to the stage and hold the prize and lift it into the sky like it's *Rocky IV* while your wife cries like Adrian because she is so full of exultant unbridled joy because you have won.

Nobody tells you that the owner of Carolines will find you so hilarious that he will ask you to stay and perform that very night, and a *Saturday Night Live* casting director is in the crowd and hands you her card and asks you to call her, and before you can process all this, you and Lauren are drinking champagne at some club called House of Planets or Gilded Rage, and the sun is coming up, and your phone is full of texts from the publicist, who tells you *Today* wants to know if you can do the show this morning, and you will sell one million books because of this. You will pay off the house. What do you say? You need to sleep. You need a shower. But you can't say no to the *Today* show, not now, no, this is your time.

Nobody tells you this, because it doesn't happen.

———

Let me tell you what happened.

There I sat at Carolines in the front row, the dream-posse enveloping me protectively, Lauren to my right, Debbie the Tuscan and Cal the Lobsterman to my left, flanked by other nice HarperCollins personnel who probably had to be there for work. The emcee did a funny thing, and then introduced a representative of the Thurber people, and the Thurber man

came up and pulled out a small index card and announced the winner, and the winner was me. I died. I laughed madly, like a crazy person. I may have high fived a few strangers as I bounded to the podium and turned and saw that Lauren really was joyfully weeping, likely because the event was almost over and dinner would be happening soon, and because she loves me. I pulled out my hilarious acceptance remarks at the very moment I realized they didn't really want me to do any hilarious acceptance remarks, because other people were waiting to use the room, and I rushed through and ruined my hilarious acceptance remarks.

Nobody tells you that in this crowning moment, you will be far away from yourself, soaring above the island of Manhattan like a man in a movie, and then it will be over.

Everybody said congratulations and departed, the room suddenly empty as a chest bereft of air, and I stood alone in back of the club filling out a W-9 for the prize money and then found myself on the sidewalk with Lauren and a heavy engraved crystal plaque and no plans and nobody to do them with but her.

I thought somebody would at least want to buy us a celebratory drink, yes? Perhaps a shower of champagne at some point, whilst jutting madly out of the roof of a limo, perhaps?

But no. Yet again, I had been wrong. This seemed to be the story of my dream, distilled into a single shuddering moment: Something amazing would happen, while I stood there, waiting for something amazing to happen, not noticing that something amazing had already happened.

"What now?" Lauren said, into the earthly din of city traffic.

"I think I would like to write a highly lucrative musical," I said.

"No, I mean dinner," she said.

Our children were several blocks away, already in bed. Mom was with them, in the adjacent room, watching *Dateline* and feeling terrible for strangers. The night was ours.

"Let's just walk," Lauren said. "We'll find something."

I had to get this woman some food, or she would hurt somebody. She would climb a building and start swatting at aircraft. We walked. I took her hand. We never do this, and now we'd done it twice in one day. The hands get all sweaty. We both hate it, but it's fine. Sometimes two funny people can just hold hands and not be weird. Nobody tells you this.

We found a restaurant out of a Billy Joel song, and were seated. I placed the award on the table, and Lauren picked it up.

"It's heavy," Lauren said.

"That's how you know it's real," I said.

"Real what?"

"Real neat."

I patted the prize and decided that the thing to do, when we got home, was teach my children important life lessons by making them clean it once a week.

I pulled out the $5,000 check. What should we do with this money? Save it? Invest? Give it to various nonprofits and churches whose work builds up, and does not tear down?

"Gimme my money," Lauren said.

"We will all be dead one day," I said, struck with the fleeting nature of it all.

"I will be dead very soon if they don't bring me my food."

The food arrived. We had a bottle of wine. She took a migraine pill.

During dinner, we received many congratulatory texts of kindness and love, and read messages aloud to one another for an hour and smiled until our eyes hurt. Later, we walked to the hotel and tiptoed into the quiet hotel room, everyone deep in their own dreams. Lauren checked to see if everyone was breathing, and I placed the hundred-pound plaque in my bag, secretly hoping TSA officials might ask to inspect it.

We turned off the light, exhausted.

"Where's the check?" Lauren said in the dark.

"In my shoe," I said.

The sad truth was that the prize money would barely cover the Wi-Fi charges at the Marriott. We both knew this. But it had been worth it.

We become who we become for reasons we cannot always know, because of what we saw our mothers love, or our fathers hate, and because of what we need deep down inside the places that others don't know about, such as respect, or security, or adoration. What I needed, I guess, was the freedom to drink before noon and wander the house in my underwear, and I needed at least one other human who believed all the naked wandering might yield fruit, and that human was on the other side of the bed, probably trying not to think about plane crashes and heart attacks and all the skeletons in the water we were going to fly over in the morning.

She is hilarious and hurting and mean and made of iron and mercy, this woman who had plenty of reasons to walk away, or run. She often left the room, occasionally slammed

doors, stood on the threshold in storms as if she wanted the wind to sweep her away for all time, but she stayed, and held my hand through the birth of this terrible beautiful fantasy that has constituted my life's work. How do you say thank you? How do you say thank you to all the people in your life who carried you here, who handed you along in your search for meaning and purpose? You are flanked by love at every turn. There is no way around it.

Nobody tells you that these revelations are the currency of human life, that if you're lucky, you'll feel like an idiot, perpetually, eternally, realizing every day new blessings that surround you, have surrounded you for years, if you'd have only looked, new mercies every morning, which had been there all along.

"Night, night," Lauren said.

"Night, night," I said.

She reached out for me in the dark, as I reached for her.

# POSTLUDE TO AN AMERICAN DREAM

*Do something worth talking about and become famous.*
*Make it look normal.*
—WRITTEN ON A NOTECARD FOUND BY AUTHOR
MIKE SACKS INSIDE A COPY OF *Comedy Fillers*
BY ROBERT ORBEN (1961)

## SPRING NOW, A WHOLE NEW YEAR

WILL YOU SPEAK AT CAREER DAY?" STARGOAT ASKED.

"Okay," I said. "But I will embarrass you. You know this."

"The teacher wants you to inspire us," she said.

"Do I inspire you?"

She looked out the window. "I guess," she said.

On the day of my presentation, I made the short walk to the Habersham School, where my wife works and my children learn. The school, or most of it, lives inside Gould Cottage, a

wide Tudor manse that lay across a sward of Savannah green like a great old goose that had spread its wings and lain down to rest. Gould had once, long ago, served as the Savannah Female Orphan Asylum, though now it served as an asylum for children with parents.

I like school buildings, always have. With a teacher for a mom, you spend a lot of time in them, on weekends, in summers, when buildings are empty and dark and clean, trembling with memory and promise, awaiting the trample and din of dreamers. Gould was not empty on this day, but humming, alive. They buzzed me in and I made my way to the modest assembly room, where I evaded notice and sat in back. About fifty or sixty students, some as young as five, including all three of my incredible daughters, stared toward the front with vague enthusiasm as the speakers made their pitches. I was up against a nurse, a dentist, and a golf pro.

For most of human history, these children's career options would have been much simpler, back when you did whatever your parents did, which was usually to die of typhoid. If your father was an evil overlord, you became an evil overlord. If your mother was a subjugated washerwoman, then maybe, with hard work, you became a subjugated washerwoman-slash-leech-gatherer. But today, thanks to the Magna Carta, penicillin, and LinkedIn, there exist many kinds of subjugation to aspire to. Plagues no longer plague. Today, we are plagued with dreams.

I watched the others, before it was my turn.

Everybody had visual aids. The pro had his irons and woods. The dentist had her giant toothbrush. The children were very excitable. The class clowns were easy to spot, per-

forming maneuvers with the enormous dental tool as it was passed to them, brushing their hair with it, their underarms and such. That would have been me, a lifetime ago, or yesterday. I could respect this behavior. Sometimes, comedy's all you got.

The nurse, she was good with people, you could tell. "Nursing is my calling," she said. "Helping others brings me so much joy."

The dentist, this was not her first rodeo. Following the revelation of the novelty toothbrush, she revealed a pair of non-chattering teeth, which had an almost ecstatic effect on the children. She then concluded with what I felt were unfair remarks on the dangers of candy.

They called me up last.

"My name is Dr. Harrison Scott Key," I said, "and I am bad at almost everything."

The children laughed. So far, so good.

"Does anybody know what I'm a doctor of?" I asked.

Approximately every hand shot up.

"Yes, you," I said, to an eager young lady up front.

"I want to be a dolphin," she said.

"Fun," I said.

"My cat has three legs," a little boy next to her explained.

"Amazing," I said. "Does anybody know what I am a doctor of? It has little to do with sea mammals and cats, I am afraid."

"You're a doctor of nothing!" came a voice from the bobbing mass of heads. It was Beetle, hiding somewhere in the middle. Children really are full of darkness.

"Who thinks this delinquent child is right?" I said. "Who thinks I'm a doctor of nothing?"

All of them, apparently. The monsters continued to laugh madly. Some of the children laughed so hard their bones could no longer hold them upright, and they slid to the floor. Two boys appeared to be filled by the Holy Spirit and danced up and down the aisle.

The teachers performed a little ritual designed to quiet the children, while I observed, greatly pleased that I had caused so much human exhilaration.

Finally, the room grew quiet again. The teachers knew their work.

"Well, that little girl is right," I said. "A doctor of nothing is exactly what I am."

I told them how books and stories did feel like nothing, sometimes. They start as invisible things, in the imagination, and they take on materiality in the figure of a book, and then they go into someone else's imagination, turning invisible once more.

"Who wants to be a writer?" I said.

There, sitting near the last row, Stargoat raised her hand, tentatively, smiling. I smiled back, gave my girl a wink.

"A dream is very much like a book," I said. "It is an invisible thing in your heart, that nobody can see, except you. Sometimes not even you can see it."

"Like nothing," I said. "Light as air. Insubstantial as a cloud."

The room was quiet now. Many were leaning forward. They believed.

I turned on my PowerPoint, and I showed them funny pictures, of my family, of a squirrel reading my book, of a deer hanging from my childhood swing set, and explained how this puzzling and incongruous image shaped my life and made

me the freak I am, and how if they are blessed, they will one day learn how they became the freaks they will one day be. I showed them the Thurber Prize, grandiloquent and glinting in the light, and they *oohed* and *aahed*, and I showed them my Most Hideous Boy trophy, and they laughed violently, pleased to know that a man so freakish had made something of himself.

"Are you really famous?" a boy asked.

"No," I said. "But I was on TV once."

"Cool!" he said.

I did not say that it was a local program and that the other guest on the show that day was a lady discussing the artificial insemination of bees.

"I was made to feel more important than I am, for a time," I said, and I told them how my modest notoriety, fleeting as it was, resulted in many extraordinary episodes. For example, I was asked to judge important contests, mostly regarding pie.

"And I won't lie, it was awesome," I said. "You sit there and they bring the pie to you. It's actually pretty easy if you focus and don't scream at people too much."

I looked out at all their eager faces, this roomful of little yearning machines, designed to love and want and work, and felt heaven heave with holy breath, that we are, all of us, made to dream. I could see in their faces the burning desire to know, to learn the nature of their destinies and seize them, to discover the truth: Did I bring candy for them, or no?

I told them what I came to tell them, which is that I am no hero. I have not discovered vaccines. I am not airlifting refugees from tyrannical governments here. All I am is a writer whose American dream came true, and to me, that is remarkable. It is more than remarkable. It is a wonder, a most happy

miracle. It could happen to them, too, if they believed, and drove themselves to the very precipice of talent and sanity, such that they, too, may one day find themselves living in a home with more ceiling fans than one could possibly fathom.

The little baby of my dream was born and was nurtured and kept alive by the love of my family and the immeasurable kindnesses of friends and strangers and the favor of almighty God, and it grew big and strong and made this beautiful life possible, such that I can now open my inbox to find a festival itinerary that reads, "3:30 p.m.—I'll pick you up at the Hampton Inn and take you to the site of the pie contest."

"Who likes cakes and pies?" I asked.

Most of the children raised their hands.

"And who likes candy?" I said.

All the children raised their hands, almost touched the ceiling.

I reached into my backpack and pulled forth the largest sack of lollipops to be found in coastal Georgia, and I lifted it high, like the head of my enemy, and the crowd went wild.

# APPENDIX A

---

## BOOKSTORES, FESTIVALS, AND RELATED TOUR PERFORMANCES THAT WERE FUN AND ALMOST KILLED ME

2015 AJC Decatur Book Festival, Decatur, Georgia

2016 Georgia OBGyn Society Annual Meeting, Sea Island, Georgia

2016 Southern Independent Booksellers Alliance Discovery Show, Savannah, Georgia

A Capella Books, Atlanta, Georgia

Alabama Booksmith, Birmingham, Alabama

Austin Peay State University, Clarksville, Tennessee

Association of Writers & Writing Programs Conference 2016, Los Angeles, California

Baylor School, Chattanooga, Tennessee

Belhaven University, Jackson, Mississippi

Blue Bicycle Books, Charleston, South Carolina

BookPeople, Austin, Texas

Booksellers of Laurelwood, Memphis, Tennessee

Château de Lacoste, SCAD Lacoste, Lacoste, France

Country Bookshop, Southern Pines, North Carolina

Douglas Anderson School of the Arts, Jacksonville, Florida

E. Shaver Books, Savannah, Georgia

Fall for the Book Festival, George Mason University, Fairfax, Virginia

Faulkner House Books, New Orleans, Louisiana

Flannery O'Connor Childhood Home, Savannah, Georgia

Flyleaf Books, Chapel Hill, North Carolina

Fountain Bookstore, Richmond, Virginia

Glen Workshop, Santa Fe, New Mexico

Golden Nugget Biloxi Hotel & Casino, Biloxi, Mississippi

Hub City Bookshop, Spartanburg, South Carolina

Ivy Hall, SCAD Atlanta, Atlanta, Georgia

Jackson Preparatory School, Jackson, Mississippi

Lemuria Books, Jackson, Mississippi

Literary Death Match, Nashville, Tennessee

Literary Guild of St. Simons Island, St. Simons Island, Georgia

Louisiana Book Festival, Baton Rouge, Louisiana

M. Judson Booksellers, Greenville, South Carolina

Malaprop's Bookstore/Cafe, Asheville, North Carolina

Marshes of Glynn Libraries, Brunswick, Georgia

McIntyre's Books, Pittsboro, North Carolina

Mid-South Book Festival, Memphis, Tennessee

Mills University Studies High School, Little Rock, Arkansas

Millsaps College, Jackson, Mississippi

Mississippi School for the Arts, Brookhaven, Mississippi

Neshoba County Fair, Philadelphia, Mississippi

Nightbird Books, Fayetteville, Arkansas

Octavia Books, New Orleans, Louisiana

Ole Miss (University of Mississippi), Oxford, Mississippi

*Oxford American*, Little Rock, Arkansas

Page & Palette, Fairhope, Alabama

Park Road Books, Charlotte, North Carolina

Parnassus, Nashville, Tennessee

Pomegranate Books, Wilmington, North Carolina

Purple Crow Books, Hillsborough, North Carolina

Quail Ridge Books, Raleigh, North Carolina

River Hills Club, Jackson, Mississippi

St. Andrew's Society, Savannah, Georgia

St. Johns County Public Library System, Ponte Vedra
    Beach, Florida

Savannah Bar Association, Savannah, Georgia

Savannah Book Festival, Savannah, Georgia

Savannah Rotary Club, Savannah, Georgia

SCAD Museum of Art, Savannah, Georgia

SCADshow, Atlanta, Georgia

SCBook Festival, Columbia, South Carolina

Seersucker Live, Savannah, Georgia

South on Main, Little Rock, Arkansas

Southern Festival of Books, Nashville, Tennessee

Southern Illinois University, Carbondale, Illinois

Southern Lit Alliance, Chattanooga, Tennessee

Square Books, Oxford, Mississippi

Tampa Bay Times Festival of Reading, St. Petersburg,
    Florida

Texas Book Festival, Austin, Texas

*Thacker Mountain Radio Hour*, Oxford, Mississippi

The Book Lady Bookstore, Savannah, Georgia

The Florida Heritage Book Festival, St. Augustine, Florida

The Habersham School, Savannah, Georgia

The home of Emily and Guy McClain, Jackson, Mississippi

The home of Emily and Toff Murray, New Orleans, Louisiana

The Shoe Burnin' Show, Columbia, South Carolina

The Shoe Burnin' Show, Savannah, Georgia

The Wild Detectives, Dallas, Texas

Thurber House, Columbus, Ohio

Turning Pages Books & More, Natchez, Mississippi

Turnrow Book Co., Greenwood, Mississippi

University of the South, Sewanee, Tennessee

Virginia Festival of the Book, Charlottesville, Virginia

Walker Percy Weekend, St. Francisville, Louisiana

WORD, Brooklyn, New York

Words and Music Festival: A Literary Feast in New Orleans, New Orleans, Louisiana

Word of South: A Festival of Literature & Music, Tallahassee, Florida

Writing in Place Conference, Spartanburg, South Carolina

## APPENDIX B

PEOPLE WHO GAVE ME A CLEAN PLACE TO
SLEEP DURING THE TOUR OR HELPED ME
IN OTHER VERY SPECIFIC AND OCCASION-
ALLY INEFFABLE WAYS AND DID NOT
USUALLY CHARGE A FEE

April Cheek and Mark Blanton
Ariel Felton
Austin Bolen
Beth Ann Fennelly and Tommy Franklin
Brian Floyd
Brian Perry
Calvert Morgan
Carol Ann Fitzgerald
Cathy Doty
Chia Chong and Amy Zurcher
Chris Offutt
Cille Norman

Curtis Wilke

Daniel Pritchett

Davey Kim

David Rush

Dayton Castleman

Deborah Grosvenor

Eliza Borné and the staff of the *Oxford American*

Emily and Guy McClain

Emily and Toff Murray

Eric Svenson

Gebre Menfes Kidus

George Dawes Green

George Hodgman

Greg Thompson

Gregory Henry

Gregory Wolfe

Hannah Hayes

Hilary Chandler

Hill Honeck and Family

James Lough

Jamie Quatro

Jan and John Remington

Jay Jennings

Jeannie Stock

Jessica and Jason Miller

Jill and Joel Bell

Jim Dees

Jim Tyler Anderson

Joe Birbiglia

John Hanners

John Maxwell

John T. Edge

Joni Saxon-Gusti

Karin Wolf Wilson

Katherine Sandoz

Kelly Pickerill

Laura Brown

Lee Griffith

Lisa and Clint "Bird" Striplin

Marc Smirnoff

Melanie Black

Mike Sacks

Nate Henderson

Neil White

Paula and Glenn Wallace

Richard Grant

Rod Dreher

Roy Blount Jr.

Sarah and Michael Spencer

Scott Spivey

Shari Smith and the Shoe Burnin' Show

Shelby and Hudson Segrest

Tanya Key Mansfield

Teresa and Jeremy Roberts

The Finn McCool Fellowship

Tim Taylor

Virginia Morell

Wanda Jewell and the Southern Independent Booksellers
    Alliance

Wynn Kenyon

# APPENDIX C

## FURTHER READING AND WATCHING ON THE NATURE OF WORK, ART, AMBITION, FAME, SUCCESS, FAMILY, LOVE, AND/OR THE GLORIES AND PERILS OF THE AMERICAN DREAM

*A Cool Million* by Nathanael West (novel)

*Act One* by Moss Hart (memoir)

*Advertisements for Myself* by Norman Mailer (memoir)

*Anvil! The Story of Anvil* (film)

*Banvard's Folly: Thirteen Tales of People Who Didn't Change the World* by Paul Collins (nonfiction)

*Bech: A Book* by John Updike (novel)

*Bluebeard* by Kurt Vonnegut (novel)

*Death of a Salesman* by Arthur Miller (play)

*Dept. of Speculation* by Jenny Offill (novel)

*Glengarry Glen Ross* by David Mamet (play)

*Invisible Man* by Ralph Ellison (novel)

*Jim & Andy: The Great Beyond* (documentary)

*Jubilee* by Margaret Walker (novel)

*La La Land* (film)

*Look Homeward, Angel* by Thomas Wolfe (novel)

*Making It* by Norman Podhoretz (memoir)

*Metallica: Some Kind of Monster* (film)

*On Fire* by Larry Brown (memoir)

*Stoner* by John Williams (novel)

The Book of Ecclesiastes (religious)

*The Right Stuff* by Tom Wolfe (nonfiction)

*The Wrestler* (film)

*Waiting for Guffman* (film)

## APPENDIX D

—

## FIVE BOOKS THAT ILLUSTRATE THE SAD-PEOPLE-EVERYWHERE-ALL-THE-TIME THEORY OF COMEDY

1. *52 McGs.: The Best Obituaries from Legendary* New York Times *Reporter Robert McG. Thomas* by Robert McG. Thomas
2. *Can't We Talk About Something More Pleasant? A Memoir* by Roz Chast
3. *The End of Vandalism* by Tom Drury
4. *Treasure Island!!!* by Sara Levine
5. *Wolf Whistle* by Lewis Nordan

# ABOUT THE AUTHOR

HARRISON SCOTT KEY's writing has been featured in *The Best American Travel Writing*, *New York Times*, *Outside*, *Salon*, *Chronicle of Higher Education*, *McSweeney's Internet Tendency*, *Southern Living*, *Reader's Digest*, *Image*, *Creative Nonfiction*, *Mockingbird*, *Green County Independent*, *Brevity*, *Gulf Coast*, and *Oxford American*, where he is also a contributing editor. He teaches at SCAD in Savannah, Georgia, where he lives with his wife and three children. Harper published his first memoir, *The World's Largest Man*, which won the Thurber Prize for American Humor.

# ALSO BY
# HARRISON SCOTT KEY

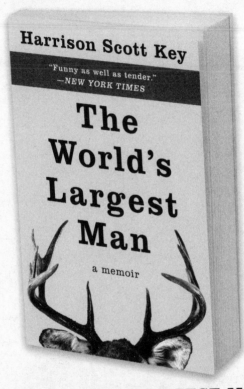

## THE WORLD'S LARGEST MAN
### A Memoir

**Winner of the 2016 Thurber Prize**

"I haven't laughed like this in years. I felt like I stumbled upon an undiscovered treasure. . . . Rare hilarity, indeed, in these asinine times." —Neil White, Author of *In the Sanctuary of Outcasts*

### Available in Paperback and eBook

Sly, heartfelt, and tirelessly hilarious, *The World's Largest Man* is an unforgettable memoir—the story of a boy's struggle to reconcile himself with an impossibly outsized role model, a grown man's reckoning with the father it took him a lifetime to understand.

Discover great authors, exclusive offers, and more at hc.com.

31901063917928